Published on the occasion of the exhibition
Between Past and Future: New Photography and Video from China,
co-organized by
the David and Alfred Smart Museum of Art, University of Chicago
and the International Center of Photography, New York,
in collaboration with
the Museum of Contemporary Art, Chicago
and the Asia Society, New York.

EXHIBITION TOUR

New York
June 11–September 4, 2004
International Center of Photography
Asia Society

Chicago
October 2, 2004–January 16, 2005
David and Alfred Smart Museum of Art,
University of Chicago
Museum of Contemporary Art

Seattle
February 10–May 15, 2005
Seattle Art Museum

London
September 15, 2005–January 8, 2006
Victoria and Albert Museum

Berlin
March 23–May 21, 2006
Haus der Kulturen der Welt

Santa Barbara
June 24–September 17, 2006
Santa Barbara Museum of Art

Durham, North Carolina
October 19, 2006–February 18, 2007
Nasher Museum of Art
Duke University

Between Past and Future

NEW PHOTOGRAPHY AND VIDEO FROM CHINA

WU HUNG

and

CHRISTOPHER PHILLIPS

with contributions by
Melissa Chiu, Lisa Corrin, and
Stephanie Smith

SMART MUSEUM OF ART, UNIVERSITY OF CHICAGO
INTERNATIONAL CENTER OF PHOTOGRAPHY, NEW YORK

in collaboration with
MUSEUM OF CONTEMPORARY ART, CHICAGO
ASIA SOCIETY, NEW YORK

Design: Froeter Design Company, Inc., Chicago
Editor and Publication Manager: Stephanie Smith
Copy Editors: Kari Dahlgren, Gregory Nosan, Stephanie Smith
Research Associate: Joy Le
Printed in Hong Kong by Asia Pacific Offset, Inc.

SMART MUSEUM OF ART, UNIVERSITY OF CHICAGO
5550 S. GREENWOOD AVENUE
CHICAGO, IL 60637
PHONE: +1-773-702.0200
HTTP://SMARTMUSEUM.UCHICAGO.EDU

INTERNATIONAL CENTER OF PHOTOGRAPHY
1114 AVENUE OF THE AMERICAS
NEW YORK, NY 10036
WWW.ICP.ORG

ISBN: 0-935573-39-9

LIBRARY OF CONGRESS CATALOGUING-IN-PUBLICATION DATA

WU HUNG, 1945–
BETWEEN PAST AND FUTURE : NEW PHOTOGRAPHY AND VIDEO FROM CHINA / WU HUNG AND
CHRISTOPHER PHILLIPS ; WITH CONTRIBUTIONS BY MELISSA CHIU, LISA CORRIN, AND STEPHANIE
SMITH. — 1ST ED.
 P.CM
INCLUDES BIBLIOGRAPHIC REFERENCES.
ISBN 0-935-57339-9 (ALK. PAPER)
1. PHOTOGRAPHY, ARTISTIC—EXHIBITIONS. 2. PHOTOGRAPHY—CHINA—EXHIBITIONS. 3. VIDEO
ART—CHINA—EXHIBITIONS. 4. PHOTOGRAPHERS—CHINA—BIOGRAPHY. I. WU HUNG, 1945– II.
TITLE
TR645.C552 D389 2004
779´.0951—DC22
 2004010566

CONTENTS

The contemporary art scene in China is one of the most exciting, the most quickly evolving, and simply one of the biggest anywhere in the world. Whereas Chinese artists often had no choice but to work in relative isolation during the 1980s and early 1990s, over the past decade this situation has completely reversed. Chinese artists are everywhere, and new art from China is some of the freshest, most engaged and engaging work one can find anywhere. Often ambitious in scale and experimental in nature, this work offers a range of highly individual responses to the unprecedented changes in China's economic, social, and cultural life over the past decade.

Between Past and Future: New Photography and Video from China represents an unusual collaboration among four institutions, led by two talented curators. In 2000, Christopher Phillips and Wu Hung met and discovered a mutual interest in organizing a definitive exhibition of contemporary Chinese photography and video. It soon became apparent that the project could not be contained within the walls of the curators' home institutions, the International Center of Photography in New York and the Smart Museum of Art at the University of Chicago, respectively. The organizers invited two other institutions, the Asia Society in New York and the Museum of Contemporary Art in Chicago, to join the project and, to our great delight, this ambitious four-way collaboration was born.

On the curatorial front, the project engages two key talents: Christopher Phillips, Curator at the International Center of Photography and one of the most active scholars and historians of photography in the West, and Wu Hung, the Harrie A. Vanderstappen Distinguished Service Professor of Art History at the University of Chicago and Consulting Curator at the Smart Museum, who is the leading scholar in the field of contemporary Chinese art. Phillips and Wu have been supported in their

roles by a terrific team of energetic young curators, including Smart Museum Curator Stephanie Smith, Asia Society Curator for Contemporary Art Melissa Chiu, and Museum of Contemporary Art Associate Curator Staci Boris. We are extremely grateful to this exceptional curatorial team, which worked closely together to conceive and coordinate this ambitious project.

Collaborations can be challenging and ours has proven to be no exception, but the benefits have far outweighed any difficulties. The partnership represents a true "dream team" that includes a leading museum devoted to photography, a distinguished university art museum, a well-known institution committed to the art and culture of Asia, and a prominent museum dedicated to contemporary art. To continue that metaphor, each institution fielded a line-up of talented staff members, without whose dedication the exhibition and the collaboration could not have been realized. We thank Lacy Austin, Erin Barnett, Phillip Block, Karlos Carcamo, Karen Hansgen, Robert Hubany, Joanna Lehan, Phyllis Levine, Diane Love, Suzanne Nicholas, Amy Poueymirou, Vanessa Rocco, Steve Rooney, Marie Spiller, Brian Wallis, and Barbara Woytowicz from the International Center of Photography. At the Smart Museum we are grateful to Rudy I. Bernal, Paul Bryan, Christine Durocher, Julie Freeney, Shaleane Gee, David Ingenthron, Uchenna Itam, Joy Le, Jennifer Moyer, and Jacqueline Terrassa. We also extend our thanks to Helen Abbott, Todd Galitz, Sebastian Haizet, Joshua Harris, Karen Karp, and Anne Kirkup at the Asia Society. We are also grateful to Greg Cameron, Kari Dahlgren, and Norah Delaney at the Museum of Contemporary Art. Special thanks goes to Tom Zurawski of Froeter Design, and Gerhard Steidl of Steidl Publishers for their work on the first edition of this publication. We also thank the following individuals at our participating venues: Lisa Corrin,

Deputy Director of Art/Jon and Mary Shirley Curator of Modern and Contemporary Art, Seattle Art Museum; Linda Lloyd-Jones, Head of Exhibitions, Victoria and Albert Museum, London; Hans-Georg Knopp, Director, Haus der Kulturen der Welt, Berlin; and Karen Sinsheimer, Curator of Photography, Santa Barbara Museum of Art.

We are enormously grateful to the exhibition funders, without whom the project would not be possible. As we began to raise funds for the exhibition, we faced a daunting task due to the scope and complexity of what we hoped to achieve. We were greatly heartened by the interest and enthusiasm of these partners, many of whom we approached jointly, and who were pleased to support an innovative and efficient collaborative venture that would bring new art from China to a broad audience. All project funders are listed in descending order on page 9.

Finally, we thank the artists whose works make up the exhibition, and whose points of view are documented in this catalogue. We know you will be as excited about their work as we are.

KIMERLY RORSCHACH
Dana Feitler Director
David and Alfred Smart Museum of Art
University of Chicago

WILLIS E. HARTSHORN
Ehrenkranz Director
International Center of Photography
New York

ROBERT FITZPATRICK
Pritzker Director
Museum of Contemporary Art
Chicago

VISHAKHA DESAI
Senior Vice President and Director of the
Museum and Cultural Programs
Asia Society
New York

This exhibition and its catalogue have been collaborative efforts, whose successful culmination has required the energy, knowledge, and good will of countless individuals. We owe a particular debt of gratitude to the directors of the four participating institutions—Buzz Hartshorn of the International Center of Photography, Kimerly Rorschach of the Smart Museum of Art, Vishakha Desai of Asia Society, and Robert Fitzpatrick of the Museum of Contemporary Art, Chicago—who immediately grasped the significance of this project and provided the unstinting support necessary to realize it.

During repeated travels in China, the curators incurred many debts to artists, museum personnel, independent curators, scholars, dealers, and friends, who all gave generously of their time and offered guidance at critical junctures. In Beijing, we received invaluable help from Ai Weiwei; Huang Rui, Beijing-Tokyo Art Projects; Chang Yung-Ho, Beijing University; Beatrice Leanza, Frank Uytterhaegen, and Xie Wenyue, China Art Archives & Warehouse; Meg Maggio and Jeremy Wingfield, CourtYard Gallery; Chaos Y. Chen; Feng Boyi; Gao Bo; Inma Gonzalez-Puy; Li Xianting and Liao Wen; Liu Ting; Antonio Ochoa; Brian Wallace, Red Gate Gallery; Karen Smith; Robert Bernell, Timezone8; Xing Danwen; and Yin Jinan. In Shanghai, we benefited from the encouragement and expert advice provided by Li Liang of Eastlink Gallery and Lorenz Helbling and Laura Zhou of ShanghART Gallery. A special word of thanks is owed to Yang Fudong, who repeatedly organized impromptu video screening sessions in his Shanghai residence, bringing together visiting curators and a range of video artists. In Guangzhou, Wang Huangsheng and Guo Xiaoyan of the Guangdong Museum of Art graciously helped to secure key loans for the exhibition. Zhang Wei of the Vitamin Creative Space in Guangzhou responded to our requests for assistance with alacrity and consummate skill. In Hangzhou, the pioneer video artist Zhang Peili of the New Media Department at the China Academy of Fine Arts helped to fill out our understanding of the development of video in China.

In New York, an enormous number of individuals contributed support at key moments. ICP board member Artur Walther deserves special recognition for his sustained commitment to this project, and for spreading his own enthusiasm to ICP's board members and committee members. We also take pleasure in acknowledging the following individuals, without whose help and encouragement the exhibition could never have come to fruition: Steven Rand, Apex Art; Mathieu Borysevic; Christophe Mao, Chambers Fine Art; France Pepper, China Institute; Ethan Cohen, Ethan Cohen Fine Arts; Anne Ehrenkranz and the ICP Acquisitions Committee; Lynn Gumpert, Grey Art Gallery, New York University; Jeanne Greenberg-Rohatyn; Jonathan Hay and Zhijian Qian, Institute of Fine Arts, New York University; Jonathan Leiter, JGS, Inc.; Andrew Lewin; Grace Rong Li; Jane Lombard; Barbara London, Museum of Modern Art; Gerald Pryor and Zhang Jian-Jun, New York University; REC Foundation, Inc.; David Solo; Howard Stein; Sarina Tang; Jack and Susy Wadsworth; Ping Jie Zhang; and Zhao Gong.

For their continuing assistance and support, we wish to thank Claire Tsu, Asian Art Archives, Hong Kong; Britta Erickson, Hou Hanru; Eloisa and Chris Haudenschild; Jerome Silbergeld, Princeton University; and Yukihito Tabata and Hiroko Muramatsu, Tokyo Gallery, Tokyo.

The exhibition has involved considerable staff time at all of the collaborating institutions, and we wish to signal our gratitude to the many individuals who have helped to bring it to completion. We wish to express special thanks to Joanna Lehan of the ICP Exhibitions Department, who mastered the intricate logistics required to realize this complex project. The success of the exhibition owes much to her boundless energy, unflappable good humor, and extraordinary thoroughness. We are also grateful for the assistance of Erin Barnett and Vanessa Rocco, who pitched in at key moments. For their expertise in handling extremely detailed Chinese-language communication with a wide range of individuals, we are deeply grateful to Ingrid Dudek, Peggy Ho, I-Fen Huang, Sally Wu, and Christina Yu.

The exhibition's elegant installation design at ICP and Asia Society was conceived and executed by Alan Bruton of Section-A Architects. The inventive exhibition graphics were devised by Alicia Cheng of Mgmt. Design. Working under daunting deadline pressure, they provided imaginative ways to effectively showcase the artists' works.

At the Smart Museum of Art, curator Stephanie Smith oversaw the production of the exhibition catalogue with cool professionalism. The complex task of translating and editing the artists' statements and interviews that contribute so strongly to the catalogue's lasting importance would have been impossible without her diligence and discerning attention to detail. Joy Le served as the Smart Museum's liaison to the Chinese-speaking artists, and her unwavering assistance was crucial to the book's success. Kari Dahlgren and Gregory Nosan enhanced the grace and clarity of the texts. Froeter Design developed an exquisite design for the publication, and Chris Froeter and lead designer Tom Zurawski deserve special thanks for their unflagging commitment to the project. We also thank Smart Museum Education Director Jacqueline Terrassa, who worked with the curators and with colleagues at the Museum of Contemporary Art, Chicago, to organize a major symposium on interrelationships among video, film, and photography in contemporary Chinese art, which will take place during the Chicago presentation of the exhibition.

To anyone who has been inadvertently omitted, we extend our sincere apologies and thanks.

WU HUNG
CHRISTOPHER PHILLIPS

EXHIBITION FUNDERS

Between Past and Future:
New Photography and Video from China
and related programs were made possible
by a broad range of contributors,
whose enthusiasm and financial support
for the project speak both to its
excellence and its importance.
We thank the following organizations and
individuals for their generosity,
with special thanks to
American Center Foundation
and
The Elizabeth F. Cheney Foundation
for their support of this catalogue.

LEAD SPONSOR
The Smart Family Foundation

BENEFACTOR SPONSORS
E. Rhodes and Leona B. Carpenter Foundation
The Henry Luce Foundation
National Endowment for the Arts
W. L. S. Spencer Foundation
The Andy Warhol Foundation for the Visual Arts

MAJOR SPONSORS
Marilynn Alsdorf
American Center Foundation
The Blakemore Foundation
The Elizabeth F. Cheney Foundation
Jeffrey A. and Marjorie G. Rosen
Fred and Stephanie Shuman
Artur Walther
Helen and Sam Zell

SPONSORS
Mrs. Catherine G. Curran
Salvatore Ferragamo Italia S. P. A.
Richard and Mary L. Gray
Illinois Humanities Council
JGS, Inc.
Virginia W. Kettering Fund of The Dayton Foundation
Jennifer McSweeney and Peter Reuss
Rosenkranz Charitable Foundation
The Shelley & Donald Rubin Foundation, Inc.
Dorie Sternberg
Sarina Tang

9

Between Past and Future:
A BRIEF HISTORY OF CONTEMPORARY CHINESE PHOTOGRAPHY

WU HUNG

During the past twenty-five years, Chinese artists have reinvented photography as an art form. Before 1979, and especially during the Cultural Revolution mobilized by Mao Zedong to reinvigorate Communism in China between 1966 and 1976, publications and exhibitions of photographs served strict propagandist purposes; unofficial photography remained private. The appearance of the first unofficial photo club and exhibition in Beijing in 1979 changed this situation fundamentally. Since then, many such clubs have emerged and numerous photography exhibitions have been organized by independent curators and artists. In the process, contemporary Chinese artists' use of the medium has evolved from imitating Western styles to developing an original language and character.

From the 1980s to the 1990s, a host of photography journals and magazines was published in China, introducing the major schools and masters of Western photography to an eager audience. Western techniques as well as social and artistic aspirations influenced a generation of young Chinese photographers, who made images for their aesthetic appeal and as authentic records of historical events and human lives. Many artists produced documentary-style photographs during the 1980s and early 1990s, creating works with a strong political agenda, either exploring the dark side of society or glorifying an idealized, timeless Chinese civilization unspoiled by Communist ideology. This period, which Chinese critics described as the Photographic New Wave *(sheying xinchao)*, laid the ground for the next generation of photographers to undertake wide-ranging artistic experiments beyond realism and symbolism.[1]

The new types of image-making, often referred to collectively by Chinese artists and art critics as experimental photography *(shiyan sheying)*,[2] became closely linked with an ongoing experimental art movement in the 1990s. Whereas experimental photographers found inspiration in performance, installation, and multimedia art, painters, performers, and installation artists have routinely employed photography in their work, sometimes even reinventing themselves as full-time photographers. As a result of this dynamic exchange, photography has played a central role in recent contemporary Chinese art. Photography's openness to new visual technology and its ability to challenge the boundaries between fiction and reality, art and commerce, object and subject, have inspired and permeated various kinds of art experimentation in China.

Containing roughly one hundred and thirty works created by sixty artists from 1994 to 2003, the exhibition *Between Past and Future: New Photography and Video from China* showcases this most recent chapter of contemporary Chinese photography, the continuous, exciting development of which has, over the past decade, been characterized by nonstop reinvention, abundant production, multifaceted experimentation, and cross-fertilization with other art forms. To provide the exhibition with a historical context, this essay covers a broader period, outlining the major trends, stimuli, and developmental stages of Chinese photography over the past twenty-five years. A review of the period from the late 1970s to 1980s establishes the starting point of this development—a "ground zero" against which documentary and "fine art" photography reemerged with rigor and a sense of mission. The following discussion focuses on two aspects of experimental photography since the 1990s: its relationship with China's social transformation and the artists' changing self-identity, and the interaction between experimental Chinese photography and postmodern theories, conceptual art, and other new forms of contemporary art such as performance and installation. Integrated into a single narrative, these two focuses will address the dominant concerns of experimental Chinese photographers and the basic direction of their experiments.

THE RISE OF
UNOFFICIAL PHOTOGRAPHY
(1976–1979)

Three consecutive events from 1977 to early 1979 together constituted a turning point in the history of contemporary Chinese photography. First, a group of amateur photographers formed an underground network, compiling their private records of a suppressed political movement into volumes for public circulation. This movement—the mass mourning for Premier Zhou Enlai in 1976—was the first large-scale public demonstration in the capital of the People's Republic of China. Toward the mid-1970s, Zhou had become the remaining hope for many Chinese, who saw him as the only person able to save China from the disasters that the Cultural Revolution had inflicted upon the country. With Zhou's death in January 1976, this hope seemed to have vanished. Even worse, the extreme leftist leaders of the Cultural Revolution—the Gang of Four headed by Mao's wife, Jiang Qing—condemned Zhou and prohibited people from mourning him. All the anxiety, frustration, disillusion, and anguish that had troubled Beijing residents for more than a decade merged into a shared feeling of grief from which a grassroots movement began to take shape.

On March 23, a single wreath of white paper, the traditional symbol of mourning, was dedicated to Zhou at the foot of the Monument to the People's Heroes in Tiananmen Square. It was immediately removed by Beijing's municipal government, which was controlled by the Gang of Four. But the prohibition only brought more wreaths, mourners, and finally the protest on April 4, the day of the Qingming Festival (the traditional day for holding memorial services for the dead). One hundred thousand people gathered in Tiananmen Square on this and the following day. By this point, white wreaths had been covered by red flags and slogans, and weeping had turned into songs, the beating of drums, and poems condemning the Gang of Four's evil deeds. Then, on the night of April 5, some ten thousand armed police and worker-militiamen rushed into the square, beating and arresting the demonstrators. Terror continued for months afterward: numerous arrests were made; photos and tapes recording the mass gathering were confiscated; people who refused to surrender these records were threatened with the death penalty.

Such extreme repression only hastened the fall of the Gang of Four. After Mao died in October of that year, the new leader Hua Guofeng arrested Jiang Qing and her colleagues. After Deng Xiaoping returned to power in 1978, Mao was openly criticized, and nearly three million

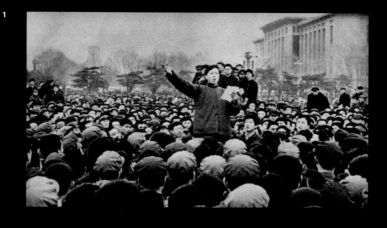

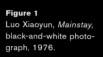

Figure 1
Luo Xiaoyun, *Mainstay*,
black-and-white photo-
graph, 1976.

Figure 2
Wu Peng, *Internationale*,
black-and-white photo-
graph, 1976.

Figure 3
Cover of *People's
Mourning*, 1979.

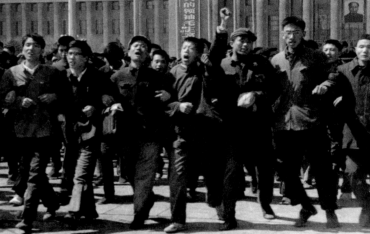

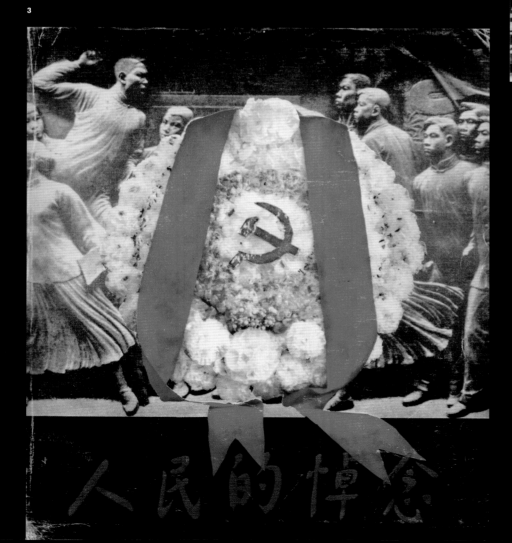

人民的悼念

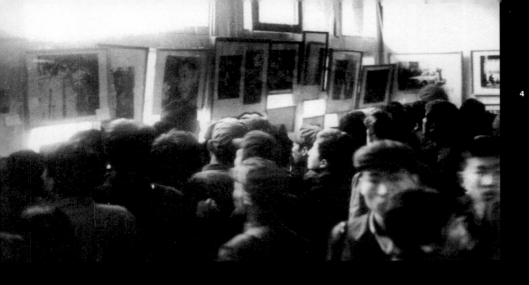

4

Figure 4
First *Nature, Society, and Man exhibition,* 1979, Sun Yat-sen Park, Beijing.

Figure 5
Jin Bohong, *The Echoing Wall,* black-and-white photograph, a work in the first *Nature, Society, and Man* exhibition, 1979.

Figure 6
Wang Miao, *Inside and Outside the Monkey Cage,* black-and-white photograph, a work in the first *Nature, Society, and Man* exhibition, 1979.

5

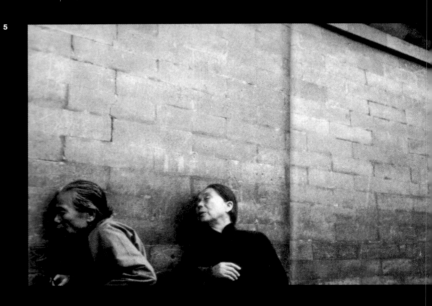

6

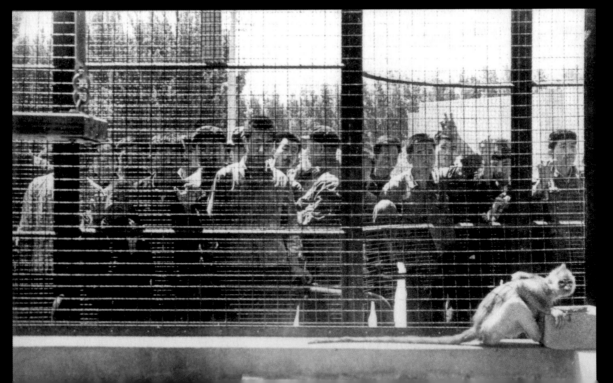

victims of the Cultural Revolution were rehabilitated. But the political situation remained unstable, and it was by no means certain that Deng's reformist faction would eventually win the battle. Because photographs of the April Fifth Movement—as the mass mourning for Zhou Enlai is called—most effectively evoked people's memories of the event and strengthened their will to pursue a better future, these images played an important role at this critical moment in contemporary Chinese history.

Most of these photographs were taken by amateurs. Some of them, such as Wang Zhiping and Li Xiaobin, would later become the leaders of the Photographic New Wave in the 1980s. But in 1976 they were beginners with little knowledge of the art of photography; what they had were cheap cameras and a burning desire to record the mass demonstration for posterity (FIGS. 1, 2). Working individually, each of them took hundreds of photos in the square throughout the April Fifth Movement and preserved the negatives during the subsequent political persecution. They became friends and comrades only later, when they saw each others' April Fifth photos and embarked on a collaborative effort to publicize these private records to represent public memory. Before this, some of them had compiled individual photo albums of the movement and presented them to Deng Xiaoping and Deng Yingchao (the latter was Zhao Enlai's widow and a veteran revolutionary leader in her own right).[3] They decided to compile the most powerful photos of the movement into a single volume and publish it nationwide. A seven-member editorial committee was established in 1977 to collect and select images.[4] Because the April Fifth Movement was still labeled an anti-government movement, they worked secretly and relied on very limited resources. It remains unclear how many negatives they actually collected, but according to Li Xiaobin, prints they enlarged from these negatives numbered between twenty and thirty thousand.[5] Some five hundred images were selected for the volume, which eventually came out in January 1979 under the title *People's Mourning (Renmin de daonian)*(FIG. 3).[6]

Published after the rehabilitation of the April Fifth Movement, however, this volume was no longer a private undertaking as the editors had planned, but became an official project endorsed by China's top leaders. While no authorship of the individual photos is explicitly identified, the volume's title page bears a dedication by Hua Guofeng, then the Chairman of the Chinese Communist Party. The volume thus helped Hua gain public support and legitimated his mandate. This official patronage also brought unexpected fame to the editors, whose "heroic deeds" were reported in newspapers, and who were invited to join the mainstream Association of Chinese Photographers. No longer considering themselves amateurs, they now took photography seriously as a lifelong pursuit; disillusioned by the official hijacking of their project, however, they turned away from political involvement to pursue an artistic photography outside the government's agendas. Li Xiaobin recalled that right before the publication of *People's Mourning,* he and Wang Zhiping took a trip to the Old Summer Palace *(Yuanming Yuan)* to photograph the famous ruins there, while Wang suddenly turned to him and said, "Let's stop making a career in politics. Let's just create art and organize our own exhibitions!"[7] This idea soon spread to other members of the group, and in early 1979, they established the April Photo Society. The club's first exhibition, *Nature, Society, and Man,* opened in April.

Two photographic groups or "salons" in Beijing formed the core of the April Photo Society. One group—most of whom had taken part in the *People's Mourning* project—met regularly in Wang Zhiping's small apartment in the eastern part of the city. The other group, formed as early as the winter of 1976, had thirty to forty members who gathered every Friday evening in the dorm of the young photographer Chi Xiaoning in the western part of the city (the dorm belonged to the Northern Film Studio). The spiritual leader of this second group, known to its members as *Xingqiwu shalong*—the Every Friday Salon—was Di Cangyuan, a special-effects photographer working in Beijing's Science Film Studio. Di's younger followers admired him for his extensive knowledge of the history of photography, and he served as the main lecturer in the group's meetings. Other photographers, film directors, and artists were also invited as guest speakers, attracting young artists citywide, among whom Wang Keping, Huang Rui, Gu Cheng, and A Cheng soon emerged as representative avant-garde artists and writers of their generation. In addition to these gatherings, the members of the group took photographing trips together to various sites around Beijing, and displayed their works in Chi Xiaoning's dorm.[8]

Organized by the April Photo Society, the *Nature, Society, and Man* exhibition opened in Beijing's Sun Yat-sen Park on April 1, 1979. Consisting of two hundred eighty works by fifty-one artists (many of whom called themselves amateurs), this unofficial exhibition created a sensation in China's capital.[9] The audience packed the small exhibition hall from morning to night (FIG. 4); enthusiasts visited the show multiple times, copying down every word that accompanied the images. According to a report, two to three thousand people visited each weekday, while more than eight thousand people showed up on a Sunday. Curiously, introductions to contemporary Chinese art rarely mention this exhibition even in passing. Instead, their authors have paid much attention to another unofficial exhibition held the same year in Beijing: the *Stars Art Exhibition (Xingxing meizhan)* organized by a group of avant-garde painters and sculptors.

The Stars exhibition openly attacked Mao's dictatorship, while the apolitical, formalist works in *Nature, Society, and Man* challenged the party's control over visual art mainly in the domain of aesthetics; this difference in focus explains the differing critical attention to these two exhibitions. The exhibition's preface, written by Wang Zhiping, made the focus of *Nature, Society, and Man* explicit:

News photos cannot replace the art of photography. Content cannot be equaled with form. Photography as an art should have its own language. It is now time to explore art with the language of art, just as economic matters should be dealt with by using the methods of economics. The beauty of photography lies not necessarily in "important subject matter" or in official ideology, but should be found in nature's rhythms, in social reality, and in emotions and ideas.[10]

Works in the exhibition reflected two main interests in representing nature and society. Many of the images guided the audience to meditate on the beauty and serenity of landscape; other images offered glimpses into people's emotional states and daily lives (FIG. 5). None of the works broke new ground in artistic representation, but their mild humanism and aestheticism was extremely fresh and had a tremendous appeal to the public. Only by juxtaposing these works with the Cultural Revolution can one understand their significance and effect: in a country where art had been reduced to political propaganda for an entire decade, any representation of private love, abstract beauty, or social satire was considered revolutionary (FIG. 6). When some official critics disparaged this exhibition for its "bourgeois tendency" and lack of "communist spirit," it attracted even more people from all levels of society, who saw it as "an unmistakable sign of the beginning of a cultural Renaissance."[11]

THE NEW WAVE MOVEMENT (1980–1989)

The April Photo Society organized two more *Nature, Society, and Man* exhibitions in 1980 and 1981 (FIG. 7). On the surface, both exhibitions continued the success of unofficial photography in China: the number of participating artists doubled; each show attracted thousands of visitors, and the 1981 exhibition was even admitted into the National Art Gallery. On a deeper level, however, the two shows no longer retained the provocative edge of the 1979 exhibition. As the Cultural Revolution was gradually becoming past memory, amateur photography could no longer create a big stir by simply filling up a cultural void. In addition, the April Photo Society's advocacy of "art photography" led to formalism and, in the worst cases, to a pretentious, stylized Salon style. Although some works in these two exhibitions dealt with serious social problems and reached a new level of artistic sophistication (FIG. 8), many images were overtly sentimental or packed with vague philosophical concepts. The photographers' attempts at abstract patterns and painterly effects often vitiated their spontaneous feelings for their subjects. Looking back, the critics Li Mei and Yang Xiaoyan attributed this to the artists' insufficient knowledge of the history of photography and their confusion between art and commercial photography, among other factors.[12] Additionally, the changing locations of the three *Nature, Society, and Man* exhibitions indicate that, by 1981, this series had been accepted by the authorities and that the April Photo Society had largely merged with the mainstream.

The second and third *Nature, Society, and Man* exhibitions, however, had a specific significance in triggering the nationwide movement known as the Photographic New Wave. While the first show was held only in Beijing, these two later exhibitions traveled to cities around the country and inspired photographers in these places to carry out similar projects. Numerous local photography clubs and exhibitions emerged from the early 1980s onward. In Xi'an, for example, a group of young amateur photographers founded the Four Directions Photo Club *(Sifang yinghui)*, and in Guangzhou, *Everyone's Photography Exhibition (Renren yingzhan)* attracted a huge crowd. Additional influential local photography clubs appeared around the mid-1980s, including the Shaanxi Group based in Xi'an *(Shaanxi quanti)* and Shanghai's North River League *(Beihemeng)*. But Beijing remained the center of this movement. According to a report, more than one hundred photo clubs were founded there in the early and mid-1980s and many unofficial exhibitions were organized on different levels during this period.[13] The two most important Beijing groups were the Rupture Group *(Liebian quanti)* and the Modern Photo Salon *(Xiandai sheying shalong)*. By organizing three influential exhibitions from 1985 to 1988, the latter became the flagship of the New Wave movement during this period.

Compared with the April Photo Society artists, members of these later groups demonstrated much greater familiarity with Western photography—their exhibitions were populated with images modeled upon almost all major styles of Western photography invented since the turn of the twentieth century. While the pursuit of qualities associated with fine art—pictorialism, abstraction, and technical perfection—continued to motivate many photographers, others, especially those of Beijing's Rupture Group and Shanghai's North River League, embraced symbolism and psychoanalysis. Their bizarre and absurd images, conceived as direct outcomes of intuition and irrationality, betray a sense of alienation from society (FIG. 9). Photographers concerned with social issues found their models in the tradition of Western documentary photography. Inspired

7

8

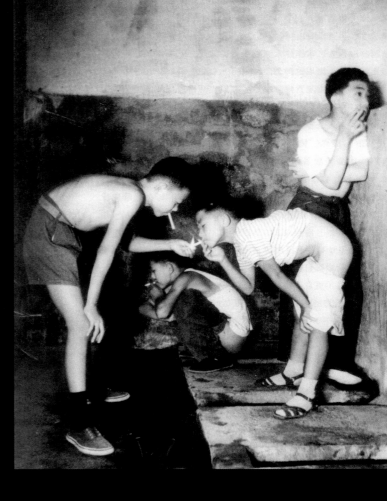

9

by works of Margaret Bourke-White, Robert Frank, Walker Evans, and Dorothea Lange, to name just a few, they began documenting neglected aspects of Chinese society and started a documentary turn that would dominate the New Wave movement from the mid-1980s to the early 1990s.

Such pluralism—one of the most important features of the 1980s Chinese cultural world—was closely related to an information explosion during the early-to-mid-1980s, when all sorts of so-called decadent Western art, forbidden during the Cultural Revolution, were introduced to China through reproductions and exhibitions. Hundreds of theoretical works by authors such as Heinrich Wölfflin and Jacques Derrida were translated and published in a short period; images by Western photographers from Alfred Stieglitz to Cindy Sherman were reproduced in books and magazines, often accompanied by historical or theoretical discussions. These texts and images aroused enormous interest among younger artists and greatly inspired their work. It was as if a century of Western art had been restaged in China. The chronology and internal logic of this Western tradition was less important than its diverse content as a visual and intellectual stimulus for hungry artists and their audience. Thus, styles and theories that had long become history to Western art critics were regarded as contemporary by Chinese artists and used as their models. In other words, the meaning of these Westernized Chinese works was located not in the original significance of their styles, but in the transference of these styles to a different time and place.

Major vehicles for such reproductions and translations were popular photo journals and magazines, which increased rapidly in number and kind throughout the 1980s. Among these, *InPhotography* (*Xiandai sheying*) started in 1984 and soon became the most popular reading material of younger photographers. Published not in a political center such as

Beijing but in the new economic zone of Shenzhen, *InPhotography* was under less scrutiny from official censorship and its editors enjoyed greater freedom to determine its content. Indeed, the journal's two major goals, announced in the "Words From the Editors" in the first issue, were "to introduce exemplary works of foreign 'photographers'" and "promote experimentation and invention in domestic photography."[14] This dual direction set a model for similar publications, which mushroomed in the following years. When another new journal, *Chinese Photographers* (*Zhongguo sheyingjia*), was founded in 1988, its foreword included this humorous survey of the field:

Speaking about today's photography, it is really as hot as this month's (July) weather. Its speedy expansion, enforced by a growing crowd of "feverish friends," has led to an increasing number of publications on photography. In addition to the two leading photo weeklies in Shanxi and Beijing (People's Photography *and* Photo Newspaper), *there are journals and magazines of every orientation and style. For the popular audience, there is* Mass (Mass Photography); *for the elite,* China (China Photography). *For the avant-garde,* Modern (Modern Photography, or InPhotography) *is the pioneer; for the experimental type,* Youth (Youth Photography) *leads the pack. On the conservative, leftist side you have* International (International Photography); *on the more liberal, rightist side there is* World (The World of Photography). *Looking at this extensive list, one would be crazy to add another new title to it.*[15]

Nevertheless, the writer of this foreword tried to justify the launching of *Chinese Photographers*. According to him, there was still much room for new publications, especially if they offered more concentrated studies of individual photographers. This agenda, adopted as the mandate of this new journal, indicated a shift of interest

from acquiring general knowledge in world photography to developing close analyses of individual styles. Other Chinese photography journals published in 1988 reveal similar tendencies. The straightforwardly titled *Photography (Sheying)*, published in Shenzhen that year, organized its first issue around six foreign photographers and seven experimental Chinese photographers. Even the veteran *InPhotography* subtly changed direction. No longer offering short introductory essays on such general topics as abstract photography or surrealist photography, its 1988 issues focused on cutting-edge photographers and their works.

This shift, in turn, indicated that by the late 1980s, photography in China had basically "caught up" with the rest of the world. A considerable number of photographers had been practicing for a decade, and had established track records that showed continuous artistic development. The intensive introduction to the history of photography, conducted by a host of popular journals and magazines over several years, had much improved the public understanding of this art. Several large-scale conferences on photography, taking place in Hangzhou, Wuhu, Xi'an, and other cities from 1986 to 1988, helped bring the study of photography and photographic theory to a new level. These meetings included discussions of such issues as the subjectivity of photography, the return to realism, and the relationship between photographic theory and general aesthetics. While most papers presented at these conferences dealt with theoretical matters, some scholars and critics began to summarize recent experiences of Chinese photography in the form of historical surveys.[16]

A DOCUMENTARY TURN

Documentary photography came to dominate the New Wave movement in the second half of the 1980s.[17] Like those of the documentary movement in the 1930s

in the United States, Chinese documentary works were closely related to the social and political context of their time; their content, form, and tropes served the social programs that the photographers aspired to undertake. Generally speaking, these works followed two main directions, both reacting against the party's propaganda art during and after the Cultural Revolution. The first developed as a branch of native soil art *(xiangtu meishu),* an important artistic genre in the 1980s that advocated representations of ordinary people and what the photographers saw as the timeless spirit of Chinese civilization. The second direction echoed scar art *(shanghen meishu)* and scar literature (*shanghen wenxue*), focusing on human tragedies in Chinese society.

Both trends started in the late 1970s. One of the earliest native soil photographic projects was conducted by Zhu Xianmin, who made eight trips to his hometown on the Yellow River (commonly considered the cradle of Chinese civilization) from 1979 to 1984 to photograph local people and their lives.[18] When photo clubs emerged in the provinces in the early-to-mid-1980s, many of them took as their mission "the search for the roots of our national culture." Among these clubs, the earliest and most famous was the Shaanxi Group (also known as *Xibeifeng* or the Northwest Wind), whose motto "back to the real" *(fugui xianshi)* provided an explicit counter to Mao's futuristic revolutionary realism (FIG. 10). This approach was also accepted by photographers in major cities. Wang Zhiping and Wang Miao, veterans of unofficial photography in Beijing, joined this trend and conducted a prolonged field survey in rural west China. When their photographs appeared in a 1985 issue of *InPhotography,* the accompanying text was welcomed by fellow photographers as a manifesto for this type of documentary photography.

They wrote, "We believe that genuine beauty, greatness, and eternity can only exist in the depth of ordinariness. . . . We try to portray you (i.e. China) with our response to your real appearance, not to give you a smiling face found on every fashion magazine's cover."[19] At this point, however, what were imagined to be records of real people began to take on overarching symbolic significance, and the photographers, driven by idealism, adapted a rhetoric that verged on nationalist propaganda.

Although both kinds of documentary photography emphasized a plain, down-to-earth style and played down the photographer's mediation between reality and representation, the native soil type produced ahistorical, romantic images with a strong ethnographic interest, while the scar type was by nature historical and critical, visualizing recent Chinese history as a series of discrete images that spoke of human experience during social or natural disasters. In many cases, images of this second type recorded historical events that would otherwise have been lost. This is why some writers have traced this type to the April Fifth Movement in 1976.[20] Made by amateurs, these unpolished images nevertheless preserved traces of a distinct moment in modern Chinese history; the memory clinging to them gave them an almost talismanic quality (see FIGS. 1, 2). These April Fifth photographs also initiated another important tradition associated with this type of documentary photography: the rhetoric of an emotional language that has come to regulate the perception and evaluation of documentary images. According to this rhetoric, visual records of historical events or social phenomena are expected to be direct, powerful, and moving, evoking strong emotional responses from viewers.

Sophisticated works from this historical, critical tradition of documentary photography began to emerge in the late

1970s. Continuing the April Fifth legacy, some photographers developed projects to depict aspects of Chinese society that had eluded artistic and media representations. One such project was Li Xiaobin's *Shangfangzhe—People Pleading for Justice from the Higher Authorities.* It dealt with an important social phenomenon ignored by most artists and reporters: tens of thousands of such *shangfangzhe,* often victims of the Cultural Revolution in remote areas, flooded Beijing's streets from 1977 to 1980. Unable to find justice through the local judiciary systems, they went to the Chinese capital to present their cases directly to the central government. Traumatized and exhausted, they waited for weeks and even months outside the Justice Department, Ministry of Internal Affairs, or Department of Public Security, hoping to receive a response to their appeals. Few of them succeeded in achieving even this most rudimentary goal, however, so they continued to wait, often until they were forced to return home. Li Xiaobin took about one thousand photographs of these homeless and hopeless people.[21] One of his pictures—arguably the most poignant work of Chinese documentary photography from this period—captures the image of a haggard *shangfangzhe* wandering next to Tiananmen Square (FIG. 11). Eyes unfocused, he seems disoriented and in a trance. Yet he still has several large Mao buttons—symbols of loyalty to the Chairman during the Cultural Revolution—pinned on his tattered clothes. This image aroused strong reactions—both sympathy and reflection—after its publication. Many viewers sensed in it an implicit criticism of Communist rule, which had ruined millions of people's lives and abused their hopes for a better China. Once again, a documentary image became a visual symbol with a meaning extending far beyond the photograph's specific content.[22]

19

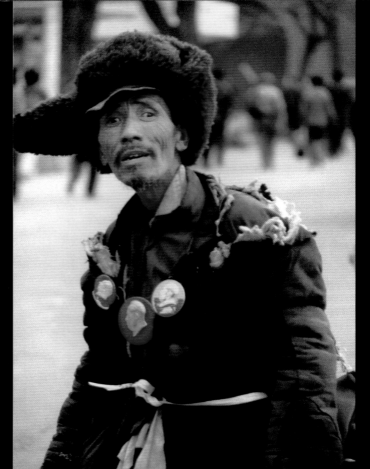

11

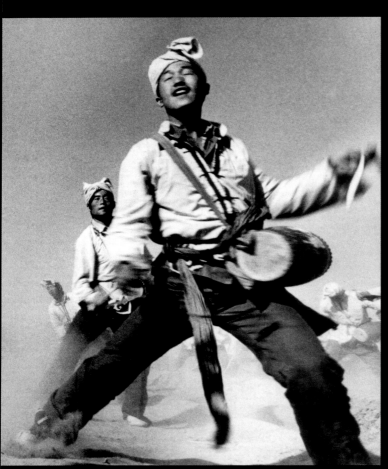

10

12

Figure 10
Wu Jun, *Drunk,* black-
and-white photograph,
1985.

Figure 11
Li Xiaobin,
*Shangfangzhe—People
Pleading for Justice from
the Higher Authorities,*
color photograph, 1977.

Figure 12
Wu Jialin, *People of
Baowei,* black-and-white
photograph, 1991.

These two types of documentary photography developed in concert and were featured abundantly in photography publications and exhibitions after 1985.[23] What followed was an intense search for new documentary subjects by individual artists. A specific subject often came to distinguish a particular photographer.[24] Wu Jialin became known for his ethnographic images of the Wa people in Yunnan (FIG. 12); Yu Deshui won several prizes for recording lives along the Yellow River (FIG. 13); and Lii Nan and Yuan Dongping spent years photographing mental patients in asylums around the country (FIG. 14). Later Lii discovered a new subject in underground, rural Catholic churches, while Yuan embarked on a large project entitled *People of Poverty (Qiongren)*. Works by the last two photographers synthesized scar and native soil traditions, and therefore also departed from both. Their subjects—mental patients, blind and retarded children, dysfunctional elderly people, and the homeless—are ordinary, but they are also wounded and ignored. Their problems are not caused by particular political or social events; in fact the reasons for their injuries are relatively unimportant in these works. One can no longer find in them the tension-ridden scenes of confrontation in Li Xiaobin's social images, while the romantic aestheticization of the ordinary in native soil art is also avoided. The artists have moved away from the earlier narrative or poetic modes and have relied instead on a less impassioned mode of presentation that allows the images to speak for themselves.

Responding to the search for new documentary subjects but also to the rapid transformation of the Chinese city, an increasing number of photographers were attracted to urban scenes—the changing cityscape, the ruins of traditional buildings and lifestyles, the invasion of Western culture and the market economy, and the new urban population and occupations. Their initial works, however, immediately

exposed the limitations of the conventional documentary style, which was supposed to be naturalistic and objective, and at odds with the transient nature of the contemporary city and the photographers' self-involvement in urban lives. Consequently, some photographers, such as Gu Zheng, Mo Yi, and Zhang Haier, began to develop new concepts and languages that allowed them not only to represent an external reality but also to respond to reality.[25] Among them, Zhang Haier most successfully made the transition from documentary to conceptual photography. Combining a flash with slow shutter speed, his images of Guangzhou's street scenes seem both real and artificial; from the dark background his distorted and blurry face emerges, screaming toward the camera (FIG. 15). Zhang's portraits of Guangzhou prostitutes were the earliest such images, which later became a subgenre in urban representations (FIG. 16). Instead of detaching himself from his subjects as a typical documentary photographer would do, he made his communication with these young women the real point of representation. Looking at these images is to look into the prostitutes' eyes, and there we find the photographer's silent existence.[26]

At this point, toward the end of the 1980s, the New Wave movement had largely accomplished its mission of restoring photography's status as an art in China. A new kind of photography was emerging that allied itself with the burgeoning avant-garde art.[27] Almost instantly, it caught the attention of the international art world, as Zhang Haier and four other young photographers were invited to participate in the 1988 Arles Photography Festival in France. Such interest from abroad encouraged other Chinese photographers to explore new territories beyond documentary photography and art photography. While Chinese photography seemed to be entering a new stage, this development was suddenly halted by a political event: the government's violent suppression of the

June Fourth Movement (the prodemocratic student demonstration in Tiananmen Square that ended in bloodshed on June 4, 1989). Avant-garde art was banned afterwards. For the next two to three years, no groundbreaking photography exhibitions were organized, and existing photographic journals only featured works devoid of political and artistic controversy. In this atmosphere, art photography and documentary photography were both tamed to become part of the official establishment. This period of repression created a significant gap in contemporary Chinese photography. When a new generation of photographers reemerged in the early-to-mid 1990s, they were challenged not only to create new images but also to reinvent their identities as independent artists.

EXPERIMENTAL PHOTOGRAPHY (EARLY 1990S TO THE PRESENT)

Like experimental art, experimental photography in China is a specific historical phenomenon defined by a set of factors, among which the artist's social and professional identity is a major one.[28] This photography first emerged in the late 1980s, but only became a trend in the early-to-mid-1990s.[29] Before this, photography had basically developed within the self-contained field of Chinese photography *(Zhongguo sheying)*, constituted by various art institutions including schools and research institutes, publishers and galleries, and various associations of Chinese photographers within the state's administrative system.[30] Even though amateur and unofficial photographers played a leading role in the New Wave movement, in their effort to reinvent these institutions they eventually had to join them.

This situation underwent a fundamental change in the 1990s, when a group of young photographers organized communities and activities outside the institutions of Chinese photography. They owed their

independent status, to a large extent, to their educational and professional background. Some of them were self-taught photographers who collaborated with experimental artists; others began their careers as avant-garde painters and graphic artists, but later abandoned brushes and pens for cameras. In either case they had few ties with mainstream photography, but constituted a sub-group within the camp of experimental artists. As concrete proofs of this identity, these photographers often lived and worked together with experimental artists, and showed their works almost exclusively in unofficial experimental art exhibitions.[31] Unlike the amateur photographers of the 1970s and 1980s, whose career paths often ended with appointments in professional institutions, the experimental photographers of the 1990s insisted on their outsiders' position even after they became well known. This was possible because Chinese experimental art was rapidly globalizing during this period, appearing frequently in international exhibitions and also becoming a commodity in the global art market.[32] In this new environment, experimental photographers could claim an independent or alternative status domestically, while collaborating with international colleagues, dealers, and museums abroad.

Three events in the first half of the 1990s played pivotal roles in the formation of this new unofficial photography. The first was the organization of a series of *Document Exhibitions (Wenxian zhan)* that helped sustain artistic experimentation during a difficult period: responding to the official prohibition of avant-garde art instituted immediately after the June Fourth Movement, a group of art critics designed this exhibition format in 1991 (FIG. 17) (second and third shows were held in 1992 and 1994, respectively). Consisting of photographic records and reproductions of recent works by unofficial artists, it traveled to different cities and provided an important channel of communication among these artists throughout the country. Although the organizers of this series defined the exhibited images as documents, not real art objects, to the participating artists the photographs, especially those recording performances and temporary installations, were their works. The situation became more complex when a performance was photographed not by the artist but by a collaborating photographer. Questions about such an image included whether it was an unmediated record of the original art project, or should also be considered a creative work of the photographer. This and other questions led to discussions and debates about the nature of art media and about photographic representations of other art forms specifically. Not coincidentally, the third *Document Exhibition* had the subtitle *Revolution and Transformation of the Art Medium (Meiti de biange)*. The debate about the authorship of performance photography finally subsided in the late 1990s. Many performance artists began to document their own works, assuming the function of a photographer, while an increasing number of experimental photographers designed and conducted performances for photographing. Both approaches reflect a further internalization of interactions between different art forms and media.

The second landmark event in the development of experimental photography was the establishment of the East Village, a community of experimental painters, performance and installation artists, and photographers on the eastern fringe of Beijing (FIG. 18).[33] Most of these artists were immigrants from the provinces, who moved into this tumbledown village from 1993 to 1994 for its cheap housing, and soon discovered their common interests and began to conduct collaborative art projects.[34] They also developed a close relationship to their environment—a polluted place filled with garbage and industrial waste—as they considered moving there an act of self-exile. The most crucial significance of the East Village community, however, lies in its formation as a close alliance of performing artists and photographers who inspired each other's work by serving as each other's models and audience. Many memorable photographs from this period, such as Xing Danwen and Rong Rong's records of avant-garde performances by Zhang Huan, Ma Liuming, and Zhu Ming, directly resulted from this alliance. Viewed in the context of experimental Chinese art, however, this alliance also initiated one of the most important developments of the mid-1990s, when experimental artists working in different media increasingly envisioned and designed their works as performances; many of these artists were also increasingly attracted by photography, not only deriving inspiration from it but also making photographs themselves.

The third event was the appearance of new types of experimental art publications. After the June Fourth Movement, the two most influential journals of avant-garde art in the 1980s—*Chinese Fine Arts Weekly (Zhongguo meishu bao)* and *Trends in Art Theory (Meishu sichao)*—were banned by the government; the existing art journals largely avoided controversial issues for political security. In response, some unofficial artists and art critics launched their own publications to facilitate the development of experimental art.[35] Among these publications, the most daring one was an untitled volume known as *The Book With a Black Cover (Heipi shu)*. Privately published by Ai Weiwei, Xu Bei, Zeng Xiaojun, and Zhuang Hui in 1994, it introduced a new generation of experimental Chinese artists to the world. Significantly, the volume featured photography as the most important medium of experimental art: readers found in it the earliest reproductions of East Village performance photographs, as well as conceptual photographic works by Ai Weiwei, Geng Jianyi, Lu Qing, Zhang Peili,

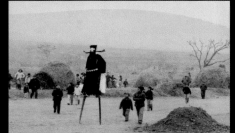

13

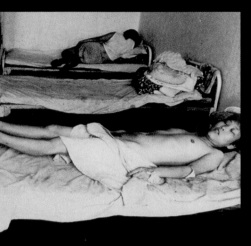

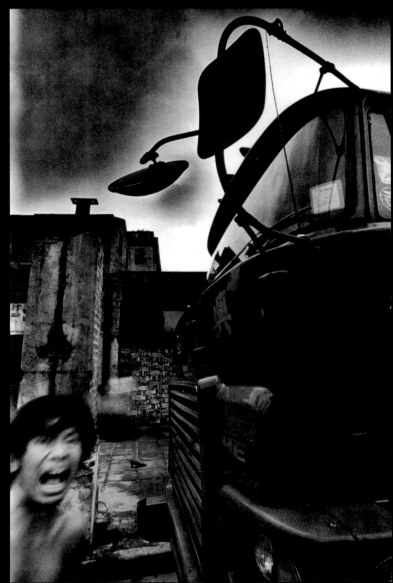

15

16

17

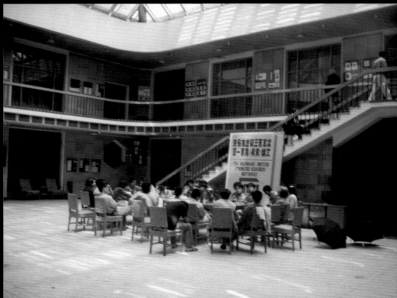

18

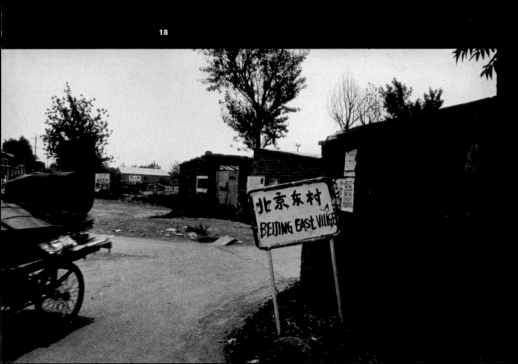

Zhao Bandi, and Zhu Fadong (FIGS. 19, 20). Avant-garde serials dedicated exclusively to photography only appeared in 1996 as represented by *New Photo (Xin sheying)*(FIG. 21). Lacking both the money for printing and a license for public distribution, its two editors, Liu Zheng and Rong Rong, resorted to high quality photocopying and produced only twenty to thirty copies of each issue.[36] The first issue bore a preface entitled "About 'New Photography,'" which defined this art in terms not of content or style but the artist's individuality and alternative identity. This definition changed a year later, however, as the two-sentence introduction to the third issue declared:

When CONCEPT *enters Chinese photography, it is as if a window suddenly opens in a room that has been sealed for years. We can now breathe comfortably, and we now reach a new meaning of "new photography."*

This statement reflected an important change that occurred in 1997, when experimental Chinese photography came to be equaled with conceptual photography. Until then, experimental photographers had identified their art mainly through negation—they established their alternative position by divorcing themselves from mainstream photography.[37] But now they also hoped to define experimental photography as an art with its own intrinsic logic, which they found in theories of conceptual art. This theoretical interest prompted them to form a new discussion group—the Every Saturday Photo Salon *(Xingqiliu sheying shalong)*—in September 1997. The exhibition they organized in conjunction with the salon's first meeting, entitled *New Photographic Image (Xin yingxiang)* and held in a theater near the Pan-Asian Sports Village in north Beijing, was the first comprehensive display of Chinese conceptual photography.[38] Dao Zi, the project's academic advisor, wrote a highly theoretical

treatise for this exhibition, interpreting "new image" photography as a conceptual art advanced by avant-garde Chinese artists under China's postcolonial, postmodern, and postautocratic conditions.[39]

It would be wrong, however, to conceive of experimental photography in the 1990s as comprising two discrete stages separated by this theorization process. In fact, although lacking a clearly articulated self-awareness, the rise of experimental photography in the early and mid-90s already implied a movement toward conceptual art, which gives priority to ideas over representation. Throughout the 1990s and early 2000s, experimental photographers also continuously found guidance in postmodern theories, conducting experiments to deconstruct reality. No longer interested in capturing meaningful moments in life, they instead focused on the manner or vocabulary of artistic expression, and fought hard to control the situation within which their works were viewed. This emphasis on concept and display has led to a wide range of constructed images; the situation can be compared with American conceptual photography of the 1970s, described by the poet and art historian Corinne Robins in these words:

Photographers concentrated on making up or creating scenes for the camera in terms of their own inner vision. To them . . . realism belonged to the earlier history of photography and, as seventies artists, they embarked on a different kind of aesthetic quest. It was not, however, the romantic symbolism of photography of the 1920s and 1930s, with its emphasis on the abstract beauty of the object, that had caught their attention, but rather a new kind of concentration on narrative drama, on the depiction of time changes in the camera's fictional moment. The photograph, instead of being presented as a depiction of reality, was now something created to show us things that were felt rather than necessarily seen.[40]

Taking place twenty years later, however, a "replay" of this history in 1990s China has produced very different results. Backed by postmodern theories and utilizing state-of-the-art technologies, experimental Chinese photography has also more actively interacted with other art forms including performance, installation, sculpture, site-specific art, advertisement, and photography itself, transforming preexisting images into photographic "re-representations."[41] Again, this tendency first surfaced in the early-to-mid-1990s; although some emerging experimental photographers such as Wang Jinsong, (CAT. 62, FIG. 22) seemed to continue the straight, documentary tradition, their works actually reconfigured fragmentary, accidental images and inscriptions into new compositions and narratives. Liu Zheng, on the other hand, photographed manufactured figures including mannequins, statues, wax figures, and live tableaux, and mixed such photographs with images in the conventional documentary style (CAT. 12–16, 50–54). The layering of representations in this assemblage effectively erased any sense of real existence and experience.[42] While these three artists approached reality as a deposit of readymade photographic materials, toward the late 1990s and early 2000s (and hence encouraged by the definition of experimental photography as conceptual art), more and more artists created objects or scenes as the subjects of photographs. Such projects as Wang Qingsong's computer-generated images of monuments (CAT. 27), Hong Lei's painted-over images (CAT. 9, 10), and Zhao Shaoruo's reconstructed historical photographs (CAT. 32, 33), have constituted the majority of experimental photographs since 1997.

This type of constructed photography could be seen as performance, not only because it involves actual performances and displays elaborate technical showmanship, but also because it takes theatricality

as a major point of departure. Artists' interest in visual effect became increasingly strong after 1997. If earlier conceptual photographers, such as Geng Jianyi and Zhang Peili, enhanced the conceptual quality of their works through repressing visual attractiveness (SEE FIG. 19), visitors to today's exhibitions of Chinese photography are often overpowered by the works' startling size and bold images, which not only rely on new imaging technologies but, more importantly, reveal the photographers' penchant for such technologies (FIG. 23).[43] To students of experimental Chinese photography (and experimental Chinese art in general), this two-fold interest in performance and technology is extremely important, because it reveals an obsessive pursuit of *dangdaixing* or contemporaneity.

Here contemporaneity does not simply pertain to what is here and now, but is an intentional artistic construct that asserts a particular historicity for itself. It may be said this construct is the ultimate goal of experimental Chinese art.[44] To make their works contemporary, experimental artists have most critically reflected upon the conditions and limitations of the present, and have conducted numerous experiments to transform the present into individualized references, languages, and points of view. Their pursuit of contemporaneity continuously underlies their fascination with postmodern theories, startling visual effects, and state-of-the-art technologies. The same pursuit also explains the content of their works, which deliver unambiguous social and political messages and express strong assertions of individuality and self-identity. In fact, these works can be properly understood only when we associate them with China's current transformation, the ongoing process of globalization, and the artists' visions for themselves in a changing world. The four sections of *Between Past and Future: New Photography and Video from China,* focusing on history and memory, self, the body, and people and place, encapsulate some of the major themes of these works.

HISTORY AND MEMORY

Works in the first section of this exhibition refer to China's history and represent collective and individual memories, reflecting the artists' particular historical visions and artistic aspirations. Some of these images feature famous historical sites, particularly the Great Wall and the Forbidden City, important symbols of Chinese civilization and the nation. Both Hong Lei and Liu Wei take the Forbidden City as their subject. Hong's carefully crafted scenes of a mutilated bird lying in the former imperial palace fuse traditional melancholy with the contemporary fascination with violence (CAT. 9, 10). Liu's computer-generated images derive inspiration from traditional puppet theater to allude to a court intrigue (CAT. 11). Ma Liuming's photograph records one of his performances on the Great Wall, in which he walked stark naked along the wall until his feet bled (CAT. 17). Entitled *Fen-Ma Liuming Walks on the Great Wall,* the performance was conceived as an interaction between the artist's androgynous alter-ego (Fen-Ma Liuming) and the national monument. With long hair, an expressionless face made up with cosmetics, and supple limbs exposed in abandon, this constructed self-image heightens his sexuality and independence.

In contrast to such works that contemplate China's nationhood and cultural origins, some images in the exhibition resurrect dark, painful memories from the country's past. Wang Youshen's *Washing: A 1941 Mass Grave in Datong* (CAT. 28) is one of the most poignant examples in this group. This installation consists of newspaper pages on the wall and photographic images in two large basins under circulating water. The newspaper reports the discovery of the remains of thousands of Chinese who were buried alive by Japanese soldiers during World War II. The images in the basins represent these remains. "The water washes the image away," the artist explained, "just as time has washed people's memories clear of

this atrocity that occurred fifty years ago."[45] Like Wang Youshen, Sheng Qi's interest lies in the historicity and vulnerability of printed images—and hence the existence and impermanence of the history and memory that they preserve. A series of photographs by Sheng represents his mutilated hand holding tiny photographs of Mao, his mother, and himself as a young boy (CAT. 21–23). While his damaged body (he cut off one of his fingers in 1989) commemorates the June Fourth Movement, the black-and-white photos are remains of a more distant past associated with his childhood.

Many experimental art projects from the 1990s were related to artists' memories of the June Fourth Movement. Song Dong's *Breathing Part 1 and Part 2* offer exceptionally powerful examples of this type (CAT. 24). The two images in this mini-sequence record a bipartite performance, with the first designed as a tribute to the ill-fated June Fourth Movement.[46] The picture was taken after New Year's Eve, 1996. Holiday lights outlined Tiananmen in the distance. Song lay prone and motionless in a deserted Tiananmen Square, breathing onto the cement pavement for forty minutes. On the ground before his mouth a thin layer of ice gradually formed. I offered this interpretation of the performance photograph when it was first shown at the Smart Museum of Art in 1999:

[Unlike some early works in experimental Chinese art] Song Dong is no longer staging a real or pretend suicide in Breathing. *Instead he tries to inject life into the deserted square, thereby bringing us to those brief moments in history when the square was transformed into a "living place." It reminds us that in 1996 the square still remained an unfeeling monolith.* Breathing *not only represents a continuing effort to challenge this monolithic power but also demonstrates the extreme difficulty of making any change: all Song Dong's effort produced was a tiny pool of ice, which disappeared before the next morning.*[47]

Figure 19
Zhang Peili, *Continuous Reproduction,* black-and-white photograph, 1993.

Figure 20
Geng Jianyi, *Building No. 5,* black-and-white photograph, 1992.

Figure 21
The first issue of *New Photo* magazine, 1996.

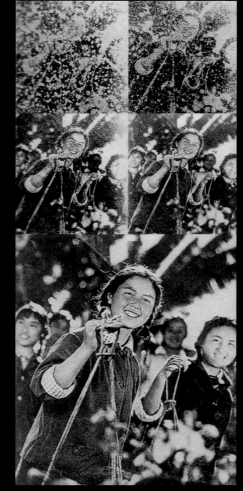

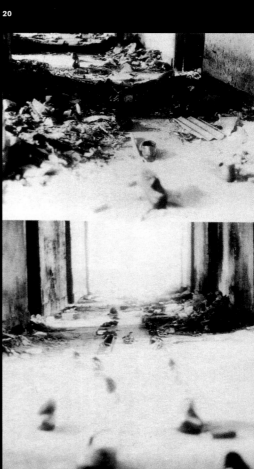

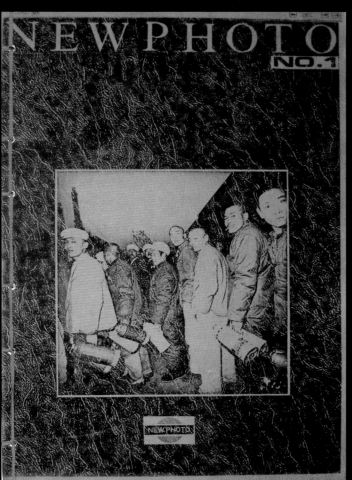

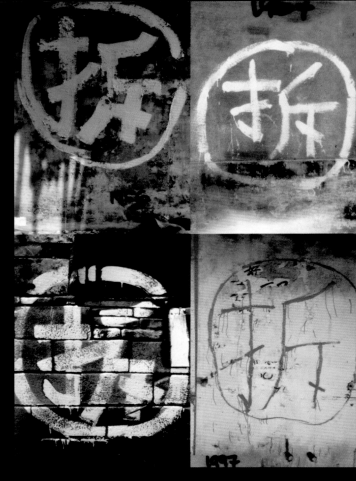

22

24

Figure 22
Wang Jinsong, *A Hundred "Chai" – "To Be Demolished,"* color photograph, detail, 1999.

Figure 23
Feng Feng, *Shin Brace,* color photograph, 1999–2000, shown in The First Guangzhou Triennial, Guangzhou, 2002.

Figure 24
Sui Jianguo, Yu Fan, and Zhan Wang, *Woman/Here,* photo installation, Contemporary Art Gallery, Beijing, 1995.

Both Sheng Qi and Song Dong connect the present to the past by evoking personal memories. Hai Bo's series of portraits more specifically forge memory links in the national psyche. Each series juxtaposes two photographs taken several decades apart (CAT. 4–8). The first, an old group photo, was taken during the Cultural Revolution and shows people in Maoist or army uniforms; their young faces glow with their unyielding beliefs in communism. The second picture, taken by Hai Bo himself, shows the same group—or in some cases, the surviving members—twenty to thirty years later. The contrast between the images often startles viewers. In an almost graphic manner, the two images register the passage of time and stir up viewers' personal memories.

Historical memory is also the subject of Xing Danwen's *Born with the Cultural Revolution* (CAT. 30) and the photo installation *Woman/Here* by Sui Jianguo, Yu Fan, and Zhan Wang (CAT. 25), but these two works give fuller accounts of the lives of specific persons and can therefore be considered biographical representations.[48] The creation of the second work responded to the Fourth International Women's Congress held in Beijing in 1995. Many leaders of women's movements around the world participated in the event, but they were kept separate from ordinary Chinese people. Reacting to such separation, the three artists created *Woman/Here* in the form of an experimental art exhibition—an alternative space where, in their words, "an ordinary Chinese woman could become part of the international event and the contemporary movement of women's liberation."[49] The installation/exhibition featured their mothers' and spouses' collections of personal photographs and memorabilia (FIG. 24). Compiled into chronological sequences and displayed in a public space, these fragmentary images told the lives of several ordinary Chinese women, unknown to most people beyond their families and work units.

PERFORMING THE SELF AND REIMAGINING THE BODY

Experimental photographers tend to be intensely concerned with their identity. The result is a large group of self-representations, including both self-portraits and images of the body. The second and third sections of this exhibition, which include forty-nine works by thirty-two artists, reflect the artists' urgent quest for individuality in a rapidly changing society.

As demonstrated by examples in the preceding section, experimental representations of history and memory are inseparable from artists' self-representations and reveal a close relationship between history and self that sets experimental art apart from other branches of contemporary Chinese art. Although academic painters also depict historical events—often episodes in the founding of the People's Republic—they approach such subjects as belonging to an external, canonical history. Experimental artists, on the other hand, find meaning of the past only from their interactions with it. When they represent such interaction they customarily make themselves the center of the representation, as in Song Dong's *Breathing* or Ma Liuming's *Fen-Ma Liuming Walks on the Great Wall*. Mo Yi's *Front View/Rear View* (CAT. 91, 92) is also inspired by the artist's experience during the June Fourth Movement: he was thrown in jail after participating in a demonstration in Tianjin. Unlike Song and Ma's performance photographs, Mo's work deconstructs the language of self-portraiture. To express his traumatic experience he repetitively obscures his face with a white metal column inscribed with the words "Made by the Police Department."[50]

These and others images allow us to generalize four basic representational modes or types. The first is interactive in nature: the artist discovers or expresses him or herself through interacting either with historical sites (the Great Wall and the Forbidden City) or political institutions (Tiananmen Square and the police department). Other works in the exhibition represent the artists' interactions with people in the present, as seen in Zhuang Hui's *Group Photos* (CAT. 80–82). To Zhuang, taking a picture of an entire crew of construction workers, or of the more than six hundred employees of a department store, requires patient negotiation as well as skilled orchestration (FIG. 25). Such interaction with his subjects is the real purpose of his art experiment, whereas the photographs, in which he always appears way over to the side, certifies the project's completion.

The second type of image explicitly displays the body, which experimental artists employ as an unambiguous vehicle for self-expression. This body art was given the strongest expressions in Beijing's East Village, where artists such as Cang Xin, Ma Liuming, Zhang Huan, and Zhu Ming developed two kinds of performances characterized by masochism and gender reversal. Ma Liuming's androgynous alter-ego, Fen-Ma Liuming, exemplifies this type (CAT. 17, 18). Masochism is a trademark of Zhang Huan—almost every performance he undertook involved self-mutilation and simulated self-sacrifice. In some cases he offered his flesh and blood; in other cases he tried to experience death, either locking himself inside a coffinlike metal case or placing earthworms in his mouth. By subjecting himself to an unbearably filthy public toilet for a whole hour, he not only identified himself with the place but also embraced it. (See Rong Rong's photographs of this performance, CAT. 118, 119.) With the same spirit, Zhu Ming designed a performance in 1997 during which he nearly suffocated inside a huge balloon (CAT. 104).[51] Masochistic body representation took more extreme forms in the late 1990s, as represented by several works in *Infatuated with Injury*, a private experimental art exhibition held in 1999 in Beijing.[52]

The third type of self-representation also features performances, but the central figure, whether the photographer or a fellow artist, disguises him or herself as a fictional character or transforms him or herself into a symbolic image. A number of works in this exhibition fall into this category, including Wang Jin's *A Chinese Dream* (CAT. 96), Sun Yuan's *Shepherd* (CAT. 95), Hong Lei's *After Liang Kai's (Song Dynasty) Masterpiece "Sakyamuni Coming Out of Retirement"* (CAT. 87) and *I Dreamt of Being Killed by My Father When I Was Flying Over an Immortal Land* (CAT. 88), and Hong Hao's *Mr. Hong, Please Come In* (CAT. 86), and *I Know Mr. Gnoh* (CAT. 85). In these last two works, Hong disguises himself as an idealized global citizen" in popular imagination—a young entrepreneur in an opulent environment served by a white-gloved servant. Examples of cynical realism, these images employ an iconography of self-mockery to express a dilemma between globalization and individuality that many experimental Chinese artists face.

Rong Rong's photograph of Cang Xin's performance *Trampling on the Face* (CAT. 93) represents a complex performative/photographic project that works within several modes of self and body.[53] For the performance, Cang made a mold from his own face and used it to cast fifteen hundred plaster masks in a month. Each mask bore a white paper strip on the forehead, on which he wrote the time of the cast's manufacture. He then laid the masks on the ground to fill the entire courtyard of his house, and also hung some masks on the walls as witnesses of the performance. During the performance, guests were invited to walk on the masks to destroy them, until all these artificial faces had shattered into shards. Finally he stripped and jumped on the broken masks, using his naked body to fragment them further.

Rong's photograph vividly records this destructive/evocative process. Numerous masks, many of them destroyed, lie behind the figure in the foreground, who holds up a mask to cover his face. The date written on the mask's forehead is "2: 21–26 PM, November 26, 1994." The mask is damaged, with the left eye and a portion of the forehead missing. The figure behind the mask is not Cang Xin, but Ma Liuming, recognizable from his shoulder-length hair and delicate hand. Here Cang Xin and Ma Liuming have interchanged their roles: wearing Cang's face, Ma makes himself a surrogate of the performer and the subject of a simulated destruction. But it was the photographer who designed this performance within a performance as a subject to be photographed.

A fourth mode of self-imaging is that of self-portraiture, which constitutes an important genre in contemporary Chinese experimental art.[54] A common tendency among experimental artists, however, is a deliberate ambiguity in portraying their likeness, as if they feel that the best way to realize their individuality is through self-distortion and self-denial. These ambiguous images are still about the authenticity of the self. But they inspire the question "Is it me?" rather than the affirmation "It is me!" More than one third of the self-portraits by experimental artists in the 2001 publication *Faces of 100 Artists* use this formula.[55] Many such images, such as Lin Tianmiao's self-portraits, make the subject's image appear blurry, fragmentary, or in the process of vanishing. Lin's digitally generated portrait, four meters high and two-and-one-half meters wide, is out of focus and devoid of hair; the image thus represses the artist's female identity but enhances its own monumentality (CAT. 89).

Other artists employ different methods to deconstruct their conventional images. Yin Xiuzhen's *Yin Xiuzhen* (CAT. 100), for example, is a concise biography of the artist, consisting of a series of her ID photographs arranged in a chronological sequence. The portraits have been cut into insoles and installed into women's shoes that Yin made with her mother. In so doing, the artist imbued the fragmented images with a sense of vulnerability and intimacy, transforming the standard ID photos into genuine self-expressions. Qiu Zhijie's photos, *Tattoo 1* and *Tattoo 2* (CAT. 115, 116), result from his persistent experiments to make his own image transparent.[56] The man standing straight in a frontal pose in both pictures is the artist himself. In one photo, a large character *bu*—meaning no—is written in bright red across his body and the wall behind him. Different parts of the character are painted on his body and on the wall. When these parts connect to form the character, they create the strange illusion that the figure's body has disappeared, and that the character has become independent, detached from the body and the wall. In other words, this character rejects the ground and makes the person invisible. The other picture employs a similar technique, with metal dots attached to both the body and the background. While the body again seems to vanish, the repetitive dots form an ever-expanding visual field, with neither set boundaries nor clear signification.

Like Yin's photo installation, these two photos by Qiu reflect upon contemporary visual identifications of individuals. The figure's unnatural pose and expressionless face make the photos look like ID pictures. As an artist well versed in postmodern theories, Qiu believes that in this world "individuals have been completely transformed into an information process. Signs and codes have overpowered actual human beings, and our bodies have become merely their vehicles."[57] These two photos illustrate an answer to the artist's question of how to make such signs and codes—passport photos, archives, etc.—disappear for a second time in an artistic representation.

PEOPLE AND PLACE

Works in the last section of this exhibition respond to drastic changes in China's

contemporary environment—the vanishing of traditional landscapes and lifestyles, the rise of postmodern cities and new urban cultures, and the large-scale migration of populations. Underlying these interests is a generational shift in experimental art: a majority of the artists featured in this section started their careers in the 1990s, and have been finally able to bid farewell to the Cultural Revolution and its visual and mental baggage. They can therefore comment on the Cultural Revolution and the June Fourth Movement as events firmly in the past. At the same time, they directly and rigorously interact with China's current transformation. An important aspect of this transformation, one that attracted many artists' attention, was the rapid development of the city. A striking aspect of a major Chinese metropolis such as Beijing or Shanghai in the 1990s and early 2000s has been a never-ending destruction and construction. Old houses were coming down every day to make room for new hotels and shopping malls. Thousands and thousands of people were relocated from the inner city to the outskirts. In theory, demolition and relocation were conditions for the capital's modernization. In actuality, these conditions brought about a growing alienation between the city and its residents: they no longer belonged to one another.

This situation is the context and the content of many works in experimental photography of the 1990s. In 1997 and 1998, Yin Xiuzhen was busily collecting, as she had said, "traces of a vanishing present" along the construction site of the Grand Avenue of Peace and Well-being *(Ping'an Dadao)*, an enormous project funded collectively by the Chinese government and individual investors with a total budget of $350 million. Envisioned as the second largest east-west road across central Beijing, the avenue took up a broad strip of land, some thirty meters wide and seven thousand meters long, in the most populated section of an overcrowded city.

Yin collected two kinds of materials: images of the houses (and their residents) before they were demolished, and roof tiles of the houses after they were demolished. She then used these materials for various installations (FIG. 26). Bearing black-and-white photos of the demolished houses, the rows of tiles in this installation have an uncanny resemblance to a graveyard. In fact, we may think of this installation in terms of a mass grave, only the "dead" here are places, not people.

But people have indeed "disappeared" during such demolition and dislocation; and this is exactly the subject of Rong Rong's photographs of Beijing's demolition sites (CAT. 56–58). Devoid of human figures, the half-destroyed houses are occupied by images left on walls, which originally decorated an interior that has now become the exterior. A pair of dragons probably indicates a former restaurant; a Chinese New Year painting suggests a similarly traditional style. The majority of such "leftover" images are various pin-ups from Marilyn Monroe to Hong Kong fashion models. Torn, and even missing a large portion of the composition, these images still exert an allure over the spectator, not only through their seductive figures but also through their seductive spatial illusionism. With an enhanced three-dimensionality and abundant mirrors and painting-within-paintings, they transform a plain wall into a space of fantasy. These works can be viewed together with photographs by Zhang Dali, the most famous graffiti artist in China, who developed a personal dialogue with Beijing through his art (FIG. 27). From 1995 to 1998, Zhang sprayed more than two thousand images of himself—the profile of a shaven head—all over the city, often in half-destroyed, empty houses (CAT. 74–78). He thus transformed these urban ruins into sites of public art, however temporarily. The locations he chose for his performance-photography projects often highlight three kinds of comparisons.

The first contrasts a demolition site with an official monument. The second contrasts abandoned residential houses with preserved imperial palaces. The third contrasts destruction with construction: rising from the debris of ruined houses are glimmering high-rises of a monotonous, international style.

Zhang's interest, therefore, lies not simply in representing demolition, but in revealing the different fate of demolished residential houses from buildings that are revered, preserved, and constructed. His photographs thus serve as a bridge from Rong's urban ruin pictures to another popular subject of experimental Chinese photography in the 1990s—representations of the emerging cityscape, as seen in Yang Yong's representations of southern Chinese cities such as Shenzhen (CAT. 73). Li Tianyuan's striking triptych *Tianyuan Space Station* (CAT. 49) further demonstrates how the new cityscape can reorient an artist's point of view and stimulate his imagination. The middle panel of the triptych represents Li standing in front of a modern glass building in central Beijing. His blurry image conceals his identity and the building's international style omits any local reference—he could be anyone in any city around the world. Following the building's vertical lines, he raises his head to the sky. The right panel is a microscopic detail from the inside of the human body, infinitely enlarged to resemble a cosmic abyss amidst a galactic nebula. The left panel presents the view of a returning gaze from space—an aerial photograph of Beijing. The white circle on this aerial map indicates where the artist stands in the city and leads the viewer back to the central panel. Once viewed on earth, however, modern Beijing is again stripped of local features and can be imagined as a space station for its inhabitants. In a very different style, Luo Yongjin offers a realistic, cynical view of the new city. Gloomy and depressing, his newly constructed residential buildings appear as abandoned ruins.

Significantly, his rejection of the new city as a promised land has guided him back to the tradition of documentary photography, in which the power of an image must lie in its exploration of truth.

The emerging city attracts experimental photographers not only with its buildings but also with its increasingly heterogeneous population. Hu Jieming's *Legends of 1995–1996* (CAT. 42), for example, registers the artist's fascination with the randomness of urban life. Made of photo transparencies with fragmentary scenes of people and their activities taken from TV and downloaded from the Internet, this installation leads the audience to explore a city by throwing them into a maze. The new Chinese city it represents deliberately rebels against its predecessor. Whereas a traditional Chinese city has the typical, orderly image of a chessboardlike space concealed inside a walled enclosure, the new city is sprawling yet three-dimensional, fast and noisy, chaotic and aggressive. It refuses to stay quiet as a passive object of aesthetic appreciation, but demands our participation to appreciate its vitality.

To Chen Shaoxiong, a member of the avant-garde Big-Tailed Elephant Group in Guangzhou, a heterogeneous city resembles the stage of a plotless tableau; what unites its characters is the place they share. This notion underlies a series of photographs which are conceived and constructed like a series of puppet theaters within the real cityscape. Images in each photograph belong to two detached layers: in front of a large panoramic scene are cut-out miniature passersby, shoppers, and policemen amidst telephone booths, traffic lights, different kinds of vehicles, trees, and anything found along Guangzhou's streets. These images are crowded into a tight space but do not interact. The mass they form is nevertheless fragmentary, without order, narrative, or a visual focus.

Representing urban spaces and population, Chen's photos are linked with another popular subject in contemporary Chinese photography-images of a new urban generation, or *dushi yidai* in Chinese. Works belonging to this category include Zheng Guogu's *Life and Dreams of Youth of Yangjiang* (CAT. 79), Yang Fudong's *Don't Worry It Will Be Better* (CAT. 71, 72), and Yang Yong's untitled installation (CAT. 73). Instead of portraying the lives of urban youths realistically, these images deliver constructed visual fictions. Each work consists of multiple frames that invite us to read them as a narrative unfolding in time. Indeed, such interest in seriality and storytelling may be linked to contemporary Chinese experimental cinema, especially the "urban generation" films of the late 1990s and early 2000s. But the stories in the photographs remain nonspecific or allegorical. What the artists hope to capture is a certain taste, style, and mood associated with this generation of people, and for this purpose they have created images that are often deliberately trivial and ambiguous. Yang Fudong's *Don't Worry It Will Be Better*, for example, represents a group of fashionable Shanghai yuppies, including a girl and several young men. The pictures resemble film stills, but the plot that connects them remains beyond the viewer's comprehension.

These images of the urban generation contrast sharply with other photographs in this exhibition, which represent deeper and less glamorous strata of Chinese society. Among these works, Liu Zheng's series *The Chinese* (CAT. 12–16, 50–54) portrays aged entertainers, female impersonators, traveling troupes in the countryside, and obnoxious entrepreneurs in a dance bar.

Experimental photography owes a great deal to the transformation of the city and the emergence of new urban spaces and lifestyles. But the city also realizes its impact on artists in a reverse way: sometimes the chaos and high pressure associated with urban life drives artists to rediscover and communicate with nature through their art. Thus Song Dong designed and photographed a performance to affix a seal on the surface of a river (CAT. 94), and Xiong Wenyun took a long journey to Tibet and photographed what she found on route (CAT. 66–69). Still, as experimental artists become self-conscious about their postmodern identities, they can never take such a return to nature at its face value. Song's obsessive seal-stamping left no impression on the water, and Xiong installed a colorful curtain on the door of each Tibetan house she photographed, to register an intrusion from an outside gaze.

When *Nature, Society, and Man* was held twenty-five years ago in Beijing, the organizers conceived this exhibition as a new beginning in an unofficial history of Chinese photography that they had embarked on three years earlier. The opening sentences of the introduction to the exhibition express this historical vision:

In April 1976, on the bingchen day of the Qingming Festival, a group of young men and women took up their simple cameras and joined the masses in Tiananmen Square. A sense of mission motivated them to record the scenes they saw; the photographs they took there have become an invaluable testimony to a life-and-death struggle that the Chinese people waged against the evil Gang of Four. In April 1979, the same group of young men and women is again playing a central role in organizing this exhibition, advancing their exploration into a new territory.[58]

This new territory was simply photography freed from politics, allowing the camera to pursue a visual language for individual expression. As commonplace as it is in art history, this idea was revolutionary in China at that moment. It laid a foundation for the New Wave movement from the 1980s to the early 1990s, and has guided the development of experimental photography throughout the past decade. The result, as seen in *Between Past and*

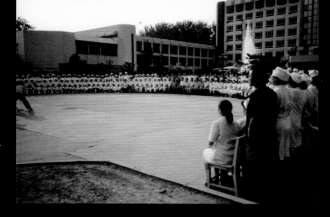

Figure 25
Zhuang Hui, *Shooting a Group Portrait,* 1997.

Figure 26
Yin Xiuzhen, *Beijing,* photo installation, Queensland Art Gallery, Brisbane, Australia, 1999.

Figure 27
Zhang Dali and his graffiti images in Beijing, 1998.

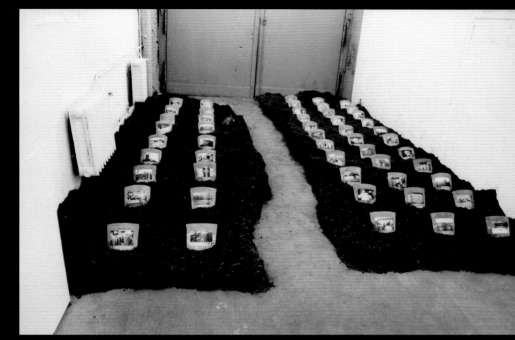

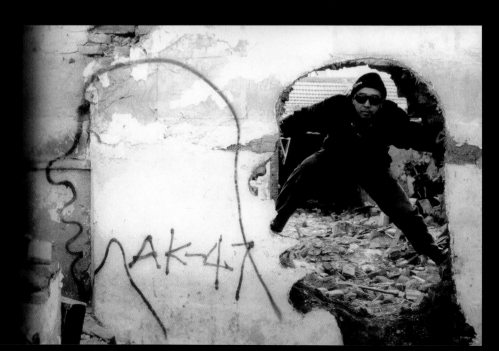

Future: New Photography and Video from China, both confirms and challenges the original intentions of the *Nature, Society, and Man* exhibition. On the one hand, the current exhibition demonstrates that the development of photography in today's China is still driven by the desire for new visual forms as vehicles of individual expression. On the other hand, these forms and expressions have never succeeded in escaping their political and social context. On the contrary, this exhibition shows how political and social issues have reentered contemporary Chinese photography and stimulated artists' experimentation with visual forms.

Many works in the exhibition address problems concerning society and the artist's identity. But even a work that does not directly deal with such problems still internalizes China's social transformation and economic development in its representation and production. Most works in this exhibition do not reflect prolonged, inward contemplation or systematic articulation of a personal style. Instead, they index explosive moments of creative impulse and energy. The lack of technical finesse in some of these images is compensated for by their unusually rich visual stimuli and bold imagination. The key to understanding these works, therefore, is not a gradual transformation of forms and perception, but the artists' sensitivity to new technology and popular culture, their fast-track experimentation with new forms and techniques, and their ease in selecting and changing visual modes. All these factors are inherent aspects of China's explosive economic development and rapid globalization. But this also implies that it is difficult, if not impossible, to predict the future development of this art: because the primary goal of experimental Chinese photography is to capture the excitement of its own time, it is a self-conscious contemporary art concerned with its own contemporaneity, and belongs to a suspended moment between past and future.

[1] See, for example, Chen Xiaoqi, "Sheying xinchao gaiguan" (An overview of the Photographic New Wave), in You Li, ed., *Dangdai Zhongguo sheying yishu sichao* (Trends in the thought of contemporary Chinese photography) (Beijing: Guoji wenhua chuban gongsi, 1989), 40–50; and Bao Kun, "Sheying xinchao de fa duan—lun Siyue Yinghui" (The beginning of the Photographic New Wave—On the April Photo Society), ibid., 28–39. Writing in 1989, both authors dated the beginning of this movement to 1979, when some amateur photographers in Beijing established the April Photo Society and organized the exhibition *Nature, Society, and Man*.

[2] For the concept of experimental art in the Chinese context, see Wu Hung, "Introduction: A Decade of Chinese Experimental Art (1990–2000)," in Wu Hung, ed., *Reinterpretation: A Decade of Experimental Chinese Art, 1990–2000* (Guangzhou and Chicago: Guangdong Museum of Art and Art Media Resources, 2002), 10–19.

[3] For example, Wang Zhiping made an album called *Funeral of the Nation* (Guo sang) and presented it to Deng Yingchao. Wu Peng and Luo Xiaoyun made similar albums and presented them to her through personal connections. Li Xiaobin titled his album *A Heroic Monument* (Feng bei) and presented it to Deng Xiaoping.

[4] The seven members are An Zheng, Gao Qiang, Li Xiaobin, Luo Xiaoyun, Ren Shimin, Wang Zhiping, and Wu Peng.

[5] Li Xiaobin, "Yongyuan de huainian" (Forever cherishing the memory), in *Yongyuan de siyue* (Eternal April) (Beijing: Zhongguo shuju, 1999), 20. On the differing accounts of the number of collected negatives, see Wu Peng, "Cong 'Si Wu' Yuandong dao *Renmin de daonian*" (From the April Fifth Movement to *People's Mourning*), ibid., 11.

[6] Editorial Committee, *Renmin de daonian* (People's Mourning) (Beijing: Beijing chubanshen, 1979). Of the more than five hundred photographs collected in this volume, nine are film stills produced by an official film studio and three are from unidentified sources. The rest were made by amateur photographers.

[7] Li Xiaobin (note 5), 23–24.

[8] According to Lu Xiaozhong, who was a member of the salon, one such "exhibition," entitled *Silver Stars* (Yinxing), was held in the winter of 1978 in Chi's house and included close to one hundred photographs. Lu designed a poster for the exhibition. See Lu Xiaozhong, "Xingqiwu shalong" (Every Fridays Salon), in *Yongyuan de siyue* (note 5), 66–67.

[9] There are differing accounts of the numbers of the works in the exhibition. The number cited here is based on an official report of the exhibition in *People's Daily*, April 24, 1979.

[10] Preface to the first *Nature, Society, and Man* exhibition, cited in *Yongyuan de siyue* (note 5), 88–89.

[11] For the audience's reactions to the exhibition, see Ren Shulin, "Yingzhan shang de wenzi" (Writings in the photographic exhibition), in ibid., 78–84; quotation, 82.

[12] Li Mei and Yang Xiaoyan, "1976 nian yilai Zhongguo sheying fazhan de xingtai yu jieduan" (Trends and stages in the development of Chinese photography since 1976), in Wang Hebi and He Shanshi, eds., *Sheying toushi—Xianggang, Zhongguo, Taiwan* (Three photographic perspectives—Hong Kong, Mainland China, Taiwan) (Hong Kong: Hong Kong Arts Centre, 1994), 13–17, especially 14.

[13] Li Yingjie, "Yipi xinxing de sheyingren" (A new type of photographer), in *Yongyuan de siyue* (note 5), 86.

[14] *Xiandai sheying* (InPhotography) no. 1 (1984), 3.

[15] *Zhongguo sheyingjia* (Chinese Photographers) no. 1 (July 1988), 63. This is not a complete list of influential photography publications at the time. Other important journals include *Guang yu ying* (Light and shadow), *Renxiang sheying* (Portrait photography), and *Sheying zhi you* (Friends of photography).

[16] For brief overviews of these conferences, see Li Mei and Yang Xiaoyan, "1976 nian yilai Zhongguo sheying fazhan de xingtai yu jie-duan;" "Huigu yiduan wangshi, xiangshi yidai xinren: Wang Miao, Peng Zhengge, Shi Baoxiu tanhualu" (An Introspection on the past events—An introduction to a new generation): A conversation featuring Wang Miao, Peng Zhengge, and Shi Baoxiu), in Wang Hebi and He Shanshi, eds., *Sheying toushi—Xianggang, Zhongguo, Taiwan* (note 12), 104–06. Some of the papers presented at these conferences were later published in two anthologies: *Dangdai Zhongguo sheying yishu sichao* (note 1) and *Sheying yishu lunwenji* (A collection of papers on the art of photography) (Beijing: Zhongguo sheying chubanshe, 1994). This second volume also includes a comprehensive bibliography of Chinese publications on photography from 1989 to 1994. Essays by Bao Kun, Chen Xiaoqi, and Bao Mu in the first anthology are early attempts at an historical narrative of contemporary Chinese photography.

[17] Some Chinese critics have called this type of photography "new documentary photography" (*xin jishi sheying*), to distinguish it from Socialist Realist documentary photography promoted by the party. According to Wang Miao, an exhibition organized by the Modern Photo Salon in 1986 entitled *Flash Back—A Decade of Chinese Photography* (Shinian yishun), marked the dominance of documentary photography. See "Huigu yi-duan wangshi, xiangshi yidai xinren: Wang Miao, Peng Zhengge, Shi Baoxiu tanhualu" (note 16), 104.

[18] For an introduction to Zhu Xianmin, see Gong Zhiming, *Zhongguo dandai sheyingjia jiedu* (Reading contemporary Chinese photographers) (Hangzhou: Zhejiang sheying chubanshe, 2002), 35–49.

[19] Wang Zhiping and Wang Miao, "Xibu Zhongguo manyou" (Wandering in western China), *InPhotography* (1985). For the reception of their writing as a manifesto of documentary photography, see Bao Mu, "Zhongguo xin jishizhuyi sheying zhi chao" (The wave of new documentary photography in China), in *Dangdai Zhongguo sheying yishu sichao* (note 16), 61.

[20] Bao Mu, ibid., 56.

[21] The most authoritative record of this project is offered by Li Xiaobin himself. See his essay "Guanyu 'Shangfang zhe' de paishe ji qita" (About photographing 'People Pleading for Justice from the Higher Authorities' and other matters), *Lao zhaopian* (Old photos) no. 15, 126–33.

[22] This image can be compared with Dorothea Lange's *Migrant Mother*. Graham Clarke analyzes Lange's image in *The Photograph* (Oxford and New York: Oxford University Press, 1997), 153: "In this Lange creates a highly charged emotional text dependent upon her use of children and the mother. The central position of the mother, the absence of the father, the direction of the mother's 'look,' all add to the emotional and sentimental register through which the image works. The woman is viewed as a symbol larger than the actuality in which she exists. As Lange admitted, she wasn't interested in 'her name or her history.'" Similarly, nothing is known about the man in Li Xiaobin's photograph.

[23] For some of these exhibitions, see Bao Mu (note 16), 63; see also "Huigu yiduan wangshi, xiangshi yidai xin-ren: Wang Miao, Peng Zhengge, Shi Baoxiu tanhualu" (note 16), 104–5.

[24] For an introduction to twelve leading documentary photographers and their subjects, see Gong Zhiming (note 18).

[25] For Gu Zheng's images of Shanghai and his pursuit of an individual style, see his *Urban Sketch* series in *InPhotography* nos. 12–13 (1988), 34–35, and his essay "Wo de Shanghai" (My Shanghai) in the same issue, 80. For Mo Yi's photographic series *Expression of the Street*, which represents the changes in Tianjin from the late 1980s to the early 1990s, see Wu Hung, *Transience: Chinese Experimental Art at the End of the 20th Century* (Chicago: Smart Museum of Art, University of Chicago, 1999), 60–65.

[26] For an inspired discussion of Zhang Haier's photographs on this subject, see Yang Xiaoyan, "Jingtou yu niixing—kan yu beikan de mingyun" (Camera and women—the fate of seeing and being seen), *Dushu* no. 279 (June 2002), 3–12.

[27] As a pioneer of this emerging alliance, Zhang Haier established close ties with avant-garde artists. Similar to many experimental photographers of the 1990s, he was first trained as a painter and then embraced photography. His works were later published in the avant-garde *Book With a White Cover* (Baipi shu, a sequel to *Book With a Black Cover*) compiled by Ai Weiwei, Zeng Xiaojun, and Zhuang Hui.

28 I have discussed the concept of "experimental art" in *Reinterpretation* (note 2), 11–12.

29 The four Bohemian artists featured in Wu Wenguang's documentary film *Bumming in Beijing: The Last Dreamers* (1990) include Gao Bo, a representative of emerging "experimental photographers" in the late 1980s.

30 For this definition of "Chinese photography," see Gu Zheng, "Guannian sheying yu Zhongguo de sheying" (Conceptual photography and "Chinese photography"), in Lo Qi and Guan Yuda, eds., *Zhongguo xingwei sheying* (Performance photography of China) (Hangzhou: China Academy of Art Press, 2001), 5–10.

31 This situation changed after 2000, when mainstream museums such as the Shanghai Art Museum and the Guangdong Museum of Art began to include experimental art in their exhibitions. For the changing world of Chinese museums and exhibitions, see Wu Hung, *Exhibiting Experimental Art in China* (Chicago: Smart Museum of Art, University of Chicago, 2000).

32 For a discussion of this phenomenon, see ibid., 14–18.

33 The real name of the village is Dashanzhuang. It was demolished in 2001 and 2002 and assimilated into the ever-expanding Chinese capital.

34 For a history of the East Village, see Wu Hung, *Rong Rong's East Village* (New York: Chambers Fine Arts, 2003).

35 For a brief introduction to publications and studies of experimental Chinese art, see Wu Hung, *Transience* (note 25), 176-79.

36 Only four issues of this serial have been produced. For the first two issues, twenty copies each were made, and thirty copies were made for each of the last two issues.

37 This attitude is clearly demonstrated in the introduction to the first issue of *New Photo*.

38 For some images by Qiu Zhijie and Mo Yi featured in this exhibition, see Wu Hung, *Transience* (note 25), pls. 6, 22.

39 Dao Zi, "Xin yingxiang: Dangdai sheying yishu de guannianhua xianzheng" (New image: Important characteristics of the conceptualization of contemporary photographic art), *Xiandai sheying bao* (Modern photography) (1998) 1, 2–13. The same issue also includes the preface of the *New Image* exhibition written by Dao Zi, 28–30.

40 Corinne Robins, *The Pluralist Era: American Art 1968–1981* (New York: Harper and Row, 1984), 213.

41 For a good discussion of this phenomenon, see Karen Smith, "Zero to Infinity: The Nascence of Photography in Contemporary Chinese Art of the 1990s," in Wu Hung, ed., *Reinterpretation* (note 2) 35–50, especially 39-41.

42 For a discussion of this group of photographs, see Wu Hung, "Photographing Deformity: Liu Zheng and His Photographic Series *My Countrymen*," *Public Culture* 13, no. 3 (2001), 399–427.

43 Partly due to this difference, some Chinese art critics have termed recent experimental photography New Conceptual Photography (*Xin gainian sheying*). See Zhu Qi, "Xinxiang zhiyi: guanyu ziwo lishi de jilu" (Images telling stories: Records of self-history), in *Images Telling Stories*, catalogue of the exhibition *Art of Chinese New Conceptual Photography*, Shanghai (2001), 2–6.

44 For a more detailed discussion of this issue, see Wu Hung, "Contemporaneity in Contemporary Chinese Art," forthcoming.

45 "Everyday Sightings: Melissa Chiu interviews the Chinese artist Wang Youshen," *Art AsiaPacific* 3, no. 2 (1996), 54. Reprinted in this volume, pp. 186–87.

46 For a fuller introduction to this project, see Wu Hung, *Transience* (note 25), 54–59.

47 Ibid., 58.

48 For a detailed discussion of Xing Danwen's work, see ibid., 48–53.

49 Sui Jianguo's letter to the art critic Gu Zhenfeng, provided by the artist.

50 For a fuller introduction to this work, see Wu Hung, *Transience* (note 25), 60–65.

51 For an introduction to this project, see Wu Hung, *Rong Rong's East Village* (note 34).

52 For an introduction to this controversial exhibition, see Wu Hung, *Exhibiting Experimental Art in China* (note 31), 204–08.

53 For a fuller discussion of this project, see Wu Hung, *Rong Rong's East Village* (note 34), 11–14.

54 For a discussion of self-portraiture in experimental Chinese art, see Wu Hung, *Exhibiting Experimental Art in China* (note 31), 108–20.

55 *Shen Jingdong, 100 ge yishujia miankong (Faces of 100 artists)* (2001). Private publication.

56 For a discussion of these experiments, see Wu Hung, *Transience* (note 25), 168–74.

57 Qiu Zhijie, "Ziyou di youxianxing-'Wo' de wenti" (The limit of freedom—Questions about "I"), 1994–96. Unpublished manuscript, 5.

58 *Yongyuan de siyue* (note 5), 88.

CHRISTOPHER PHILLIPS

My interest in recent Chinese art was first kindled in 1998, when the exhibition *Inside Out*, at that time the most comprehensive survey of contemporary works from China to appear in the United States, was presented at P.S.1 and the Asia Society in New York. *Inside Out* traced the main directions in Chinese art from the late 1970s to the mid-1990s; it charted the rise and fall of such movements as Political Pop and Cynical Realism, and, more significantly, brought to wide attention the achievements of such figures as Cai Guo-Qiang, Gu Wenda, and Xu Bing. I was struck by the freshness and inventiveness of the paintings, prints, and above all the installations on display, and during the show's run I had the good fortune to meet a number of the participating artists. They seemed to me a remarkable group, distinguished by their hyperalertness to the world around them, their unusual imaginative scope, and their confidence in their own creative powers and cultural idiom.

1

2

3

The following year I began what became a series of regular visits to China. As I made the rounds of artists' studios in Beijing, Guangzhou, Hangzhou, Shanghai, and other urban centers, I noticed that a shift toward media-based work was underway among younger practitioners, even those who had trained as painters and sculptors. My path soon crossed that of Wu Hung, who for the past decade has been one of the most insightful commentators on contemporary Chinese art. At our first meeting, we discovered a shared fascination with the sudden emergence of photography and video as central preoccupations of Chinese artists. The work that captured our attention stood out by reason of its brash energy, to be sure, but also because of its sweeping range of historical and cultural references. The monumental scale, too, preferred by many of the artists seemed to mirror the breathtaking ambition of the changes taking place throughout the country. Finally, this Chinese work did not really translate easily into the familiar categories of global contemporary art, but stubbornly insisted on its own concerns.

It was in response to this remarkable turn in Chinese art that Wu Hung and I began to plan this exhibition and catalogue. We have chosen not to attempt an all-embracing survey of recent Chinese media-based art, but rather to adopt a more limited and selective approach. Our hope is to introduce to American audiences a remarkable group of younger artists who are at this point still little known in the United States, and to concentrate on works that convey the complexity of these artists' responses to the changes in Chinese life that confront them every day.

For those who have not spent regular stretches of time in China in the past decade, and who have not witnessed the constant daily upheavals that constitute the Chinese boom, these artworks can at first seem a mixture of bewildering elements. Artist Zhang Peili, a frequent participant in international exhibitions,

speaks frankly of the "quite basic ignorance of China and Chinese culture on the part of the Western art world," which he feels prevents a full understanding of works that spring directly from the current realities in China.[2]

Certainly it is not always apparent to foreign visitors that, for the majority of its people, China is still an agricultural society, tied to the slow, seasonal rhythms of rural life. At the same time, a classic modernization process is unfolding, complete with breakneck industrialization; the massive transfer of population from the countryside to urban zones; the construction of towering skyscraper cities; and the advent of previously undreamed-of individual mobility thanks to the proliferation of private automobiles. Simultaneously, a postindustrial information society is also taking shape, the signs of which are already visible in the growing presence of personal computers with Internet connections, as well as in the inescapability of mobile telephones. All of these tendencies, existing side by side and usually in tension, yield the surrealistic juxtapositions that occur at every turn in early-twenty-first-century China.[3]

The same dizzying sense of scrambled temporalities greets the foreign viewer's first encounter with China's contemporary artistic life. Present-day artists such as Wang Qingsong have expressed the feeling that China's ancient cultural traditions have been shattered in the past century, reduced to a heap of disconnected fragments for artists to pick through and attempt to turn to their own purposes.[4] At the same time, Chinese artists, effectively isolated from the Western art world from 1949 to 1979, have felt compelled to assimilate as rapidly as possible the key lessons of international modern and contemporary art. As a result, Henri Matisse and Marcel Duchamp, Joseph Beuys and Cindy Sherman, have all been avidly gulped down at once. The references to the works of these predecessors that now surface in contemporary Chinese art can at first seem alarmingly

out of kilter to outside observers—at least until we grasp the unpredictable ways in which these works have been incorporated and assigned new values.

Not surprisingly, the recent emergence of photography and video as leading art media in China follows a similar pattern. Before considering how this situation bears on specific contemporary artists and their work, however, it may be useful to briefly sketch out some of the ways in which the Chinese historical experience of these media has significantly differed from that of Europe, Japan, and the United States.

PHOTOGRAPHY IN CHINA: A DIVERGENT PATH

The full story of photography's development in China remains unwritten. As provocative as they are, current scholarly accounts are episodic and disconnected, and have yet to be woven into a coherent narrative. One crucial task, the collation of the Chinese and non-Chinese historical research that already exists, has barely begun. Even so, enough is known to suggest that in several important respects the Chinese experience of photography stands apart from both that of Japan and the West.[5]

The year that witnessed photography's invention, 1839, also saw the beginning of the First Opium War between Britain and China. Upon the conflict's conclusion in 1842, the victorious British forced upon the humiliated Chinese government the Treaty of Nanjing, which opened six coastal ports to Western trade and ceded Hong Kong to British control. In December of that year, coinciding with Queen Victoria's signing of the agreement, the British Foreign Office engaged the London calotypist Henry Collen to produce photographic facsimiles of the Chinese-language version. According to Collen, one of these copies was meant to be forwarded to the Chinese government with the expectation that this example of Western ingenuity would "astonish the natives."[6]

The following year, the diplomat Sir Henry Pottinger, who had successfully directed British military operations in China and had just been appointed governor of Hong Kong, presented a photographic portrait of himself and his family to his Chinese counterpart, the Guangdong governor-general Qi Ying.[7] In 1844, the French trade official Jules Itier spent two months in the same region negotiating a treaty that guaranteed his nation commercial access to Chinese ports on terms equal to those enjoyed by Britain. After the treaty was signed aboard the French ship *Archimède*, Itier bade Qi Ying and the members of the Chinese negotiating team to assemble before his camera for a daguerreotype portrait. A French witness reported that the Chinese "were stunned by the rapidity and veracity of the reproduction, whose secret they could not fathom."[8] Qi Ying, as a consequence of these incidents, furnished in two official communications to the emperor what are perhaps the earliest written references to photography in Chinese. In the second missive, he explained to the emperor that, having received photographic portraits as gifts from Pottinger, he felt obliged to be able to reciprocate in kind. This report was titled "Shi Ying's Second Memorial to the Throne on the Necessity of Presenting to Them Photographs of Himself to Express His Understanding of Them."[9]

Photographic portrait studios appeared in Hong Kong by 1846 and soon thereafter in the coastal treaty ports. Such establishments were mainly owned and operated by Western photographers who consciously worked for multiple publics, producing commissioned portraits for a local clientele and visiting traders (FIGS. 1, 2) but also making photographs for sale in the West. The subjects of these images directly echoed the established themes of the paintings and watercolors that anonymous Chinese artisans had made for export since the mid-eighteenth century. These included harbor scenes and topographic views, portraits of Chinese "types" associated with various trades and occupations, and illustrations of commercial processes such as tea growing and silk manufacture.[10]

Until late in the nineteenth century, photography seems to have been largely confined to China's coastal cities. Only after the imperial government had received another disastrous defeat in the Second Opium War of 1856–60 did it become possible for foreigners to range freely throughout all China. Whether it was because they were seen as the advance guard of intrusive Western powers or as practitioners of an occult art, early photographic travelers often met with open hostility. The British photographer John Thomson, who ventured deep into the Celestial Empire to obtain material for his book *Illustrations of China and Its People* (1873–74), frequently received a rough reception from the populace:

At Chao-Chow-Fu, I got up one morning before daybreak, to photograph an old bridge across the river there, and I fondly thought that, being so early astir, I should get clear of the city mob. . . . I had just time to show myself and take a photograph, when a howling multitude came rushing down to where I stood near my boat on the shore. Amid a shower of missiles I unscrewed my camera, with the still undeveloped film inside, took the apparatus under my arm, and presenting my iron-pointed tripod to the rapidly approaching foe, backed into the river, and scrambled on board the boat.[11]

By the 1870s, the presence of Chinese-owned-and-operated photographic studios in the treaty ports had become familiar. The surviving portraits and topographic views of Lai Afong, the leading Chinese photographer in Hong Kong, rival in every respect those of his Western colleagues. Yet compared to relentlessly modernizing Meiji Japan, where by 1877 there were one hundred and sixteen professional photographers active in Tokyo and more than a dozen photographic supply houses in operation, the growth of photography in China lagged demonstrably.[12] Only Hong Kong and Shanghai appear to have established a substantial number of portrait studios, and only in 1877 was the first Chinese-language technical manual, *Tuoying qishi* (Extraordinary sights of photography), published.[13]

The commercial use of photography gradually expanded in the international port cities. By the 1890s, for instance, Japanese portrait studios such as that of Ueno Hikoman began to establish overseas branches in Shanghai, and the city's courtesans took to circulating photographic portraits as a way to draw a clientele. Imperial recognition, however, came slowly. In Beijing, where the Qing government did its utmost to block the spread of Western culture, the first commercial-portrait establishment did not appear until the opening of Ren Qingtai's celebrated Fengtai Studio in 1892.[14] Only in the waning years of the Qing dynasty did photography come into regular use to document the court's activities and personalities, after the elderly Empress Dowager, Cixi, began in 1903 to stage fanciful tableaux compositions recorded by a young court photographer.[15]

In China, as in Europe, Japan, and the United States, the early years of the twentieth century saw not only the adoption of photography by the illustrated press, but also the establishment of small, elite art-photography groups. As part of the wider cultural ferment spurred by the May Fourth Movement (1919), circles began to appear in Beijing and Shanghai thanks to the efforts of individuals such as Chen Wanli, Lang Jingshan, Liu Bannong, Pan Dawei, and Zhang Yinquan.[16] Yet because of the political and social volatility of the 1920s and 1930s, a full-scale dialogue between photography and the diverse currents of modern Chinese painting never took place. During a period that saw constant bickering among regional warlords, the wary and sometimes bloody rivalry of the Chinese

Communist Party and Chiang Kai-shek's Guomindang movement, and finally an all-out Japanese invasion, the lives of promising young artists and photographers were subject to wrenching changes of direction.

Wu Yinxian (1900–1994), for example, studied painting at Shanghai's Art Academy and became a professional photographer in that city in 1920. His early works show a mastery of the soft-focus style that was then the hallmark of the international Pictorialist movement (FIGS. 3, 4); from the outset, too, he appears to have used his images to examine the conditions of Chinese social life. In the early 1930s, he became a highly regarded cinematographer and movie art director in Shanghai, at which point his photographs show the influence of film-industry glamour portraits; yet, at the same time, he was exhibiting jointly with the left-wing realist painter Xu Xingzhi. This was the diverse background that the artist brought with him when he made his way to distant Yanan, a city in Shaanxi province, in 1938 to join Mao Zedong and his Communist forces. His subsequent portraits of Mao (FIG. 5) and other party leaders, as well as his images of the spartan life they led, helped create the irresistible and enduring myth of the "Yanan Way."[17]

Other photographers following a similar path during these years included Sha Fei (1912–1949), who worked in 1930s Shanghai, exhibiting landscapes and documentary-style views of everyday life while also producing paintings and woodcuts. He joined the Communist forces in the northern city of Taiyuan in 1937, and executed an extensive series of compelling photographs chronicling the bitter struggle against the Japanese.[18] Similarly, Xu Xiaobing (b. 1916), who had been active in photography and motion pictures in early-1930s Shanghai, joined the Communists in Yanan in 1938. He and his wife and photographic partner, Hou Bo (b. 1923), went on to become Mao's longtime personal photographers, until Hou Bo's fall from favor and exile to a labor camp during the Cultural Revolution.[19] As all of these instances suggest, the main career trajectory for photographers during the desperate years of the 1930s and 1940s inevitably led through political engagement, not aesthetic exploration.

Following the triumph of the Communist revolution and the founding of the People's Republic in 1949, the most technically accomplished Chinese photographic work could be found in the pages of *Renmin huapao* (People's illustrated), a sumptuous monthly with an English-language edition that appeared under the name *China Pictorial*. Launched in 1950 and based on the Soviet publication *USSR in Construction*, it was the Chinese Communist Party's official picture magazine, meant to present a shining vision of the new China and its people. In 1956, again taking a cue from the Soviets, the party founded the Association of Chinese Photographers, which included both professionals and amateurs. Maintaining an unswerving emphasis on celebratory images that testified to the achievements of Mao's China, and holding tight control over scarce photographic materials and equipment (only in 1958 did the first Chinese-manufactured cameras begin to appear), the association left no room for independent art photography, photojournalism, or documentary projects.

During the decade of the Cultural Revolution (1966–76), when the country's isolation reached such a degree that even contacts within the Socialist bloc withered, journalistic photography was increasingly paralyzed by ongoing battles between rival political factions.[20] *China Pictorial* was one of the few illustrated magazines to publish continuously during these years, its covers graced by artfully doctored portraits of a vivacious and rosy-cheeked Mao (FIGS. 6, 7; see FIGS, 8, 9 for popular and personal images from the same era). Following the chairman's death in 1976 and Deng Xiaopeng's consolidation of power in 1979–80, there began a gradual cultural opening that enabled the Association of Chinese Photographers to cautiously mount more stylistically and thematically varied exhibitions. Nevertheless, even the supposedly "new wave" works on view in the putatively independent China Modern Photo Salon exhibitions of the mid-1980s demonstrated that eye-catching visual techniques alone were not enough to reinvigorate the stock themes of landscape, portraiture, and industrial photography. The timidity of such images demonstrated chiefly how well Chinese photographers, subject for decades to the dictates of party officials, had learned the art of circumspection.

SELECTIVE APPROPRIATION: ENCOUNTERS WITH INTERNATIONAL PHOTOGRAPHY AND VIDEO IN THE 1990S

In his essay in this catalogue, Wu Hung details the complex stages that Chinese independent photography moved through as it took shape from the end of the Cultural Revolution in 1976 to the early 1990s. These included the stop-and-start relaxation of official controls, the appearance of a cycle of short-lived photography groups, and the awakened awareness of developments in Western photographic practice. By the early 1990s, too, a small but growing number of young, experimental artists had begun to establish regular contact with the global art world, seizing the previously unavailable opportunities for overseas travel that arose through their participation in foreign-organized, internationally touring exhibitions such as *China's New Art Post-1989*, *China Avant-Garde*, and the Venice Biennale, which included artists from the People's Republic for the first time in 1993. Even though the majority of these individuals specialized in painting, sculpture, and installation work, the information that they brought back to China sparked a sudden recognition of the

unexpected prestige enjoyed by photography and video on the global art scene.

This surprising status reflected the fact that, since the 1960s, the aesthetic questions raised by photography and video had proved central to wider developments across the field of contemporary art. Photography, in particular, enjoyed a position at the crossroads of two distinct currents: as a crucial element in hybrid artistic practices combining, for example, photography and painting, photography and text, or photography and performance; and as the source of an objective, quasidocumentary visual style that had won recognition as a legitimate direction in and of itself.[21] Consequently, experimental Chinese artists in the early and mid-1990s were able to confront, simultaneously and in a single rush, the myriad ways in which photography might be encountered in contemporary art. In the ensuing years, they have carried out a continuing inventory and selective appropriation of the photographic modes they discovered in use, taking over only what seems best suited to furthering their own artistic goals.[22] Nevertheless, there are broad swaths of international photo art that have so far awakened little response among Chinese artists. It is difficult, for example, to locate instances of photography used as a means of overt political critique—not surprising, perhaps, given China's status as a still-authoritarian society in which open criticism of current political leaders remains taboo. Neither have Chinese artists generally shown interest in photography's potential as a medium of abstraction. Furthermore, given the long literati tradition of an intimate dialogue between painting and poetry, it is curious that so few Chinese artists have yet attempted to place photographic images into a sophisticated relation with written language.

For its part, Chinese video art has followed what seems to an outsider to be a similarly idiosyncratic path. It comes as an initial surprise to realize that video made its appearance in China well before most artists came to think of photography as a viable creative medium. The pioneering Chinese video-maker Zhang Peili began to experiment with video in 1988, while still a painter; he quickly conceived ambitious video installations, many of which were shown internationally. It was in 1991 that he presented one of China's first publicly exhibited video works in the now-famous exhibition *The Garage Show* in Shanghai. Zhang was quickly joined in his enthusiasm for video by younger artists such as Qiu Zhijie, Yan Lei, and Zhu Jian. The first half of the 1990s saw their attempts to come to terms with the historic stages through which international video art had passed since the 1960s, as represented by figures such as Nam June Paik, Wolf Vostell, Bruce Nauman, Bill Viola, and Tony Oursler. By 1996 the first exhibition in China to focus exclusively on video art, *Image and Phenomena,* was organized in Hangzhou by Qiu Zhijie and Wu Meichun.

It remains rare for Chinese artists to specialize exclusively in video, given the almost complete absence of domestic venues in which videos can be screened. One consequence of this situation, Qiu Zhijie has indicated, is that most artists have given a much higher priority to making video installations than single-channel video works. "There is always the possibility of finding a gallery or some other space, or . . . a so-called 'avant-garde' exhibition, in which to show video installations. If you only work with video—that is, only make videotapes—then in China you have no chance to show these works. There are simply no possibilities."[23] Since 1995 there have been only a handful of Chinese artists who, like Zhang Peili, have chosen to concentrate mainly on video and new media; these include Feng Mengbo, Wang Gongxin, and Yang Fudong. Some of the most innovative video work, however, has been produced by artists—many of them included in this exhibition—who regard video as simply one among a number of available media.

During the early part of the 1990s, Chinese videos were often characterized by a direct, almost minimalist style; to a large extent this look sprang from artists' attempts to turn their lack of access to professional equipment to their own advantage. Until late in the decade, in fact, many artists had to rely on borrowed equipment to make their work. One important result of this circumstance is that artists were encouraged to approach videos as one-shot exercises in imagination and self-expression rather than extended, complex explorations of form.[24] Since the end of the 1990s, however, Chinese video artists have achieved a new level of technical sophistication thanks to the diminishing cost of equipment and the spread of high-quality editing software that can be installed on personal computers. Moreover, a lavishly equipped New Media center, headed by Zhang Peili, was recently established at the China National Academy of Fine Art in Hangzhou. This development is a clear, official acknowledgment of video's importance as an art form, and promises that the next generations of Chinese media artists will enjoy access to technologies that their predecessors could only dream of.

THE PERSISTENCE
OF THE PAST

Most Chinese artists of my acquaintance are steeped in the art of their country's past. Even when their own preferred aesthetic approach is experimental rather than traditional, their artistic heritage serves them as both a central reference point and an ultimate standard against which they can measure the art of the present. It also provides an array of historical examples that they can use to consider such thorny issues as the place of the artist in society or the relation of intellectuals to state power.

Wang Qingsong's *Night Revels of Lao*

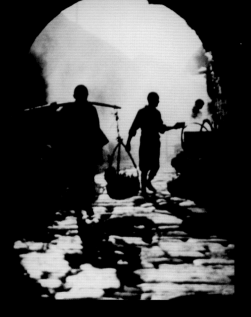

4

5

6

Figure 4
Wu Yinxian, *Spirting, Jiangsu,* 1933, gelatin silver print, collection International Center of Photography.

Figure 5
Wu Yinxian, *Mao Zedong Addressing Soldiers of the People's Liberation Army,* 1945, gelatin silver print, collection International Center of Photography.

Figure 6
China Pictorial, cover, 1966, no. 9, special issue announcing the beginning of the Great Proletarian Cultural Revolution, collection International Center of Photography.

Li (2000, CAT. 97) is a brilliant reinterpretation of one of China's most celebrated artworks, a tenth-century scroll painting by Gu Hongzhong entitled *Night Revels of Han Xizai,* now in the Palace Museum, Beijing.[25] There are many versions of the story that purports to explain the genesis of this famous image. The one that relates most directly to Wang's work tells how the high official Han Xizai, despairing of his long and futile efforts to reform imperial policy, abandoned himself to a life of debauched amusement, which the scroll painting discreetly evokes through glimpses of rumpled beds and lovely courtesans. The emperor, hearing of Han Xizai's extravagant evenings, began to suspect that they gave cover to political conspiracy. He ordered a trusted artist to infiltrate one of the gatherings and surreptitiously take the visual notes from which the final painting was elaborated.

In updating this work, Wang replaced the figure of Han Xizai with that of Li Xianting, a prominent critic and curator of contemporary art. In the early 1980s, because of his support for experimental art, Li was removed from his position as editor of a leading art magazine, an event that propelled him into a life within the capital's bohemian art circles. In an interview, Wang observed, "After so many years of Chinese history, I find no change in the destinies of intellectuals in China. . . . My work *Night Revels of Lao Li* depicts the fact that there is no way for intellectuals to do something for the government— except to have fun and enjoy themselves in private. Yet after the feast is over and the guests are gone, the intellectual is very sad. Beneath the superficial excitement lie his deep worries and disappointment."[26]

Past, Present, Future (2001, CAT. 27), a large-scale triptych that is one of Wang's most ambitious works, grew out of his reflections on China's recent past and the prospects for its people. By carefully posing and arranging his models, the artist ingeniously mimicked the monumental,

Socialist Realist public sculpture that can still be seen in Chinese cities. Each of the three sections refers to a different historical moment. *Past,* the right-hand panel, depicts seventeen figures on a raised pedestal. In their mud-covered military uniforms, these men and women are far from glamorous. We see soldiers brandishing pistols, rifles, and swords, and one man blowing a bugle. Another holds over his head a length of heavy chain that represents the weight of oppression that he and his comrades are fighting to throw off. Wang himself stands at the base of the monument as an observer, dressed as a soldier whose head is wrapped in bloody bandages. Gazing upward, he holds out a bouquet of flowers as if in tribute to the unsung heroes of China's revolutionary epoch.

In *Present,* the left-hand panel, the muddy soldiers have given way to a procession of seventeen gleaming, silver-covered workers being urged along by a unit leader with a megaphone. Instead of weapons they carry industrial tools, and many wear protective goggles over their eyes. Once again the artist positions himself outside the group. Looking up at the monumental heroes of labor, he appears this time as a young civilian wearing a jaunty white cap and accompanied by a pampered pet dog.

In the central panel, *Future,* a host of radiant, golden figures carry flowers and baskets overflowing with fruit. In this section, Wang has taken his place at the center of the group, holding up a pair of cymbals as if to announce the dawn of a triumphant age. But this shining forecast is not completely assured: one man grasps a rifle as if awaiting battles to come, and all of the faces that surround him are somber and vigilant. Are they really convinced that a glorious future lies ahead? An era like the present, the artist seems to suggest, has thrown into doubt the confident certainties of China's revolutionary heroes.

In the video *Our Future is Not a Dream* (2000, CAT. 29), Weng Fen compiled short

excerpts from feature films of the Maoist era to the present in order to highlight the wrenching changes in official expectations for the future. Because the artist assembled these clips from cheap bootleg DVDs, frequent visual pauses and stutters undermine the coherence of these elaborately dramatized scenes. Each segment presents a conversation between two or more people who are discussing the prospects they envisage for the years ahead. In the opening excerpt, a bright-eyed young man in Red Guard attire addresses his wife, who wears more traditional clothing. "I am at ease now that I have handed in my written party application," he announces, beaming. "And our party will have a new member." He is apparently to be sent to the countryside. "Though hard and bitter," his wife resolutely intones, "we can bear it till you are back." Their young son gazes transfixed at his father, who fervently vows, "We will build socialism and communism."

Another segment of the video, clearly from the period following the advent of China's market economy in the 1980s, seems to belong to a different world. This clip consists of a late-night exchange between a woman and man who may be husband and wife, or simply business partners brainstorming ideas for cheap, mass-market books. "I hit on a subject this afternoon," the woman announces. "The title is *Lady, Beautify Your Face in 365 Days.* If we publish it with a desk calendar, we can make money from it, surely." The man is aroused by her vision. "People have money now," he muses. "They're keen on eating as well as beauty. Do a project on beauty this year, and on food the next—that's it," he exults, jabbing the air emphatically. Caught up in this moment of entrepreneurial bliss, she continues excitedly, "We can also plan a series of guidebooks such as *Blood Type Guide* and *Vigorous and Graceful Guide.* Lots of people will buy this for sure." Whether the battle is for a socialist utopia or a market niche, Weng wryly observes, official cinema serves up charac-

44

ters who are meant to provide models for popular emulation.

Yang Fudong has found a different kind of inspiration in the classic Shanghai films of the 1930s. To him, the past often seems more vivid and immediate than the present. "I personally have an affinity for what we refer to as literati short films," he says. "They aren't major productions, nor do they employ large techniques. They come from the heart, something that you want to express."[27] His fourteen-minute *Liu Lan* (2003, CAT. 98), shot with 35mm black-and-white film and using nonactors in the main roles, tells the story of a young pair whose paths cross for a brief moment. To the sound of traditional flute music, a woman sits in a wooden fishing boat on an atmospheric lake or bay. She attends to her embroidery, almost hidden beneath a flat hat trimmed with a gauze veil. A man arrives on the shore, wearing a suit and plaid scarf that mark him as a city dweller. They gaze at one another, and he joins her in the boat. They sit together in silence, cooking fish and eating together amid watery reflections as the sun slowly sets. He curls up to sleep, and she covers him with blankets. In the morning, he gets off the boat and departs. Throughout the film, the young man seems almost an apparition, an urbanite moving uneasily through the kind of spare, stylized rural landscape that is now increasingly rare in China. Recalling early Ming-era paintings that portray tranquil fisherfolk as symbols of escape from a violently changing world, *Liu Lan* conveys an intimate, aching yearning for a vanished past. This longing takes concrete form in a fleeting, hopeless encounter between a woman who is rooted in the natural world and a man whose home is the city.

CHINA'S NEW URBAN SPACES

Since the early 1990s, a number of forces have combined to irrevocably alter China's metropolitan culture. The first is urbanization—the accelerated growth of cities that typically marks the change from an agricultural to an industrial society. But if the pattern is familiar, the scale is unprecedented, with China's urban population now swelling by twenty million people each year. One result has been a persistent, unquenchable demand for new residential housing. This need has been met in large part by the unleashed energies of private real-estate speculation, leading to the razing of older residential districts and the construction of innumerable high-rise apartment blocks in all of the nation's major cities. Another momentous development has been the advent of a car culture, with bicycles increasingly giving way to private automobiles for everyday transportation. As personal ownership of autos has soared, massive traffic jams have become an inescapable fact of life, spurring calls to carve out new expressways through densely populated areas.

Artists such as Zhang Dali have responded to the scope and pace of this urban metamorphosis with horrified fascination. After the Tiananmen Square events of 1989, the artist, who had trained as a painter at Beijing's Central Academy of Fine Arts, emigrated to Italy, where he remained for six years. It was there that he saw graffiti art for the first time and began to employ in his own work the motif of a crudely outlined head seen in profile—a kind of self-portrait. Returning to Beijing in 1995, Zhang was struck by the accelerating pace of demolition in the central city. As a consequence he started, at first anonymously, to spray-paint his trademark image on walls around town, suggesting a mute witness to the ongoing cycle of destruction and construction. Eventually he carried out more than two thousand of these graffiti profiles. At length, too, he began to enlist the help of local workers to chisel this design into buildings slated for imminent demolition. To document his ongoing activity he compiled a steadily growing number of color and black-and-white photographs.

To my mind, the most haunting of these images are those in which the teetering ruins of three-hundred-year-old structures frame the impersonal glass-and-steel towers that have become the ubiquitous sign of Beijing's new urban spaces (CATS. 75, 76). Yet the artist has stated that nostalgia for the past is not primarily what drives his work. "The word 'nostalgia' isn't appropriate. We're talking about ways of life. If the physical environment changes, the resultant change in the style of life affects your thinking. My work has intersected this process, but what is going to be the result? I don't know."[28]

A cooler, more analytic response to China's rapid pace of urbanization can be found in the works of Luo Yongjin. This artist has devised a remarkable photographic procedure to depict, within a single overall image, the many stages that mark the construction of high-rise blocks. Having identified a major building site in Beijing or Shanghai, he determines a camera position and then diagrams the scene in front of him as a grid that sometimes includes more than one hundred individual frames. He returns regularly during the course of construction, and repeatedly photographs the entire site frame-by-frame. The resulting photo works capture the drama of the vertical sprawl now found in all Chinese cities. *Lotus Block* (1998–2002, CAT. 55), for example, consists of sixty black-and-white photographs that condense a range of different moments—laying the foundations, erecting the steel girders of the framework, applying the exterior cladding—into one monumental image.

The extraordinary plasticity of the new Chinese city is also at the heart of Song Dong's video *Crumpling Shanghai* (2000, CAT. 59). This work records a number of street scenes shot in contemporary Shanghai, which are all projected onto a sheet of paper that the artist holds in his hands. We see throngs of pedestrians, towering skyscrapers, a natty policeman directing traffic, expressways packed with autos,

cruise ships gliding on the Pudong River, and the blazing neon signs of the nighttime skyline. Each image appears just long enough to establish its own specific texture of reality. Then Song abruptly crumples the paper, and the image melts into the darkness. The incredible dynamism of cities such as Shanghai, the artist seems to say, can also lend the lives lived there an alarmingly fragile and fleeting quality.

Song Dong underscores the visual malleability of the city in a similar way in *My Motherland Set Me Up a Stage* (1999, CAT. 60). During the celebrations marking the fiftieth anniversary of the People's Republic, when Beijing was crowded with tourists from all over the country, the artist took his video camera and a mirrored clapboard to a number of locations. In each short segment, we see his hands holding the clapboard (which bears the tongue-in-cheek inscription "Song Dong Art Travel Agency Films, Ltd.") in the center of the frame. At the beginning of each shot, he crisply orders "Start!" and at the end "Cut!" Thanks to the mirrored reflection, we see not only what is in front of the camera but also what is behind it, at least until the clapboard is pulled away.

During the course of the video, we move along a whimsical and almost anarchic path through anonymous urban settings. Approaching Tiananmen Square, the crowds grow ever thicker. We see people on bicycles, broad boulevards jammed with red taxis, and occasionally floats being readied for a parade. As night falls, the city's looming office towers blaze triumphantly with light. Standing in the zone that lies between Tiananmen Square and the Forbidden City, Song is surrounded by tourists clutching their own photo and video cameras, blithely unaware of his presence.

Like the European "city films" made by avant-garde directors such as Walter Ruttmann and Dziga Vertov in the 1920s, Song's video revels in the visual dazzle of the modern metropolis. Unlike those earlier works, though, which portray the city

as an ultimately benign, machine-age utopia, *My Motherland Set Me Up a Stage* swings between moods of sharp-eyed skepticism and bemused melancholy as it encounters an all-encompassing urban spectacle created by the government authorities. As the video's title implies, this spectacle extends beyond the heavy-handed street decorations of the anniversary festivities to include the whole hallucinatory visage of modern Beijing.

The true calamity occurring in China's cities, Song has made clear in interviews, includes not only the annihilation of their historic urban textures. It also involves the loss of a fragile web of human relations:

Regarding the issue of demolishing the old city, I have had contradictory thoughts that have evolved over time. Now, for example, I am learning how to drive, and I see that large streets are much better for automobile traffic. But practical issues are not everything. . . . The type of relationships I used to entertain with other people living in the same hutong, *which was probably very similar to those of other people living in other ones, is slowly disappearing. Now everybody lives in compounds, in high-rise buildings. The relationships between family and family, between who is living here and who is living there, have changed. So have the relationships among individuals with the same family. Nothing is so multifaceted anymore. Everything is much narrower and more clearly spelled out. Perhaps I am infatuated with a slowly vanishing type of relationship between people.*[29]

TOWARD A SOCIETY OF INDIVIDUALS

The rending of this delicate social fabric opens up prospects that can be either exhilarating or anxiety-laden. The steady erosion of the prestige of such formerly all-embracing institutions as the family and the Communist Party; the promotion of the private entrepreneurial values demanded

by a market-driven economy; the precipitous arrival of a global consumer culture that recognizes only individual satisfactions—all of these factors have created in China an unprecedented space in which to test the possibilities of personal autonomy.

Zhang Huan is one artist engaged in that test. Trained as a painter at the Central Academy of Fine Arts in Beijing, he has won recognition with performance works in which he subjects his body to extreme situations. One of his earliest and most compelling performances, *Twelve Square Meters* (1994), took place in a squalid public toilet in Beijing's impoverished East Village. (See Rong Rong's photographs of this performance, CAT. 118, 119.) Coating himself with honey and fish oil, Zhang Huan sat in the foul-smelling room for an hour as flies slowly congregated, covering his naked body. The aim, he reported, was to create a vivid demonstration of his "essential existence" being reduced to the level of waste—a grim metaphor for the status of the experimental artist in Chinese society.

Zhang has said that "the body is the only direct way through which I come to know society and society comes to know me. The body is the proof of identity. The body is language."[30] *Family Tree* (2000, CAT. 101) springs from the artist's intuition that society's claims are somehow directly inscribed upon each individual's body. In a remarkable sequence of nine color photographs, Zhang's face is slowly covered with black-ink calligraphy. Some characters refer to family relationships such as those of uncle and aunt; others refer to the titles of famous Chinese stories; yet others stand for the primal elements of earth, fire, and water. As the artist's visage slowly disappears beneath the ink, we come to feel how this elaborate web of familial, social, and cultural relations can obliterate any sense of individual identity. Yet the artist's stubborn, unyielding expression signals his refusal to passively accept any preordained destiny. Among the many inscriptions on

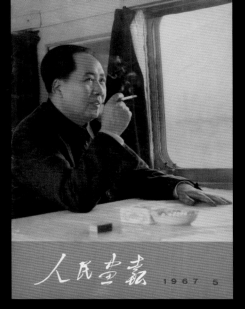

7

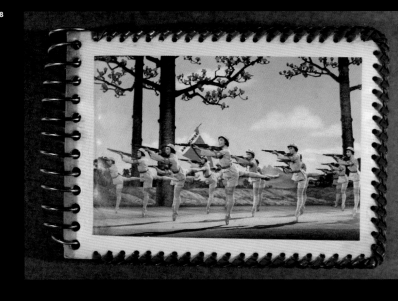

8

Figure 7
China Pictorial, cover,
no. 5, 1967, collection
International Center of
Photography.

Figure 8
Anonymous photo album,
1965–75, collection
International Center of
Photography. The cover
photograph is a scene
from one of the revolu-
tionary operas created
during the Cultural
Revolution.

Figure 9
Anonymous photo album,
c. 1965–75, collection
International Center of
Photography.

9

his face, in fact, is the title of a celebrated Chinese tale called "The Foolish Old Man Who Moved the Mountain," which he prizes for its lesson that one person's determination can overcome seemingly insurmountable forces.

The relentless battle between the individual and the collective is also expressed in the work of prominent installation artist Lin Tianmiao. Trained as a textile designer, she often employs both fabrics and knitting and sewing techniques. Lin's installations frequently consist of accumulations of old-fashioned, quotidian objects that she has meticulously wrapped in white twine or cotton thread. The wrapping process, which preserves the objects but also changes them into useless, ghostlike forms, is meant to evoke the ever-present tension between tradition and modernization in today's China.

While traditional women's craft techniques play an important role in Lin's works, her latest installations also call upon technological media such as video and photography. For example, she has executed a series of hauntingly pale photographic images of herself on canvas, hanging them like semitransparent screens in exhibition spaces. In *Braiding* (1998, CAT. 89), an out-of-focus, black-and-white picture of the artist's impassive face is printed on an oversized piece of fabric that hangs in midair. The gray tones of the image are further softened by the many small stitches that extend across the work's surface; from each one, a thread trails down behind the suspended fabric. These threads are woven together to form an enormous, braidlike form that spills out behind the work, creating a strange contrast with the bare, shaved head of the artist seen on the front. For Lin, these threads are metaphors for the countless habits and customs that make up our lives, and which can sometimes be experienced as bindings. To break free of them and assert one's own individuality, the work implies, requires the greatest possible strength.

For Li Tianyuan, however, it is not the struggle against the force of tradition that is the paramount challenge, but rather the effort to locate oneself in a world that has been dramatically redefined by science and technology. This artist, who works principally as a painter, created the photo series *Tianyuan Space Station* after a group of artists from Beijing's Qinghua Art Academy met with a group of scientists in 2000 to develop collaborative projects. The results were presented as part of the exhibition *Art and Science* at Qinghua University's Fine Art Museum the following year.

Li Tianyuan's contribution (CAT. 49) consisted of three large photographic self-portraits, all triptychs. He made the works with the technical support of the Institute of Remote Sensing and the Institute of Chemistry (both part of the Chinese Academy of Sciences), which gave him access to satellite imagery and electronic microscopy. The left-hand panel of each work consists of a photo taken by a Chinese satellite at roughly the moment when the artist stood in the area over which it was passing. The central panels, made with a standard camera, are conventionally realistic photographs of the artist taken at street level. The right-hand panels show a tiny portion of Li Tianyuan's body—in this case, his fingernails—as revealed by the magnification of an electron microscope. Together these images suggest that today, an individual can truly come into focus only through an overlay of macrocosmic, realistic, and microcosmic points of view.

The awareness of being an individual is, however, intimately connected to the consciousness of one's own inevitable extinction.[31] The Shanghai-based artist Yang Zhenzhong's ongoing video project *I Will Die* (CAT. 99) places this reality at center stage. In a sequence of short portraits shot in China, Belgium, Germany, Mexico, and the United States, we meet an apparently random selection of people from all walks of life and ranging from the very young to the very old. Most are presented in their own homes or in casual, everyday settings. Each sitter gazes silently at the camera for a period of time and then, speaking in his or her own language, utters the phrase "I will die."

What is immediately evident is the awkwardness that overcomes almost all of the subjects when they search for a natural way to say these words. Most of the younger men and women betray their discomfort with nervous laughter; others act out attitudes of exaggerated macho bluster, whining self-pity, or suddenly startled self-awareness. The consistently false pitch of these performances, while at first irritating, slowly becomes a source of fascination in its own right. For most of Yang's subjects, this appears to be the first time they have been called upon to publicly acknowledge their individual mortality. Simply contemplating the phrase "I will die" seems to trigger a spasm of inner panic that they seek desperately to disguise.

In the end, the recent surge of media-based work in China might best be imagined as the product of three distinct types of artistic encounter. The first, and perhaps least significant, consists of Chinese artists' ever-growing exposure to the techniques, traditions, and institutions of global art, both modern and contemporary. This exposure has lent special urgency to their renewed encounter with their own, incomparably rich cultural heritage, which they are now reevaluating as a resource for their own work. Most important of all, it appears to me, has been the depth of artistic response to the immensity of the changes that are sweeping the land. The embrace of photography and video by Chinese artists doubtless owes much to the speed and flexibility with which such media enable them to trace this enormous transformation.

Because of the near-universal use of

photography and video in contemporary art, most of the works in this exhibition speak in a visual idiom that allows them to slip effortlessly into galleries or museums around the world. At the same time, they manage to encompass a world of subtle references that speak only to those conversant with China's cultural traditions, its historical path, and its current, explosive expansion. For me, it is precisely this duality that lends such art its power and poignancy. Regarding these works, you find yourself hurtling toward China's future, with one eye turned to its rapidly receding past.

1 See Gao Minglu, ed., *Inside Out: New Art from China* (San Francisco and New York: San Francisco Museum of Modern Art and Asia Society Galleries, 1998). Of the roughly fifty-four artists who took part in *Inside Out,* only twelve figure among the approximately sixty artists represented in the current exhibition.

2 Francesca dal Lago, "Zhang Peili: Neither Panda Bears nor Students' Homework," in John Clark, ed., *Chinese Art at the End of the Millennium* (Hong Kong: New Art Media, 2000), 243.

3 On contemporary China as a nation of "multiple temporalities superimposed on one another," see Sheldon H. Lu, *China, Transnational Visuality, Global Postmodernity* (Stanford, Calif.: Stanford University Press, 2001), 13.

4 See Wang Qingsong's artist statement of 2002, archived on his web site, http://www.wangqingsong.com/words.html.

5 For general accounts, see Clark Worswick and Jonathan D. Spence, *Imperial China: Photographs 1850–1912* (New York: Pennwick Publishing, 1978); Nigel Cameron, *The Face of China As Seen by Photographers and Travelers, 1860–1912* (Millerton, N.Y.: Aperture, 1978); and Roberta Wue, *Picturing Hong Kong: Photography 1855–1910* (New York: Asia Society Galleries, 1997). Perhaps the most scrupulous archival research to date can be found in Régine Thiriez, *Barbarian Lens: Western Photographers of the Qianlong Emperor's European Palaces* (New York: Gordon and Breach, 1998). Important from an iconographic standpoint are the catalogues published in the 1990s by the Los Angeles dealer Dennis George Crow. The most detailed Chinese-language history of photography's development in that country is Ma Yunzeng et al., *Zhongguo she ying shi, 1840–1937* (The history of photography in China, 1840–1937) (Beijing: Zhongguo sheying chubanshe, 1987). I am grateful to I-Fen Huang for guiding me through the book's contents.

6 Cited in Larry Schaaf, "Henry Collen and the Treaty of Nanking," *History of Photography 6,* no. 4 (October 1982), 353–54. On Collen and the photographing of the treaty, see Derek Wood, "Photocopying the Treaty of Nanking in January 1843," http://www.mid-leykent.fsnet.co.uk/Nanking/Nanking/html. One copy of the calotype facsimile of the treaty resides in the collection of the George Eastman House, Rochester, N.Y. Schaaf reports that the British exploit attracted the attention of the London correspondent for the German *Allgemeine Zeitung,* who informed his readers that "the black ink bottle has become the light of the earth, one that penetrates every corner of every hut. Inert China, which has not seen any change for centuries . . . is now to be opened up to that European light. What an enlightenment that is going to bring!"

7 Ma Yunzeng et al. (note 5), 16.

8 Quoted in *Le Daguerréotype français: Un Objet photographique* (Paris: Réunion des Musées Nationaux, 2003), 352. Translated by the author. On this incident, see also Jules Itier, *Journal d'un voyage en Chine en 1843, 1844, 1845, 1848* (Paris: Dauvin et Fontaine, 1848), 1:325. It was Itier who appears to have issued the first account of a Chinese commercial painter's encounter with the new image-making medium. In November 1844, he noted in his journal a visit by a celebrated Guangzhou portrait painter known as Lam Qua (Guan Chaoqiong, 1801–c. 1860), of whom Itier made a daguerreotype portrait. See ibid., 2:74. The making of small oil paintings based on photographic portraits quickly became a stock-in-trade of the Chinese artisans in the commercial ports.

9 Cited in Congmin Ge, "Photography, Shadow Play, Beijing Opera, and the First Chinese Film," *Eras: School of Historical Studies On-line Journal* 3 (June 2002), http://www.arts.monash.edu.au/eras/edition_3/ge.htm. In 1844 Qi Ying appears to have given photographic portraits of himself to representatives of Italy, Britain, Portugal, and the U.S.

10 See Craig Clunas, ed., *Chinese Export Art and Design* (London: Victoria and Albert Museum, 1987), 116–18.

11 John Thomson, *Through China with a Camera* (London: A. Constable, 1898), 93.

12 Kinoshita Naoyuki, "The Early Years of Japanese Photography," in Anne Wilkes Tucker et al., *The History of Japanese Photography* (New Haven: Yale University Press, 2003), 24.

13 This publication resulted from the efforts of a British medical missionary in Beijing, Dr. John Hepburn Dudgeon, and apparently featured a preface by Prince Kung. It is mentioned in D. K. Griffith, "A Rolling Stone's Visit to Pekin," *Photographic News* 19, no. 895 (October 29, 1875), 525.

14 See Congmin Ge (note 9). Ren Qingtai (also sometimes called Ren Jingfeng and Ren Fengtai) and his studio have attracted the interest of film historians, who identify him as the producer of the first Chinese-made motion picture in 1905.

15 Lin Jing, *The Photographs of Cixi in the Collection of the Palace Museum* (Beijing: Forbidden City Publishing House, 2002), 27.

16 See Xu Xiaoyu, "Die Entwicklung der Fotografie in China," in *Zeitgenössische Fotokunst aus der Volksrepublik China* (Heidelberg: Braus, 1997), 26–31.

17 See Wu Yinxian, *Selected Photographs by Wu Yinxian, 1923–1948* (Harbin: Heilongjian People's Publishing House, 1980).

18 A visual overview of the photographer's work is provided in Sha Fei (Beijing: People's and Workers' Publishing House, 2002). For a biographical account of his life, see Cai Zi'e, *Sha Fei zhuan: Zhongguo ge ming xin wen ying di yi ren* (Sha Fei: A revolutionary Chinese photographer) (Beijing: Zhongguo wenlian chubanshe, 2002).

19 See Xu Xiaobing and Hou Bo, Lu: Xu Xiaobing Hou Bo *sheying zuopin* ji (The Road: Photo Work by Xu Xiaobing and Hou Bo) (Hangzhou: Zhejiang renmin meishu chubanshe, 1988); and Claude Hudelot and Margo Renisio, "Hou Bo, Xu Xiaobing, photographes de Mao," in Arles: Rencontres de la photographie 2003 (Arles: Actes Sud, 2003), 260–64.

20 For a firsthand account of this period, see Li Zhensheng, *Red-Color News Soldier* (New York: Phaidon, 2003).

21 A very partial list of the ways that photography was utilized by Western artists since the 1960s might include: 1) photography as a distinct pictorial model introduced within the framework of painting, as with Robert Rauschenberg, Andy Warhol, or Gerhard Richter; 2) photography as a vehicle for deconstructing the system of perspectival rendering inherited from the Renaissance, as in works by Michael Snow or Jan Dibbets; 3) photography as a document of public or private performance works, as with Chris Burden, Marina Abramovic or Arnulf Rainer; 4) photography as a visual record of temporary sculptures, as with Bruce Nauman, or physically remote site works, as with Robert Smithson; 5) photography as a tool enabling comparative analyses of architectural or social structures, as with Bernd and Hilla Becher or Dan Graham; 6) photography as a component of works involving projected imagery, as with James Coleman or Fischli/Weiss; 7) photography as a medium of elaborately fictionalized tableaux compositions, as with Jeff Wall or Cindy Sherman; 8) photography as a historical trace permitting an archeology of personal or social memory, as with Christian Boltanski or Carrie Mae Weems; 9) photography as a component of works that explore the ways that meaning is generated by image/text combinations, as with Barbara Kruger or Victor Burgin; 10) photography as a means of casual, snapshot realism, as with Nan Goldin and her countless followers. On this subject, see Christopher Phillips, "The Phantom Image: Photography within Postwar European and American Art," in *L'immagine riflessa* (Prato: Centro per l'arte contemporanea Luigi Pecci, 1995), 142–52.

22 A detailed consideration of the many permutations taken by Chinese photo art during the 1990s is provided by Karen Smith, "Zero to Infinity: The Nascence of Photography in Contemporary Chinese Art of the 1990s," in Wu Hung, ed., *Reinterpretation: A Decade of Experimental Chinese Art, 1990–2000* (Guangzhou and Chicago: Guangdong Museum of Art and Art Media Resources, 2002), 35–50. For a discussion of photography in relation to the wider field of Chinese contemporary art, see Wu Hung, *Transience: Chinese Experimental Art at the End of the Twentieth Century* (Chicago: Smart Museum of Art, University of Chicago, 1999).

23 Inke Arns, "Die Geschwindigkeit der Bilder in China ist der unseren sehr ähnlich-ein Gespräch über Video und neue Medium in der VR China," interview with Qiu Zhijie, 1998, http://www.v2.nl/~arns/Texts/Media/china-dt.html. Translated by the author. A shortened version of this interview appears in Inke Arns, "Ping Pong-Videokunst in der VR China. Interview mit Qiu Zhije (Guanzhou)," in *Electro: Die Medienbeilage im Freitag* no. 7 (May 8, 1998), n. pag. On the development of video in China, see Binghui Huangfu, ed., *Compound Eyes: Contemporary Video Arts from China* (Singapore, Earl Lu Gallery and LaSalle-SIA College of the Arts, 2001).

24 Another result of the extremely limited availability of video equipment to Chinese artists was to discourage any convergence with the independent Chinese documentary video movement that arose in the wake of the Tiananmen Square events of June 1989. Often enjoying the surreptitious support of friends who worked for official television production facilities, the members of this group had access to relatively sophisticated film and video equipment. See Ernest Larsen, "Video Verité from Beijing," *Art in America* 86, no. 9 (September 1998), 53–57, for a report on MOMA's video documentary series "New China/New Visions."

25 For an extended analysis of this classic work, see Wu Hung, "The Night Entertainment of Han Xizai," Chapter Two of *The Double Screen: Medium and Representation in Chinese Painting* (Chicago: University of Chicago Press, 1996).

26 Mai Chi, "Night Revels of the Intellectuals," interview with Wang Qingsong, *Talawas* (Oct. 24, 2003), http://www.talawas.org/gocnhin/gnh26e.html.

27 Chen Xiaoyun, "An Interview with Yang Fudong," Chinese-art.com 4, no. 3 (2001).

28 Francesca dal Lago, "Space and Public: Site Specificity in Beijing," *Art Journal* 59, no. 1 (Spring 2000), 84. For a discussion of specific photographs by Zhang Dali, see Wu Hung, "Zhang Dali's Dialogue: Conversation with the City," *Public Culture* 12, no. 3 (Fall 2000), 749–68.

29 Francesca dal Lago (note 28), 86.

30 Qian Zhijian, "Performing Bodies: Zhang Huan, Ma Liuming, and Performance Art in China," *Art Journal* 58, no. 2 (Summer 1999), 63.

31 Indeed, one of the consequences of the decline of communal identity is the transformation of dying from a shared group ritual to an individual affair. See Philippe Ariès, *The Hour of Our Death,* trans. by Helen Weaver (New York: Knopf, 1981), for a classic account of the shift in European attitudes toward dying from the feudal era to the present.

HISTORY
and
MEMORY

CANG XIN

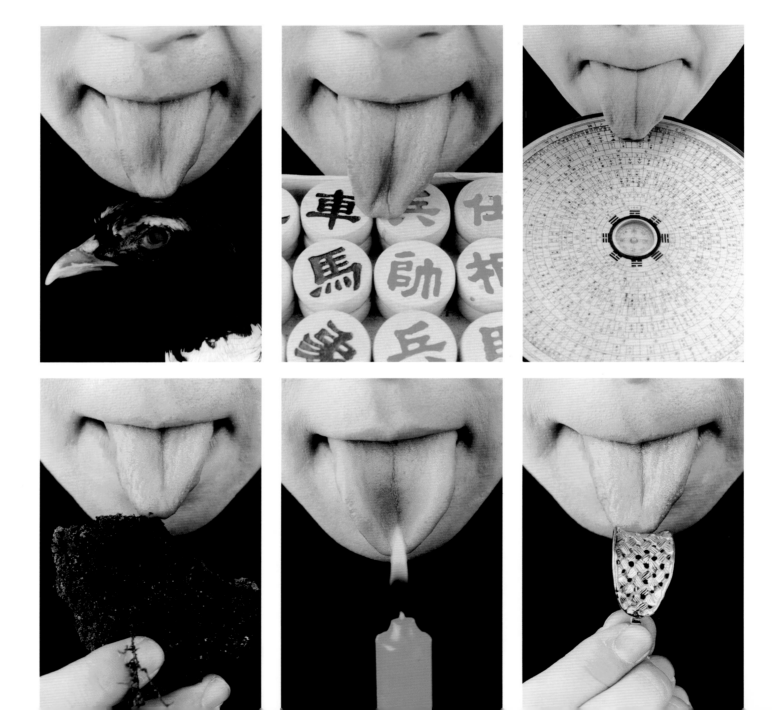

*Communication
(Series No. 2)*,1999,
Twelve chromogenic
prints, 19 ⁵/₈ x 15 ³/₄
inches (50 x 40 cm),
Courtesy of the artist and
CourtYard Gallery, Beijing

(CAT. 1)

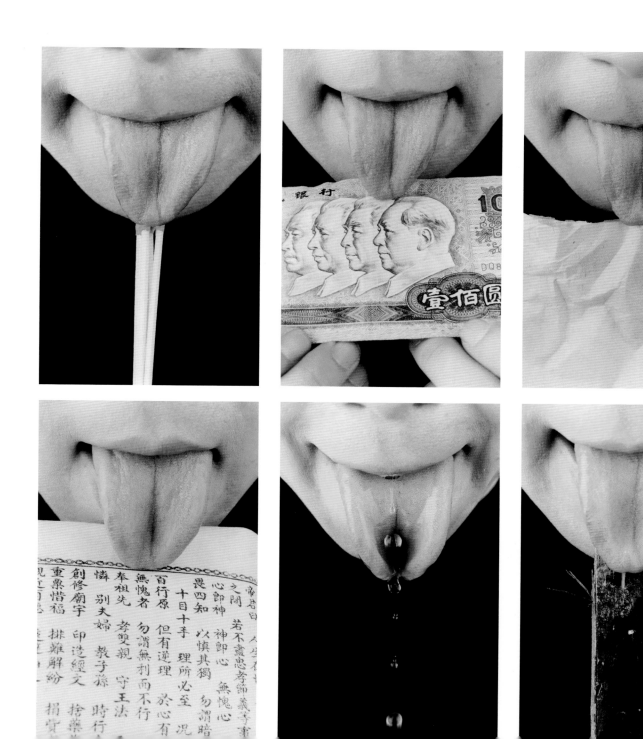

FENG MENGBO

我的藝術涉及的是普通人的一般生活。令我着迷的是，人類歷盡艱辛為生存和榮譽而斗爭；這既滿懷希望又充滿幽默。我總是喜愛表現樂觀精神的作品。

我的CD-ROM與其說是一件藝術作品，還不如說是一邱家庭歷史。它是一部聲像文獻。每個家庭都能制作其"私人照相簿"。我的只是最普通家庭的一個例子。

我的CD-ROM是互動的；它不是為畫廊墻面所作的。它的尺寸是人人都能接近的。通過它，我邀請觀眾體驗我想象連續的創作過程。也許，將來我們的記憶都會以這種方式互相對話，逐漸形成一個既混亂又有包容性的關塊。

My art is concerned with the commonplace lives of ordinary people. I'm fascinated by the fact that despite all of its travails humankind battles on for survival, struggles to maintain its basic dignity, ever hopeful, and often humorous. I've always been partial to works that express a spirit of optimism.

My CD-ROM is more of a family history than a work of art. It is an audio-visual document. Every family can produce its own "Private Album". Mine is just an example of the most ordinary kind of family.

My CD-Rom is interactive; it's not a work made for the imposing walls of an art gallery. It's in an accessible format that anyone can use. Through it I extend an invitation to you to experience it in the whimsical manner in which I have produced it. Perhaps in the future all of our memories will speak to each other in this way, gradually forming an opaque mass, at once both chaotic and inclusive.

FENG MENGBO 馮夢波

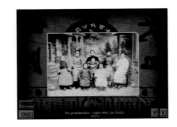

My Private Album, 1996, Mixed media installation including interactive CD-Rom, computer, and flat panel monitor, Dimensions variable, Courtesy of the artist

(CAT. 2)

GAO BROTHERS
(GAO QIANG AND GAO ZHEN)

HAI BO

They No. 7, 2000, Two gelatin silver prints, one vintage and one contemporary, 2 ⁵⁄₁₆ x 3 ⁵⁄₁₆ inches each (5.8 x 8 cm), Collection Smart Museum of Art, University of Chicago

(CAT. 8)

They No. 6, 1999, Two
gelatin silver prints,
2 ³/₈ x 3 ¹/₈ inches each
(6 x 8 cm), Courtesy of
the artist and CourtYard
Gallery, Beijing

(CAT. 7)

HONG LEI

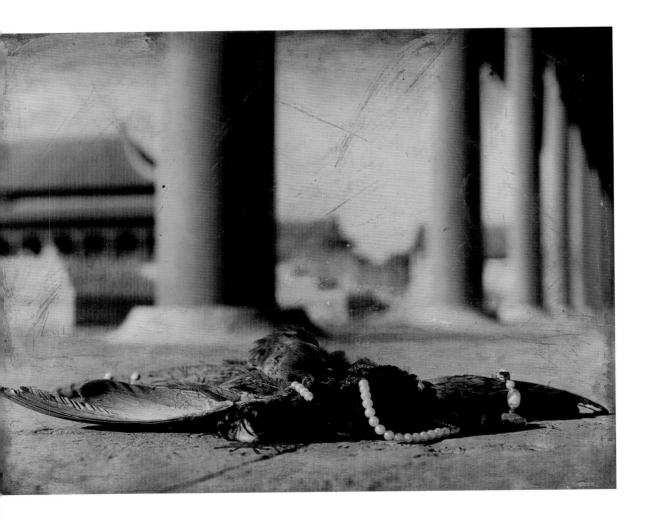

Autumn in the Forbidden City, East Veranda, 1997, Chromogenic print, 41 x 50 inches (104.1 x 127 cm), Collection JGS, Inc.

(CAT. 9)

*Autumn in the Forbidden
City, West Veranda,*
1997, Chromogenic
print, 41 x 50 inches
(104.1 x 127 cm),
Collection JGS, Inc.

(CAT. 10)

LIU WEI

 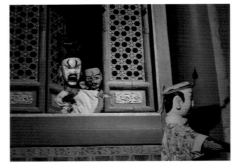 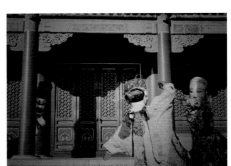

 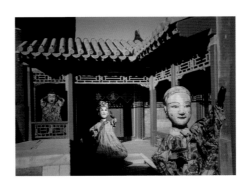

Forbidden City, 2000,
Ten chromogenic prints,
13 ¹/₄ x 17 ³/₄ inches
each (33.6 x 45 cm),
Courtesy of the artist

(CAT. 11)

LIU ZHENG

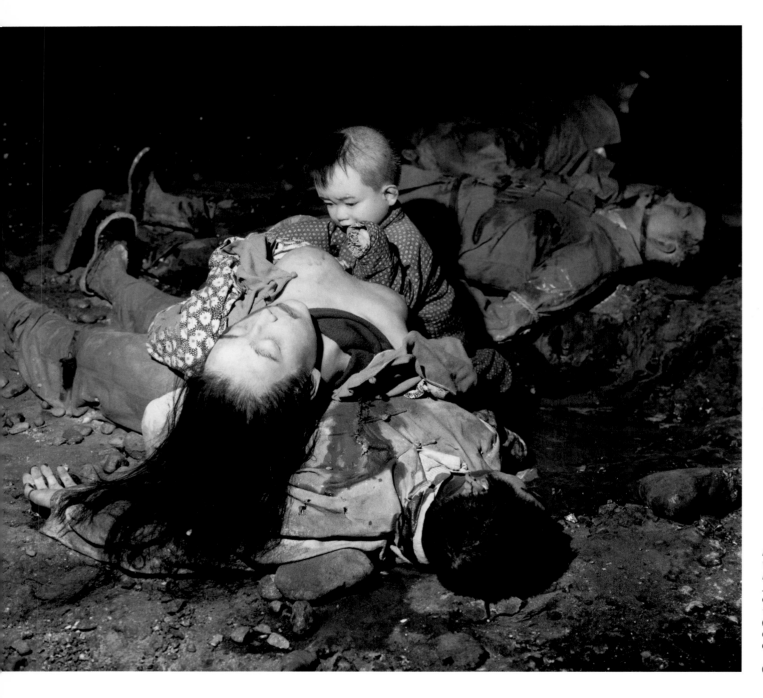

*Nanjing Massacre
Waxwork in the Memorial
Museum, Nanjing,
Jiangsu Province,* 2000,
Gelatin silver print,
14 1/2 x 14 1/2 inches
(36.8 x 36.8 cm),
Courtesy of the artist and
CourtYard Gallery, Beijing

(CAT. 15)

Symbols of Revolution,
1999, Gelatin silver print,
14 1/$_2$ x 14 1/$_2$ inches
(36.8 x 36.8 cm),
Courtesy of the artist and
CourtYard Gallery, Beijing

(CAT. 16)

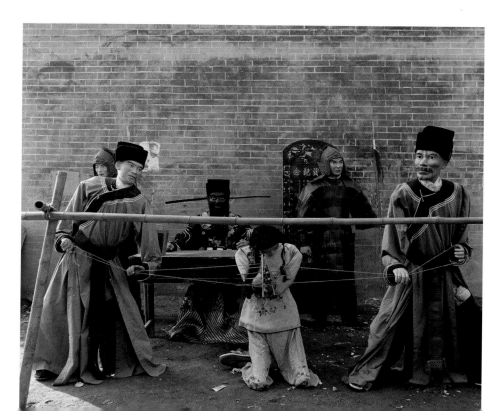

*Clay Sculpture: The
Punishment of the
Wife Who Misbehaved,
Houshentai, Henan
Province,* 2000, Gelatin
silver print, 14 1/$_2$ x 14 1/$_2$
inches (36.8 x 36.8 cm),
Courtesy of the artist and
CourtYard Gallery, Beijing

(CAT. 13)

MA LIUMING

*Fen-Ma Liuming Walks
on the Great Wall,* 1998,
Chromogenic print,
50 x 78 ³/₄ inches
(127 x 199.9 cm),
Collection JGS, Inc.

(CAT. 17)

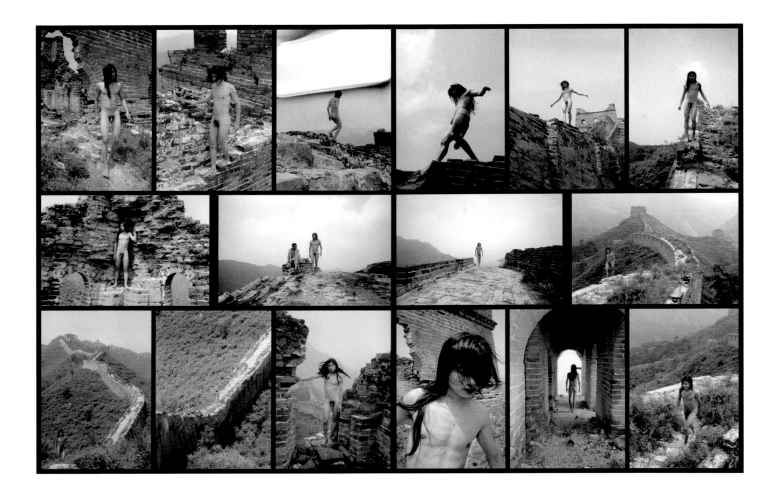

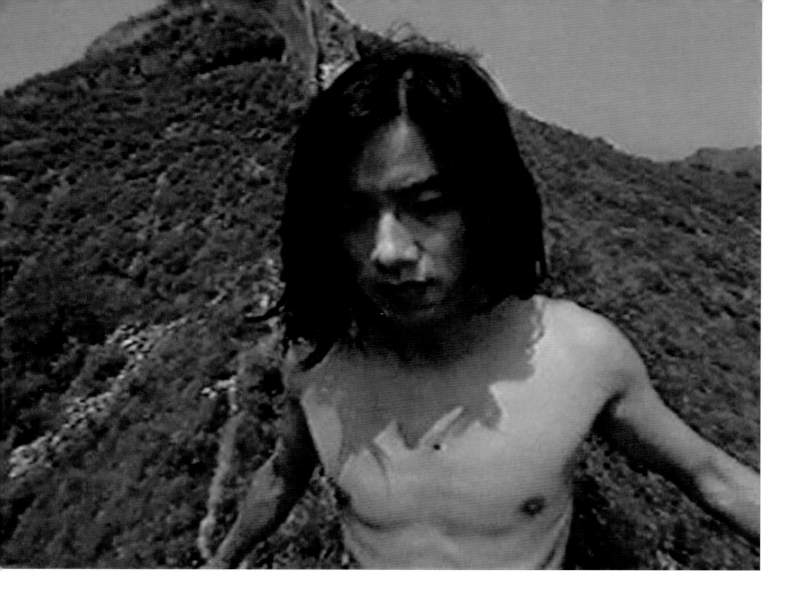

Fen-Ma Liuming Walks on the Great Wall, 1998, Video, color, sound, 24:00 minutes, Collection Artur Walther

(CAT. 18)

MIAO XIAOCHUN

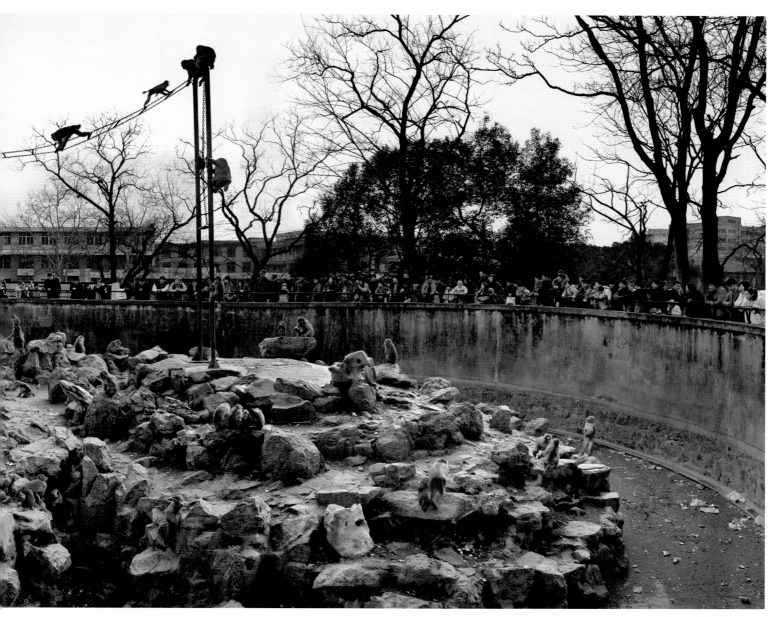

Opera, 2003, Five
chromogenic prints,
74 ¹/₈ x 189 inches overall
(189 x 480 cm),
Courtesy of the artist

(CAT. 19)

QIU ZHIJIE

*Prophesying Catalogue
of "Pushing Back"*, 2001,
Video, color, sound,
8:00 minutes, Courtesy
of the artist and
CourtYard Gallery, Beijing

(CAT. 20)

SHENG QI

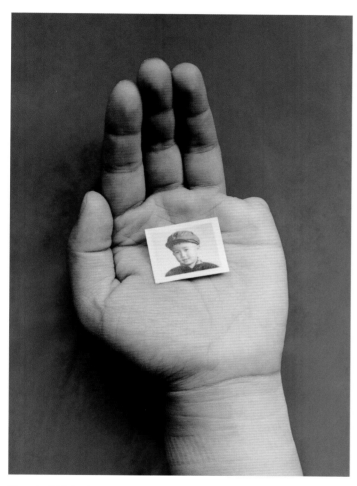

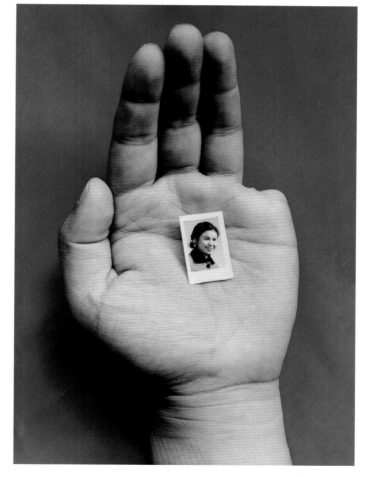

Memories (Me), 2000,
Chromogenic print,
47 ¹/₄ x 31 ¹/₂ inches
(120 x 80 cm), Collection
of the International Center
of Photography,
Purchased with funds
donated by Anne and Joel
Ehrenkranz, 2004

(CAT. 22)

Memories (Mother),
2000, Chromogenic print,
47 ¹/₄ x 31 ¹/₂ inches
(120 x 80 cm), Collection
of the International Center
of Photography,
Purchased with funds
donated by Anne and
Joel Ehrenkranz, 2004

(CAT. 23)

SONG DONG

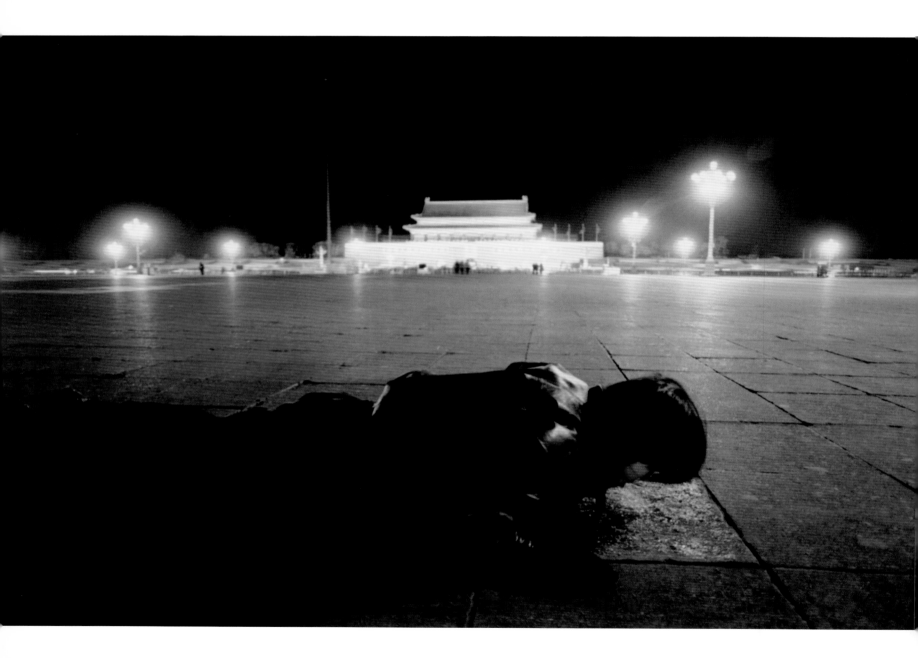

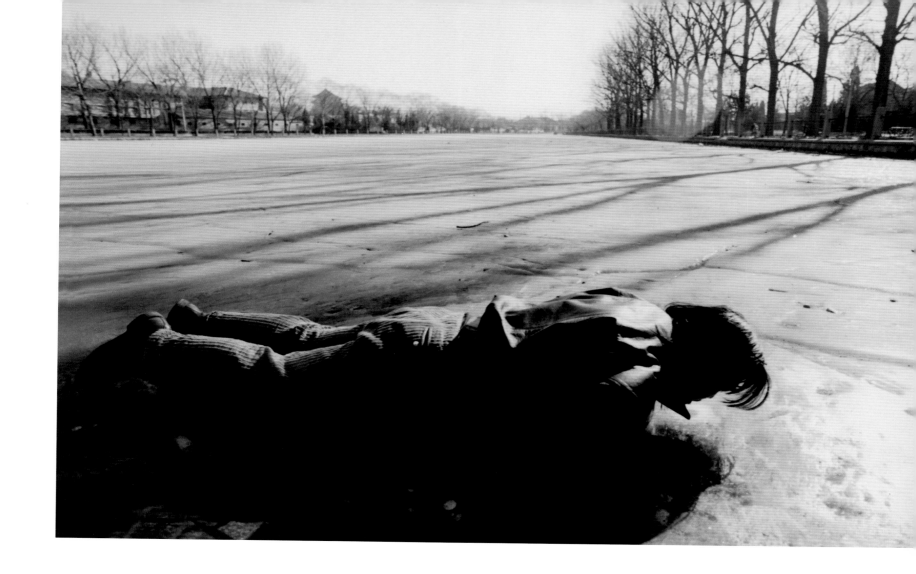

Breathing Part 1 and Part 2, 1996, Two light-box transparencies with audio CD, 62 x 96 inches each (121.9 x 243.8 cm), Collection Smart Museum of Art, University of Chicago; exhibition prints courtesy Chambers Fine Art, New York

(CAT. 24)

SUI JIANGUO, YU FAN, AND ZHAN WANG (THREE MAN UNITED STUDIO)

Woman/Here, 1995,
Installation, mixed media,
Dimensions variable,
Courtesy of the artists

(CAT. 25)

73

WANG GONGXIN

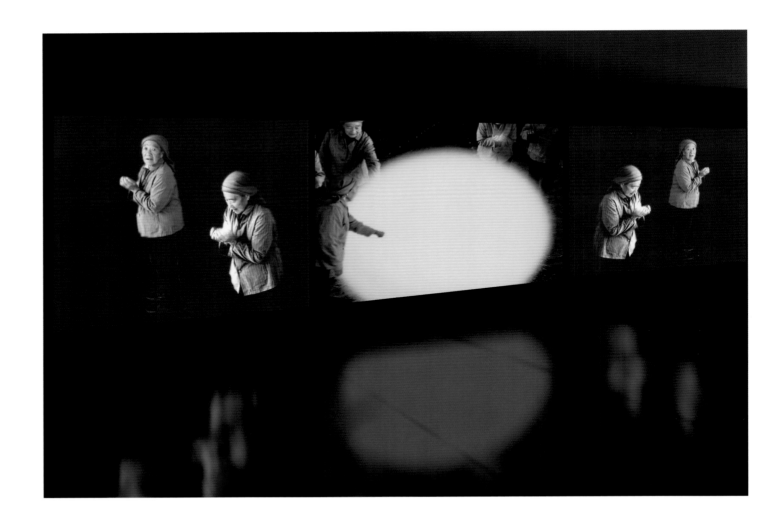

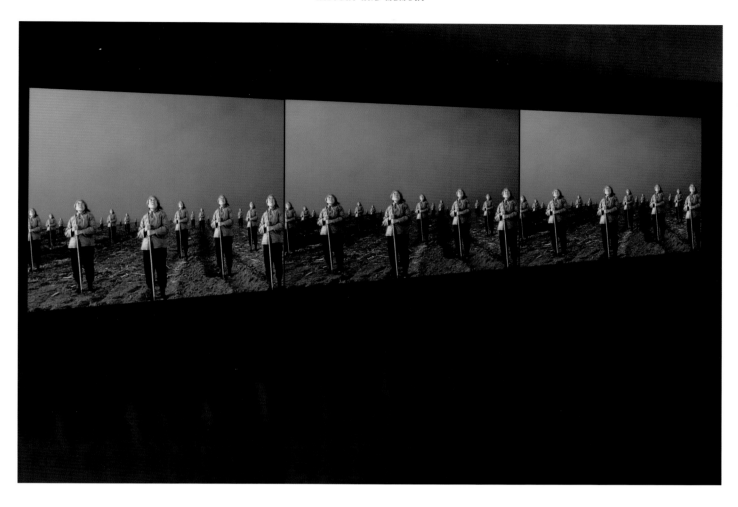

My Sun, 2001, Video,
7:00 minutes, Courtesy of
the artist

(CAT. 26)

WANG QINGSONG

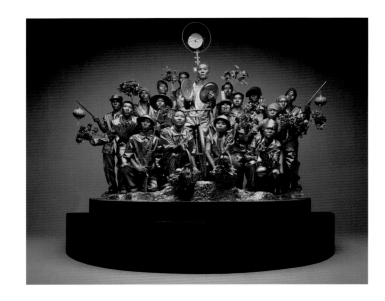

*Past, Present,
Future,* 2001, Three
chromogenic prints,
47 ¹/₄ x 215 ¹/₂ inches
overall (120 x 550 cm),
Collection JGS, Inc.

(CAT. 27)

WANG YOUSHEN

Washing: A 1941 Mass Grave in Datong, 1995, Mixed media installation including two bathtubs and two electrical pumps, Dimensions variable, Collection Guangdong Museum of Art, Guangzhou

(CAT. 28)

WENG FEN

*Our Future Is Not a
Dream,* 2000, Video, color,
sound, 12:08 minutes,
Courtesy of the artist and
CourtYard Gallery, Beijing

(CAT. 29)

XING DANWEN

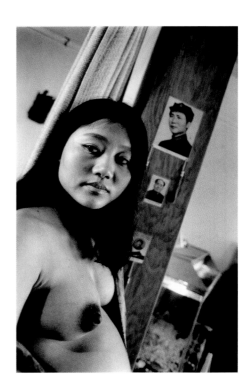

*Born with the Cultural
Revolution,* 1995,
Three chromogenic prints,
21 $^{1}/_{2}$ x 64 $^{1}/_{2}$ inches
overall (54.4 x 163.8 cm),
Courtesy of the artist

(CAT. 30)

YANG ZHENZHONG

922 Rice Corns, 2000,
Video, color, sound,
8:00 minutes, Courtesy of
ShanghART Gallery,
Shanghai

(CAT. 31)

ZHAO SHAORUO

In the Name of the Market, 1996, Chromogenic print, 59 ¹/₈ x 79 ⁵/₈ inches (150 x 200 cm), Courtesy of the artist

(CAT. 33)

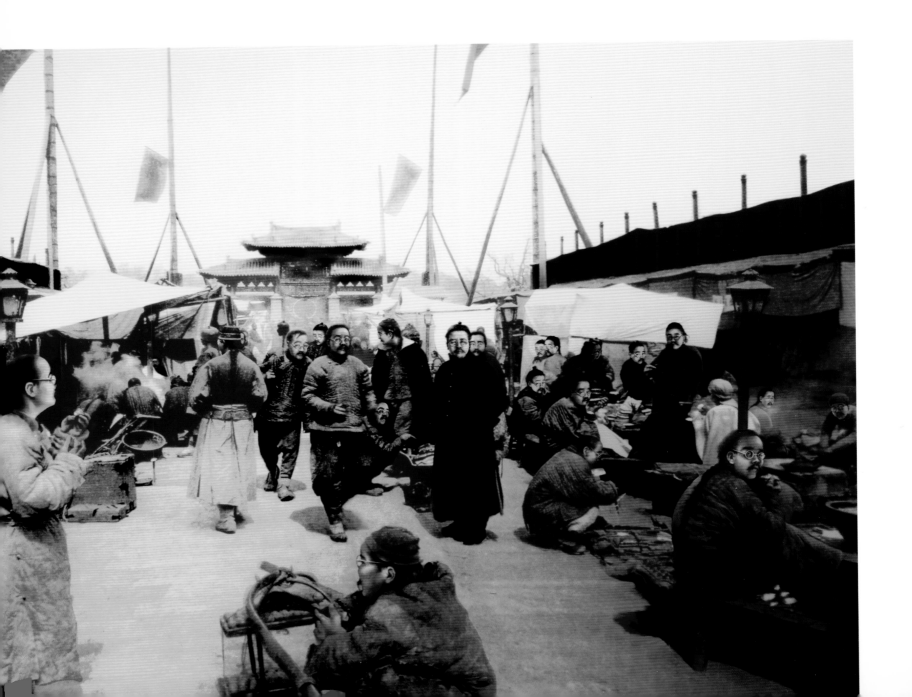

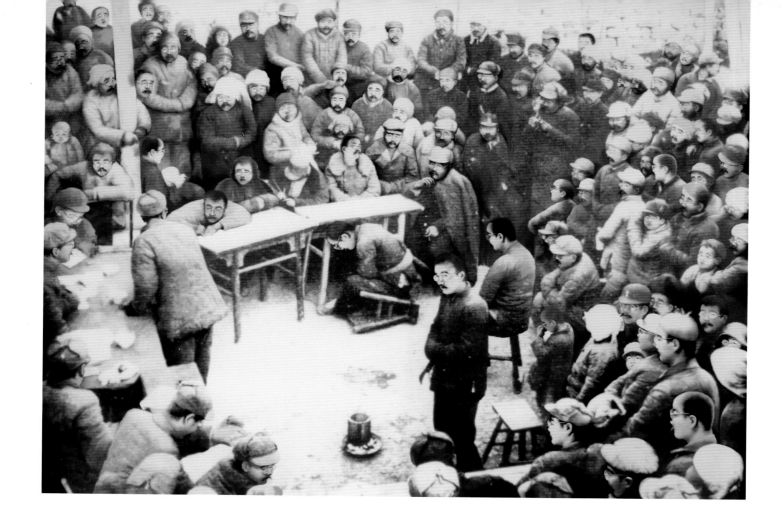

*In the Name of the
Dictatorship of the
Proletariat,* 1996,
Chromogenic print,
59 ¹/₈ x 79 ⁵/₈ inches
(150 x 200 cm),
Courtesy of the artist

(CAT. 32)

ZHOU XIAOHU

Utopian Machine, 2002,
Video, color, sound,
8:03 minutes, Courtesy
of the artist

(CAT. 34)

PEOPLE
and
PLACE

AI WEIWEI

Seven Frames, 1994,
Gelatin silver print,
18 x 73 ¹/₂ inches
(48.6 x 186.5 cm),
Courtesy of China Art
Archives & Warehouse,
Beijing

(CAT. 35)

The People, 2002,
1600 gelatin silver prints,
sewn together,
78 ³/₄ x 145 ³/₄ inches
(200 x 370 cm),
Collection JGS, Inc.

(CAT. 36)

BAI YILUO

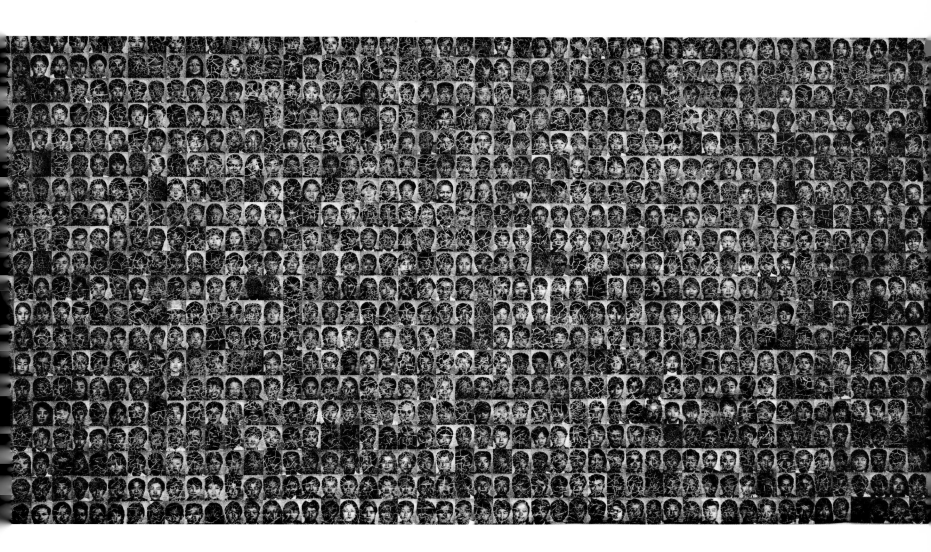

CHEN LINGYANG

25:00, No. 2, 2002,
Rear-illuminated trans-
parency, 22 x 68 inches
(56 x 173 cm),
Courtesy of China Art
Archives & Warehouse,
Beijing

(CAT. 37)

CHEN SHAOXIONG

Landscape II, 1996,
Video, color, sound,
8:00 minutes,
Courtesy of the artist and
Vitamin Creative Space,
Guangzhou

(CAT. 38)

Multilandscape, 2004,
Mixed media installation
including photographic
cutout and two videos,
Dimensions variable,
Courtesy of the artist and
Vitamin Creative Space,
Guangzhou (detail)

(CAT. 39)

CUI XIUWEN

Ladies Room, 2000,
Video, color, sound,
6:21 minutes, Courtesy
of the artist

(CAT. 40)

HONG HAO

Spring Festival on the River No. 2, 2000, Chromogenic print with collage, 15 x 472 ¹/₂ inches (38 x 1200 cm), Collection JGS, Inc.

(CAT. 41)

HU JIEMING

Outline Only, 2000, Video, color, sound, 9:25 minutes, Courtesy of the artist and ShanghART Gallery, Shanghai

(CAT. 43)

SZE TSUNG LEONG

Wangjing Xiyuan Third District, Chaoyang District, Beijing, 2002, Chromogenic print, 12 x 15 inches (38.1 x 30.5 cm), Courtesy of the artist

(CAT. 47)

*Jiangbeicheng, looking
towards Chongqing City,
Chongqing Municipality,*
2003, Chromogenic print,
32 x 40 inches
(101.6 x 81.3 cm),
Courtesy of the artist

(CAT. 44)

LI TIANYUAN

Tianyuan Space Station, 12 December 2000, 2000, Three chromogenic prints, 78 ¹/₂ x 13 ¹/₂ inches each (199.4 x 34.3 cm), Collection JGS, Inc.

(CAT. 49)

LIU ZHENG

Qigong Performers, Mt. Wutai, Shanxi Province, 1998, Gelatin silver print, 14 ¹/₂ x 14 ¹/₂ inches (36.8 x 36.8 cm), Courtesy of the artist and CourtYard Gallery, Beijing

(CAT. 51)

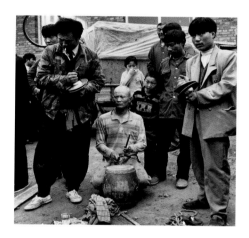

Three Women at a Country Funeral, Longxian, Shaanxi Province, 2000, Gelatin silver print, 14 ¹/₂ x 14 ¹/₂ inches (36.8 x 36.8 cm), Collection of the International Center of Photography, purchased with funds from the acquisitions Committee, 2002

(CAT. 53)

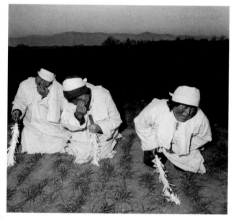

Three Elderly Entertainers, Beijing, 1995, Gelatin silver print, 14 ¹/₂ x 14 ¹/₂ inches (36.8 x 36.8 cm), Collection JGS, Inc.

(CAT. 52)

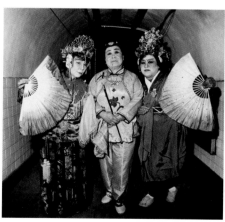

Two Rich Men on New Year's Eve, Beijing, 1999, Gelatin silver print, 14 ¹/₂ x 14 ¹/₂ inches (36.8 x 36.8 cm), Collection JGS, Inc.

(CAT. 54)

LUO YONGJIN

Lotus Block, 1998/2002,
60 gelatin silver prints,
12 1/4 x 8 5/8 inches each
(31 x 22 cm each),
Collection Artur Walther

(CAT. 55)

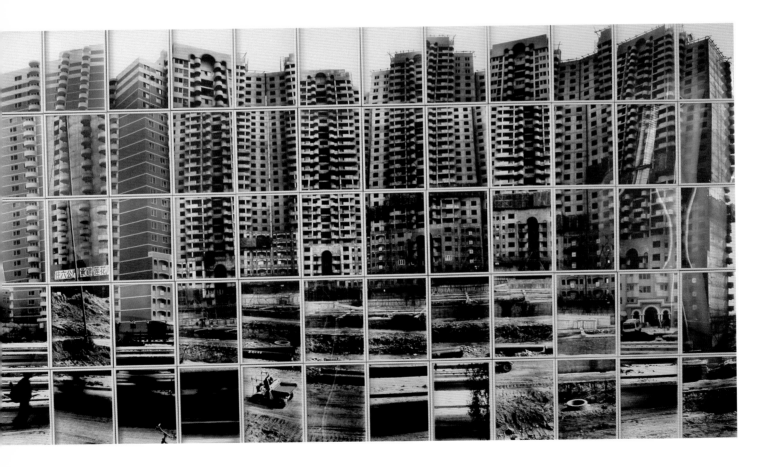

*Beijing (1997, No. 1
[Parts 1 and 2])*, 1997,
Two gelatin silver prints,
48 x 69 ¹/₂ inches each
(122 x 176.5 cm),
Courtesy of the artist

(CAT. 58)

RONG RONG

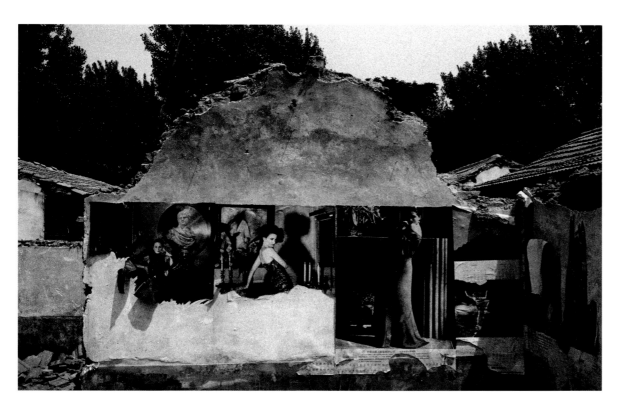

SONG DONG

Crumpling Shanghai,
2000, Video, color,
sound, 16:00 minutes,
Courtesy of the artist

(CAT. 59)

WANG JIANWEI

Spider, 2004, Video,
color, sound,
11:40 minutes,
Courtesy of the artist

(CAT. 61)

WANG JINSONG

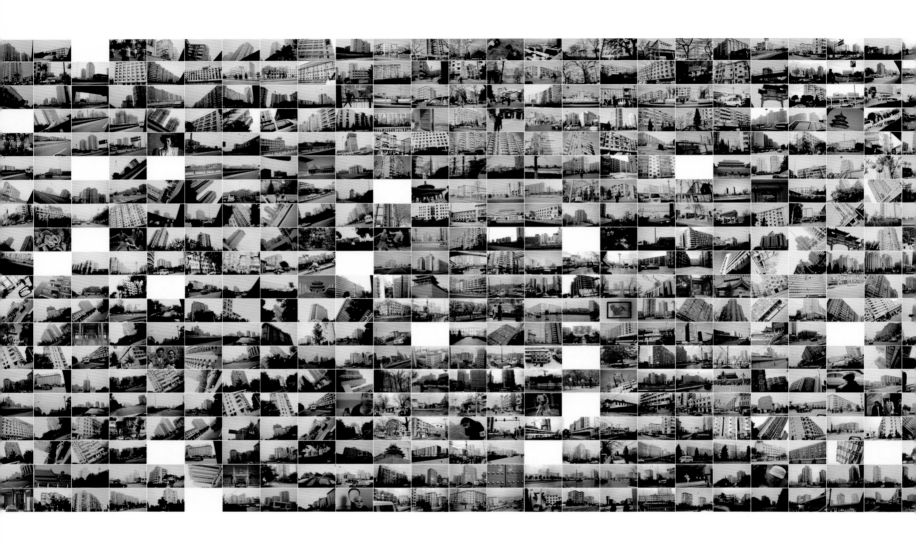

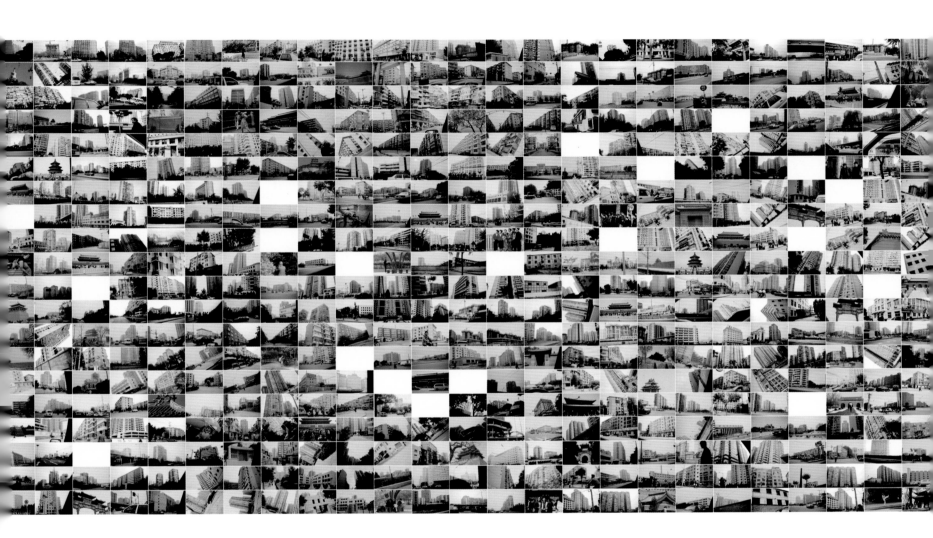

WANG Jinsong
City Wall, 2002, Five
chromogenic prints,
49 3/4 x 36 3/8 inches
each (127 x 91 cm),
Collection JGS, Inc.

(CAT. 62)

XING DANWEN

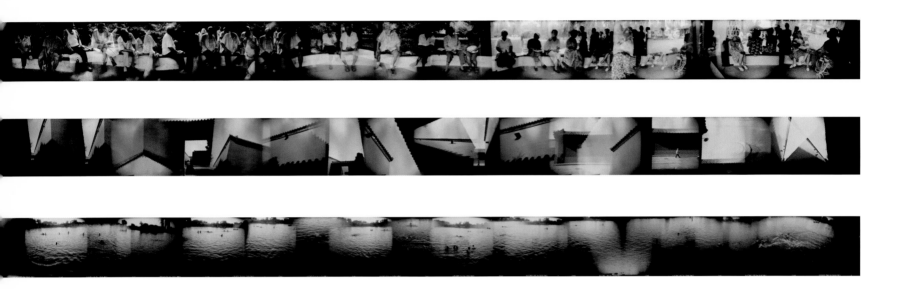

Scroll Series (A1),
1999–2000,
Chromogenic print, 8 x
100 inches
(19 x 254 cm), Collection
JGS, Inc.

(CAT. 63)

Scroll Series (B2),
1999–2000,
Chromogenic print, 8 x
100 inches
(19 x 254 cm), Collection
JGS, Inc.

(CAT. 65)

Scroll Series (A4),
1999–2000,
Chromogenic print, 8 x
100 inches
(19 x 254 cm), Collection
JGS, Inc.

(CAT. 64)

On Mount Erlang No. 4,
from the series
"Rainbow", 1998,
Chromogenic print,
31 1/2 x 31 1/2 (80 x 80
cm), Courtesy
of the artist

(CAT. 69)

On Mount Erlang No. 3,
from the series
"Rainbow", 1998,
Chromogenic print,
31 1/2 x 31 1/2 (80 x 80
cm), Courtesy
of the artist

(CAT. 68)

XIONG WENYUN

On Mount Erlang No. 1,
from the series
"Rainbow", 1998,
Chromogenic print,
31 1/2 x 31 1/2 (80 x 80
cm), Courtesy of the artist

(CAT. 66)

113

YANG FUDONG

Don't Worry It Will Be Better (No. 5), 2000, Chromogenic print, 33 ¹/₂ x 47 ¹/₄ inches (85 x 120 cm), Courtesy ShanghART Gallery, Shanghai

(CAT. 72)

City Light, 2000, Video,
color, sound,
6:00 minutes, Courtesy
ShanghART Gallery,
Shanghai

(CAT. 70)

YANG YONG

Untitled installation, 1996–2004, 34 chromogenic prints, dimensions variable, Courtesy of the artist and ShanghART Gallery, Shanghai

(CAT. 73)

ZHANG DALI

Dialogue: Full Link Plaza, Beijing, 1998, Chromogenic print, 35 $^1/_2$ x 23 $^5/_8$ inches (90 x 60 cm), Collection JGS, Inc.

(CAT. 77)

Demolition: Forbidden City, Beijing, 1998, Chromogenic print, 35 $^1/_2$ x 23 $^5/_8$ inches (90 x 60 cm), Collection Andrew Lewin

(CAT. 74)

ZHENG GUOGU

Life and Dreams of Youth of Yanjiang, 1995–98, Chromogenic print, 24 x 41 ³/₄ inches (61 x 106 cm), Collection Artur Walther, Image courtesy ShanghART Gallery, Shanghai

(CAT. 79)

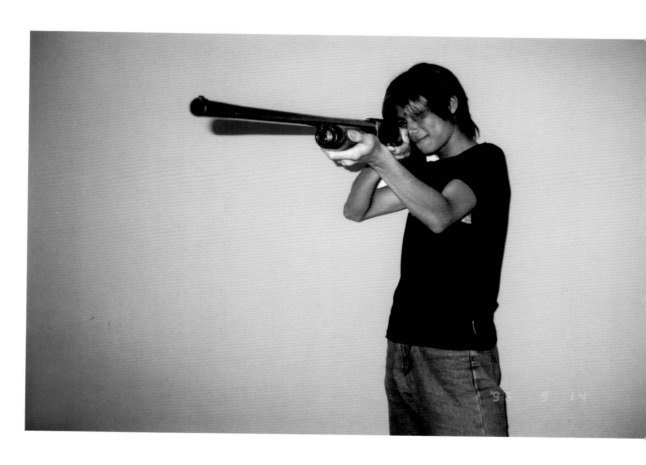

ZHUANG HUI

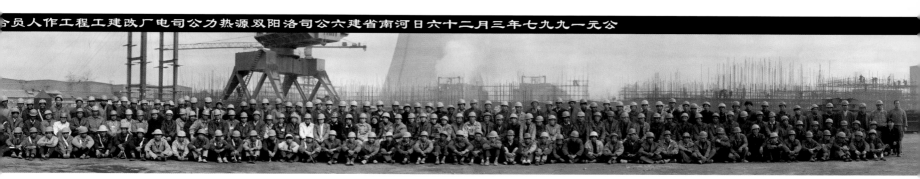

公元一九九七年三月二十六日河南省建六公司洛阳双源热力公司电厂改建工工程工作人员合

十二月七年七九九一元公

Group Photo of Construction Company, Henan Province, 1996, Chromogenic print, 15 x 120 inches (38 x 305 cm), Courtesy of the artist and CourtYard Gallery, Beijing

(CAT. 80)

Group Photo of Gao Village Residents, Jiuzhi District, Daming County, Hebei Province, 1997, Chromogenic print, 14 x 92 ¹/₈ inches (38 x 234 cm), Courtesy of the artist and CourtYard Gallery, Beijing

(CAT. 81)

Group Photo of Military Camp Officers of 51410 Army, 4th Artillery Division, Beiyi County, Hebei Province (Performance), 1997, Chromogenic print, 15 x 98 ¹/₂ inches (38 x 250 cm), Courtesy of the artist and CourtYard Gallery, Beijing

(CAT. 82)

七九九一元公

PERFORMING

the

SELF

AN HONG

Untitled, 1998,
Chromogenic print,
49 $^7/_8$ x 36 inches
(127x 90 cm), Courtesy
of the artist

(CAT. 83)

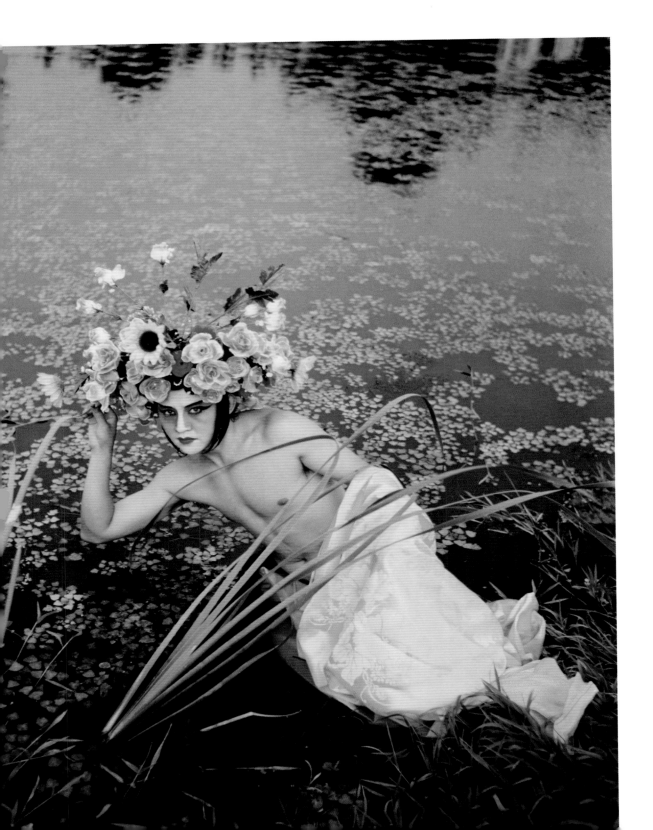

Rabid Dogs, 2002, Video,
color, sound, 8:52 minutes,
Courtesy of the artist and
CourtYard Gallery, Beijing

(CAT. 84)

HONG HAO

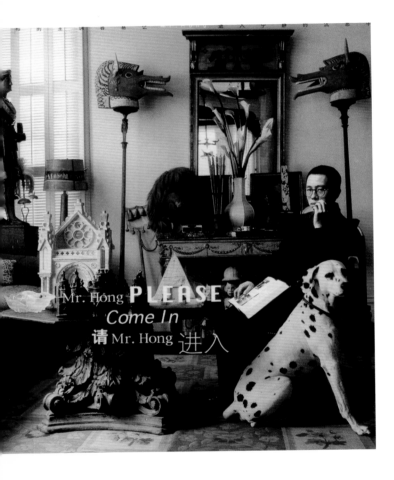

*Mr. Hong, Please Come
In,* 1998, Chromogenic
print, 54 ¹/₄ x 47 ¹/₈ inches
(137.8 x 119.7 cm),
Courtesy of the artist and
CourtYard Gallery, Beijing

(CAT. 86)

HONG LEI

I Dreamt of Being Killed by My Father When I was Flying Over an Immortal Land, 2000, Chromogenic print, 24 ³/₄ x 77 ³/₄ inches (63 x 197.5 cm), Courtesy of China Art Archives & Warehouse, Beijing

(CAT. 88)

LIN TIANMIAO

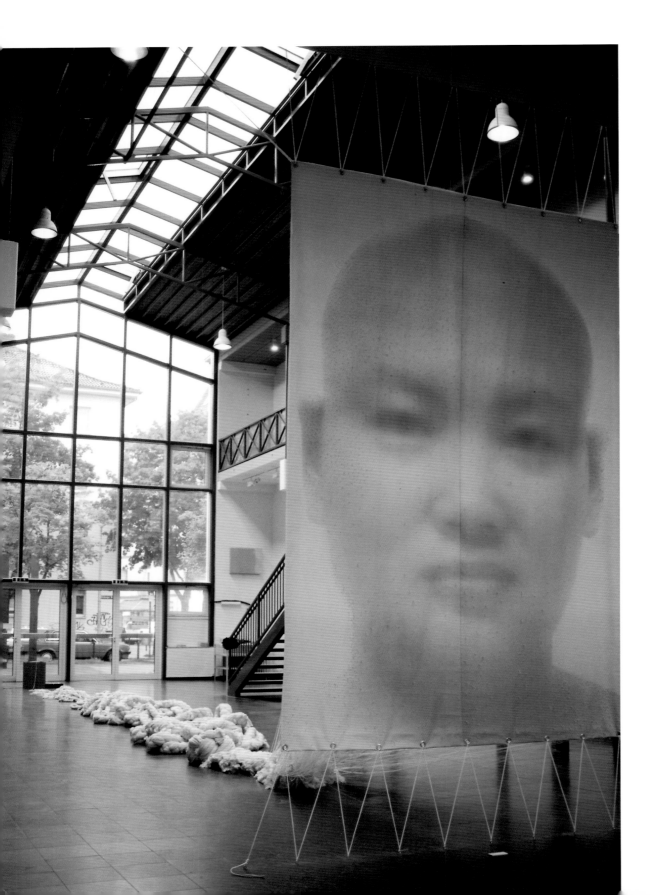

Braiding, 1998, Mixed
media installation,
157 ¹/₂ x 98 ³/₈ inches
(40 x 250 cm), Courtesy
of the artist and
CourtYard Gallery, Beijing

(CAT. 89)

LIU JIAN AND ZHAO QIN

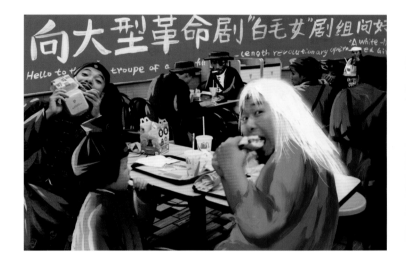
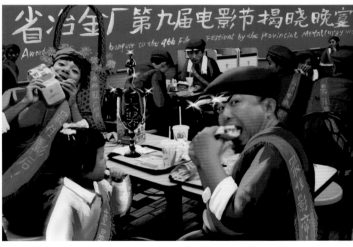

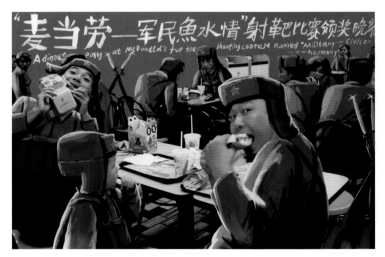

I Love McDonald's,
1998, Six chromogenic
prints, 26 ³/₈ x 39 ³/₈
inches each (67 x 100
cm), Courtesy of the
artists

(CAT. 90)

MO YI

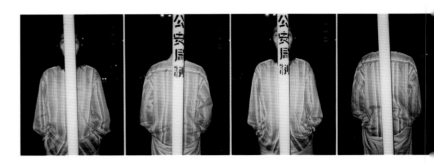

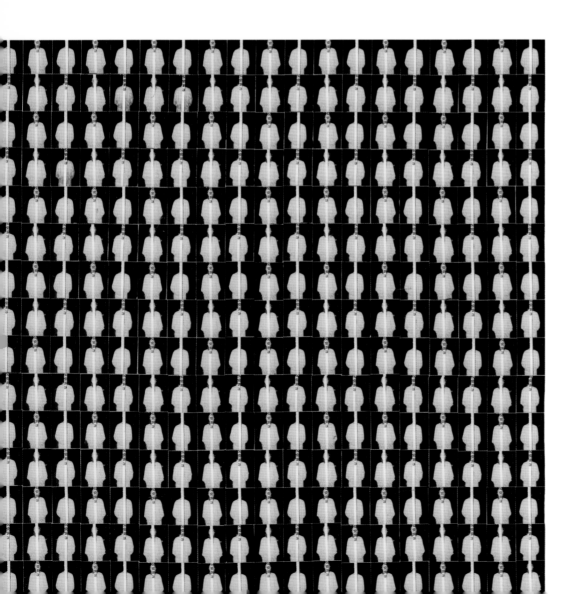

Front View/Rear View, Part 1, 1997, Unique photographic collage, 14 1/4 x 13 3/4 inches (36.4 x 34.8 cm), Courtesy of the artist

(CAT. 91)

RONG RONG

*East Village, Beijing
(1994, No. 70)*, 1994,
Gelatin silver print, 23 ¹/₄
x 30 inches (59.7 x 77
cm), Courtesy of the artist

(CAT. 93, photograph of
Trampling on the Face,
performed by Cang Xin)

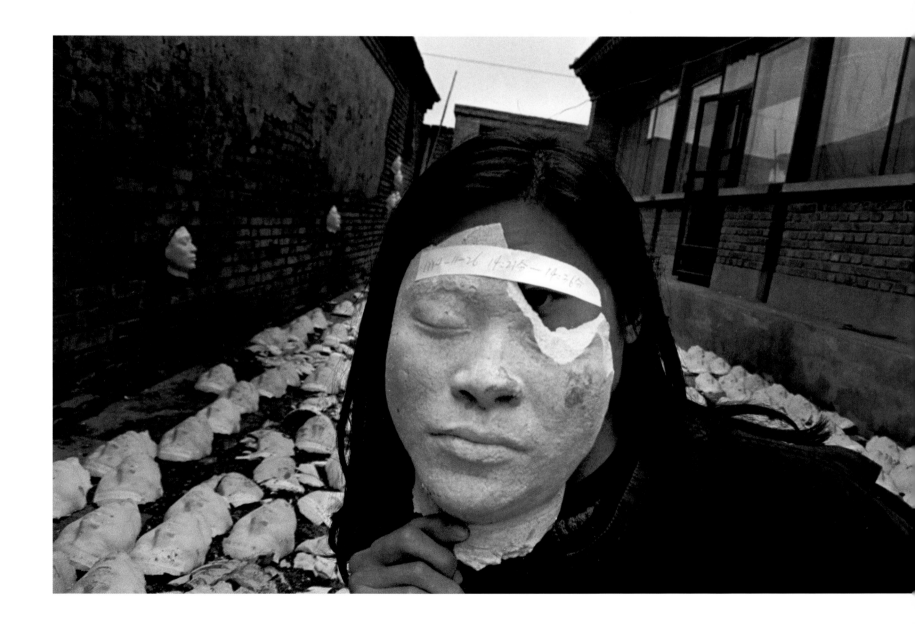

SONG DONG

Water Seal, 1996, 36
chromogenic prints,
23 ⁵/₈ x 15 ³/₄ inches
each (62 x 42 cm),
Collection Artur Walther

(CAT. 94)

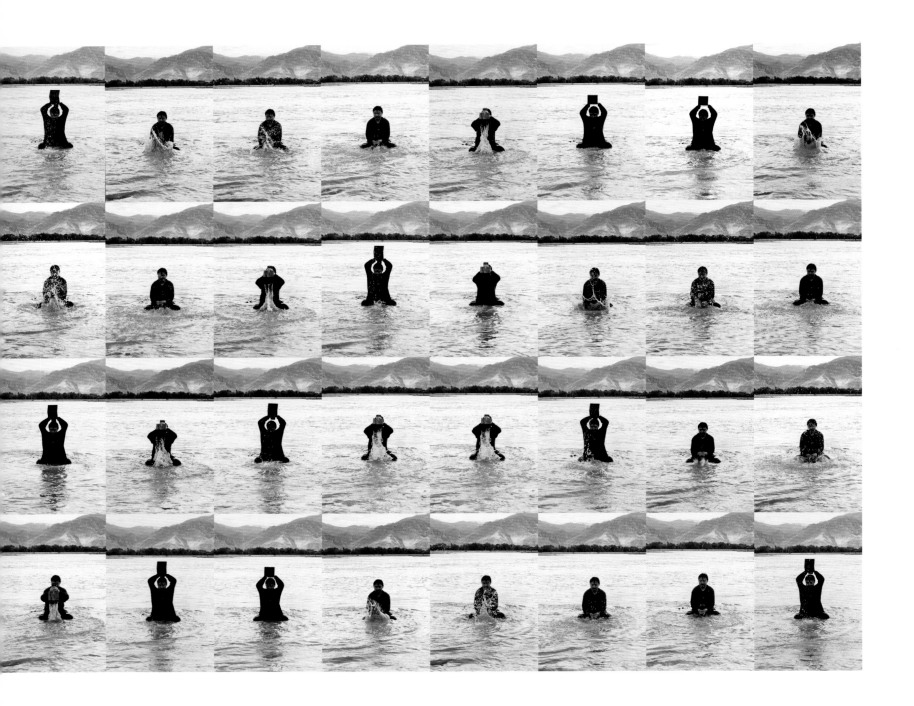

SUN YUAN

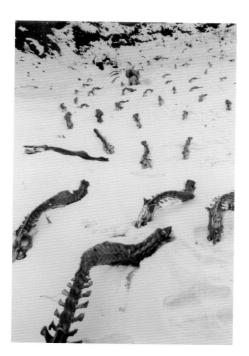

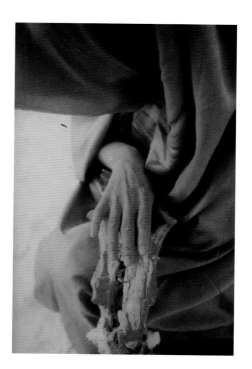

Shepherd, 1998, Three
chromogenic prints,
47 1/4 x 31 1/2 inches
each (120 x 80 cm),
Courtesy of the artist

(CAT. 95)

WANG JIN

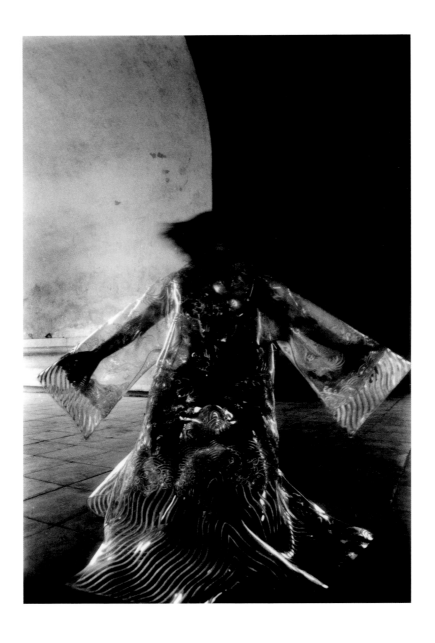

A Chinese Dream, 1998,
Chromogenic print,
54 x 49 $^{1}/_{2}$ inches
(137.1 x 124.5 cm),
Courtesy of the artist

(CAT. 96)

WANG QINGSONG

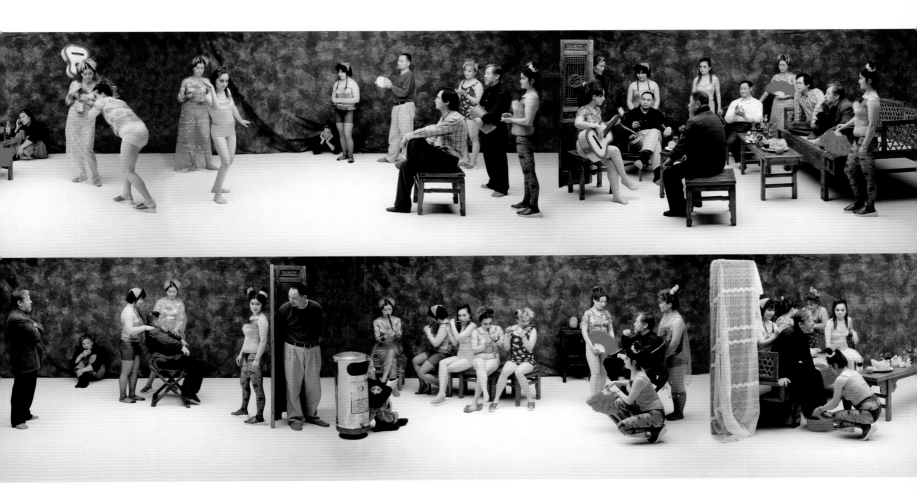

Night Revels of Lao Li,
2000, Chromogenic print,
47 $^1/_4$ x 378 inches
(120 x 960 cm),
Collection JGS, Inc.

(CAT. 97)

YANG FUDONG

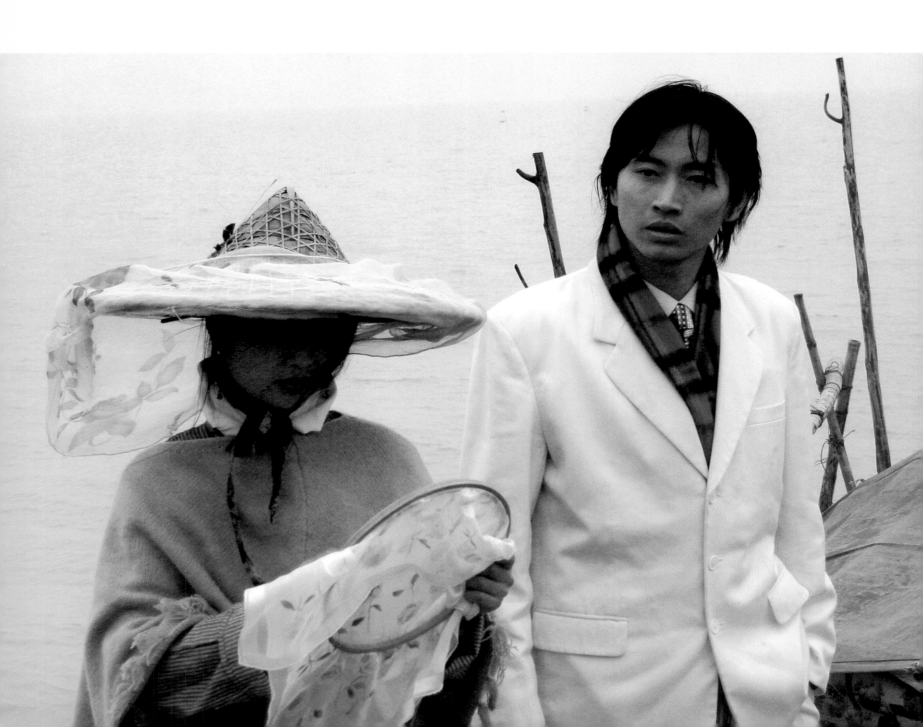

Liu Lan, 2003, Video,
14:00 minutes, Courtesy
of ShanghART Gallery,
Shanghai

(CAT. 98)

YANG ZHENZHONG

I Will Die, 2000–2003,
Video, color, sound,
21:38 minutes, Courtesy
of ShangART Gallery,
Shanghai

(CAT. 99)

YIN XIUZHEN

Yin Xiuzhen, 1998, Mixed
media installation including
ten pairs of shoes and ten
chromogenic prints,
Dimensions variable,
Courtesy of the artist and
CourtYard Gallery, Beijing

(CAT. 100)

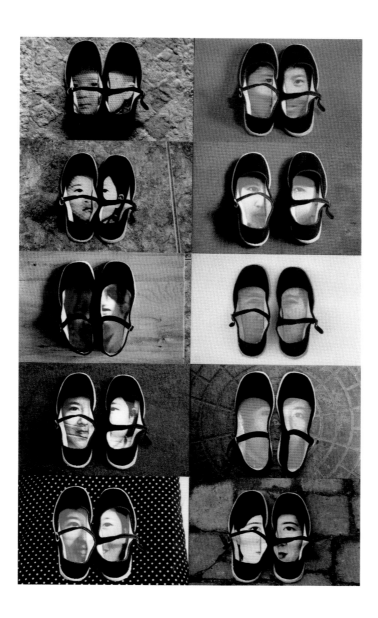

ZHANG HUAN

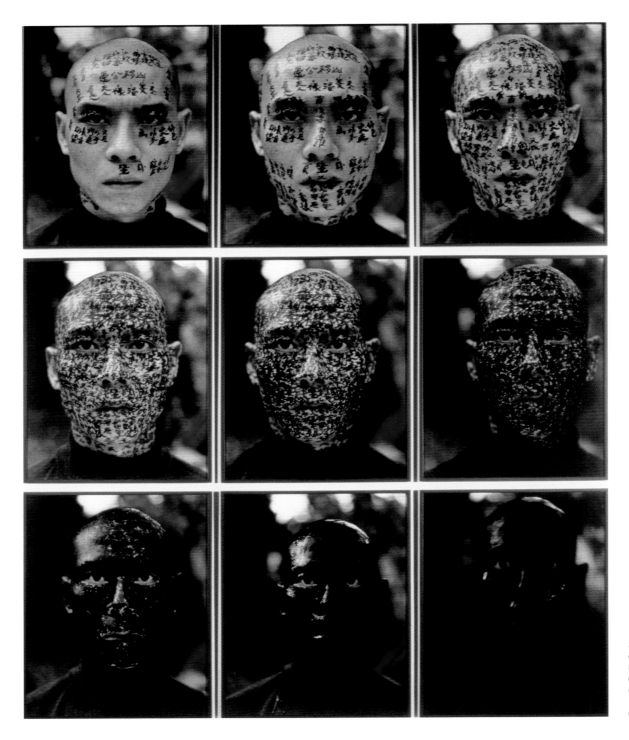

Family Tree, 2001, Nine chromogenic prints, 50 x 40 inches each (127 x 101.6 cm), Collection JGS, Inc.

(CAT. 101)

ZHAO BANDI

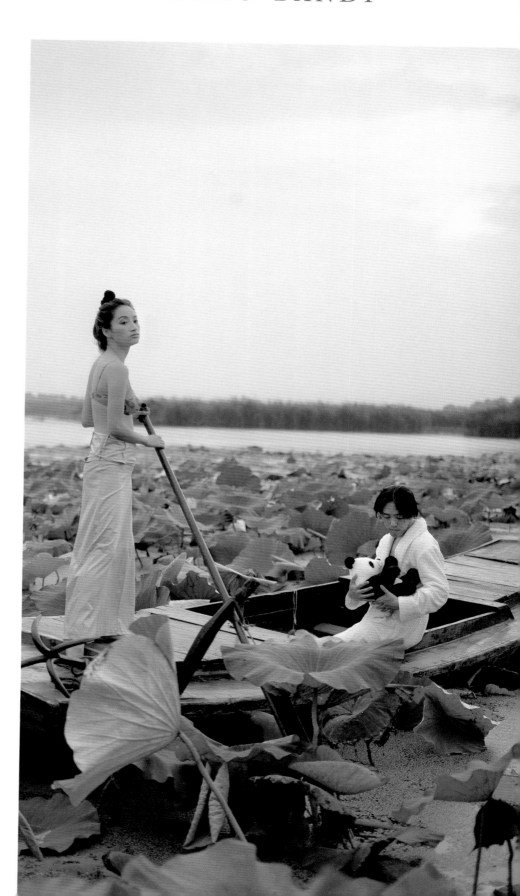

Chinese Story, 1999,
Chromogenic print, 51 1/4
x 29 1/2 inches (130 x
74.5 cm), Courtesy of the
artist

(CAT. 102)

ZHAO LIANG

Social Survey, 1998,
Video, color, sound,
7:05 minutes, Courtesy
of the artist

(CAT. 103)

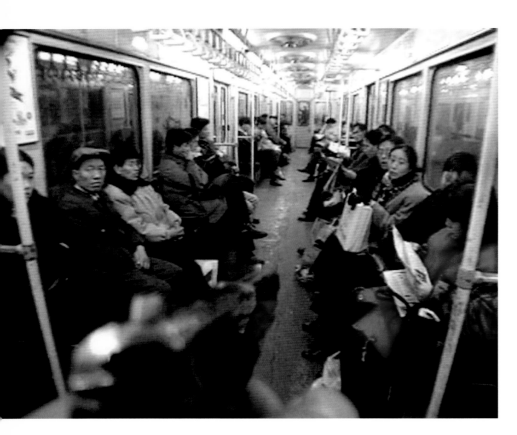

ZHU MING

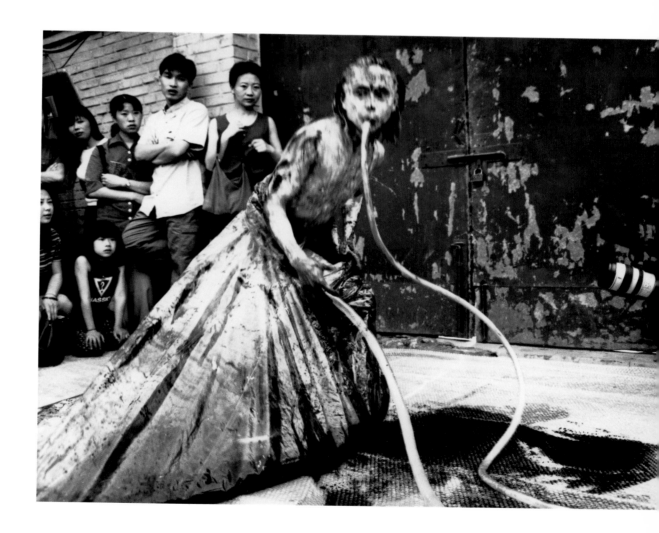

May 8, 1999, 1999,
Chromogenic print,
39 $^5/_8$ x 49 $^1/_2$ inches
(96 x 116 cm), Courtesy
of the artist

(CAT. 104)

REIMAGINING
the
BODY

FENG FENG

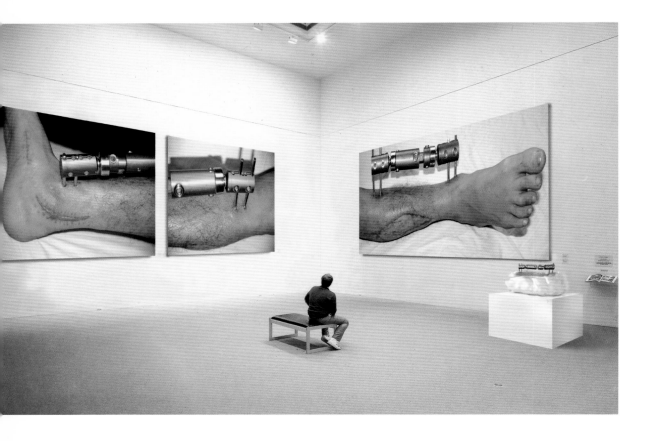

Shin Brace, 1999–2000,
Two inkjet prints,
Dimensions variable,
Courtesy of the artist

(CAT. 105)

GU DEXIN

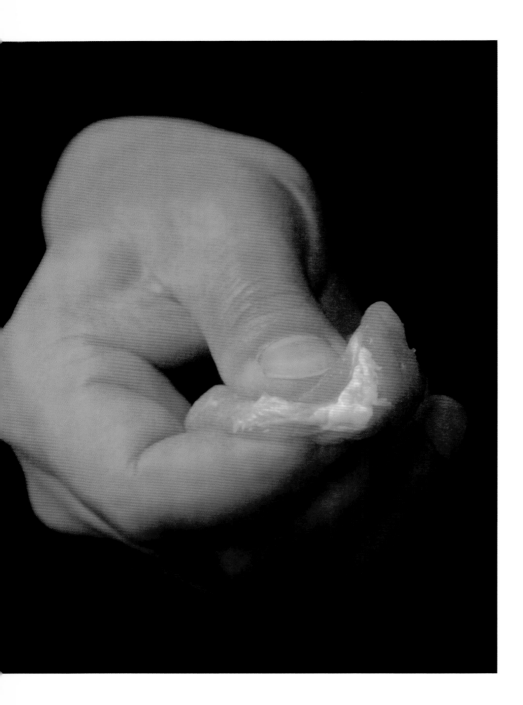

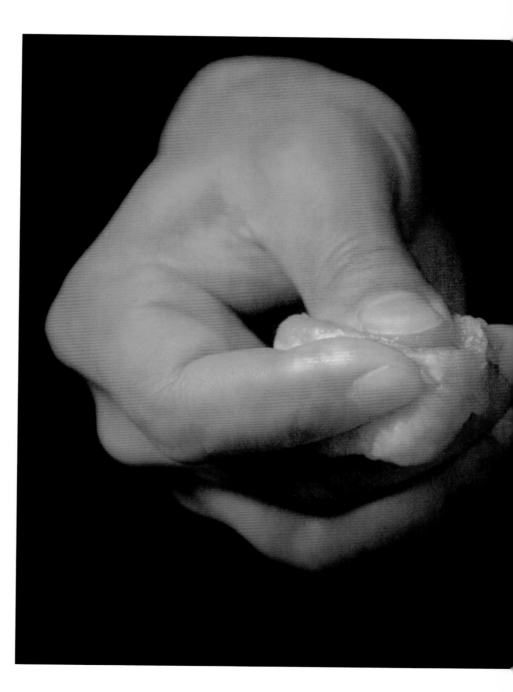

October 31, 1998,
Two chromogenic prints,
39 ⁵/₈ x 49 ¹/₂ inches
each (150 x 153 cm),
Courtesy of the artist

(CAT. 106)

HUANG YAN

*Chinese Landscape—
Tattoo,* 1999,
Chromogenic print,
31 ¹/₂ x 39 ³/₈ inches
(80 x 100 cm),
Collection Artur Walther

(CAT. 107)

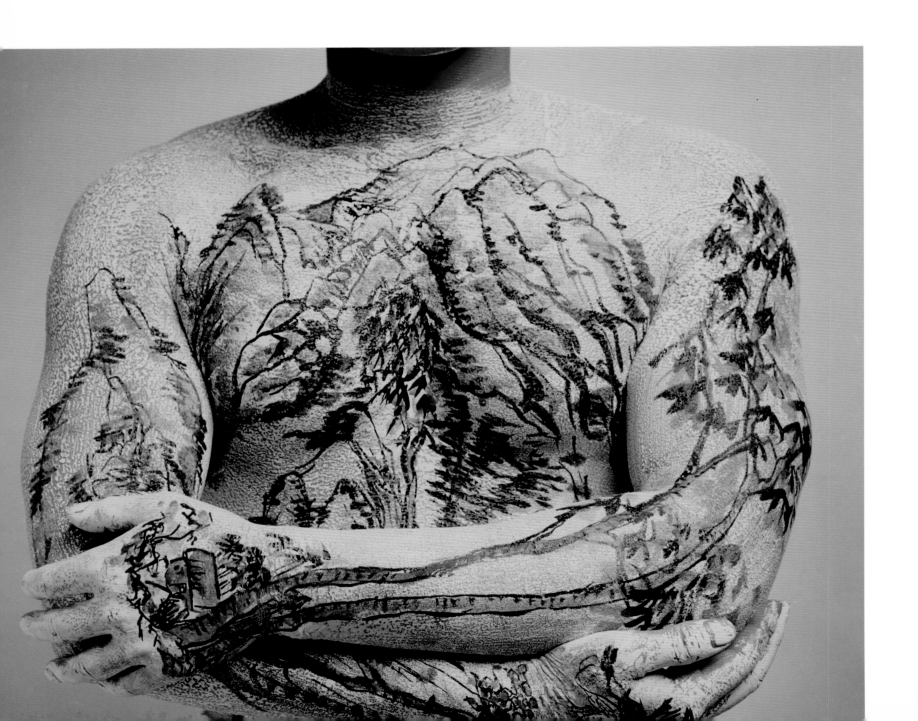

*Chinese Landscape—
Tattoo*, 1999,
Chromogenic print,
31 $^1/_2$ x 39 $^3/_8$ inches
(80 x 100 cm),
Collection Artur Walther

(CAT. 108)

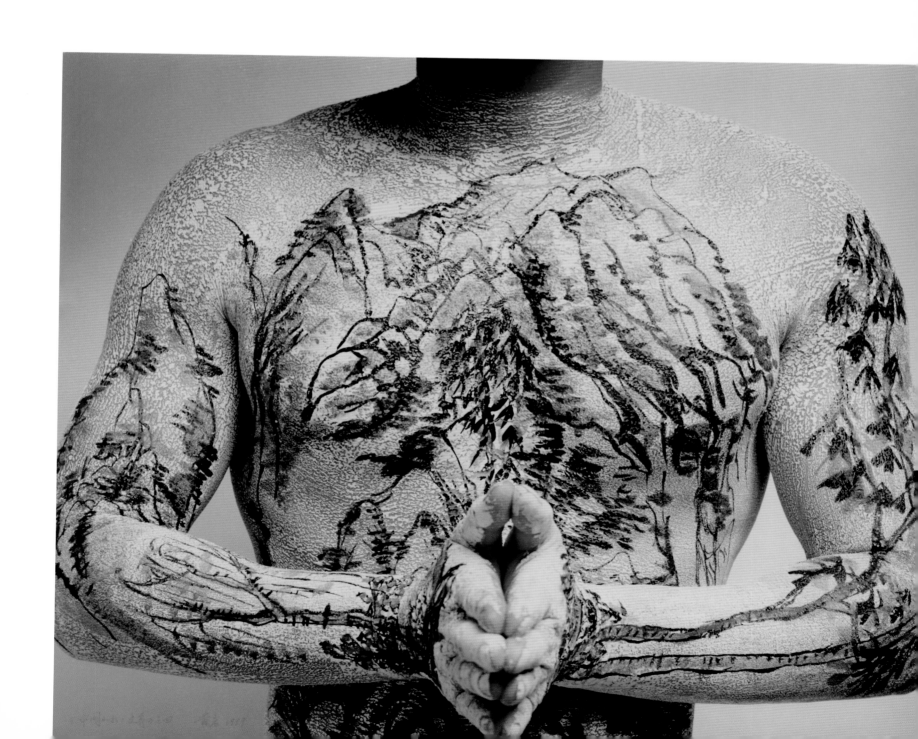

JIANG ZHI

Fly Fly, 1997, Video,
5:14 minutes, Courtesy
of the artist

(CAT. 110)

LI WEI

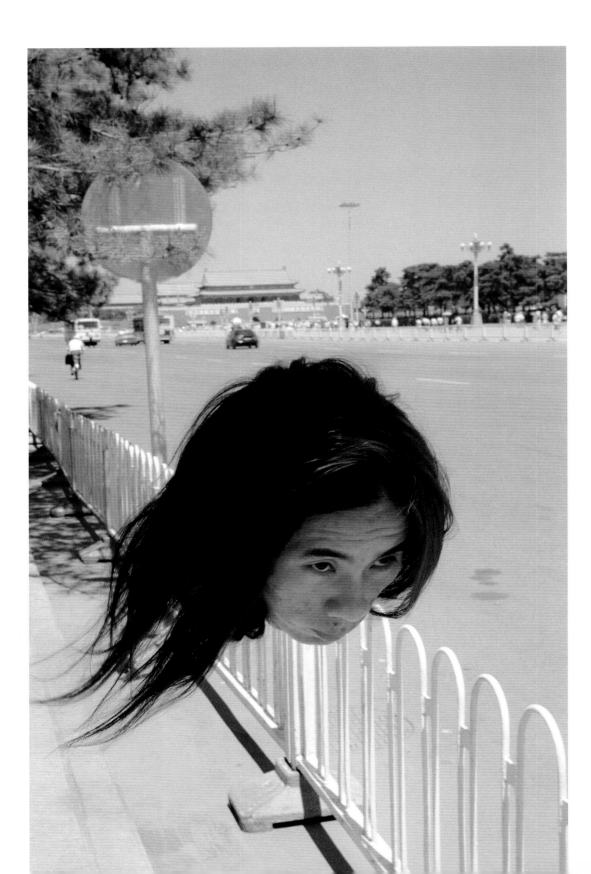

*Mirroring: Tiananmen
Square,* 2000,
Chromogenic print,
39 $^2/_5$ x 27 $^3/_5$ inches
(100 x 70 cm),
Courtesy of the artist

(CAT. 113)

Mirroring: On Coal Hill,
2000, Chromogenic print,
39 $^2/_5$ x 27 $^3/_5$
(100 x 70 cm),
Courtesy of the artist

(CAT. 112)

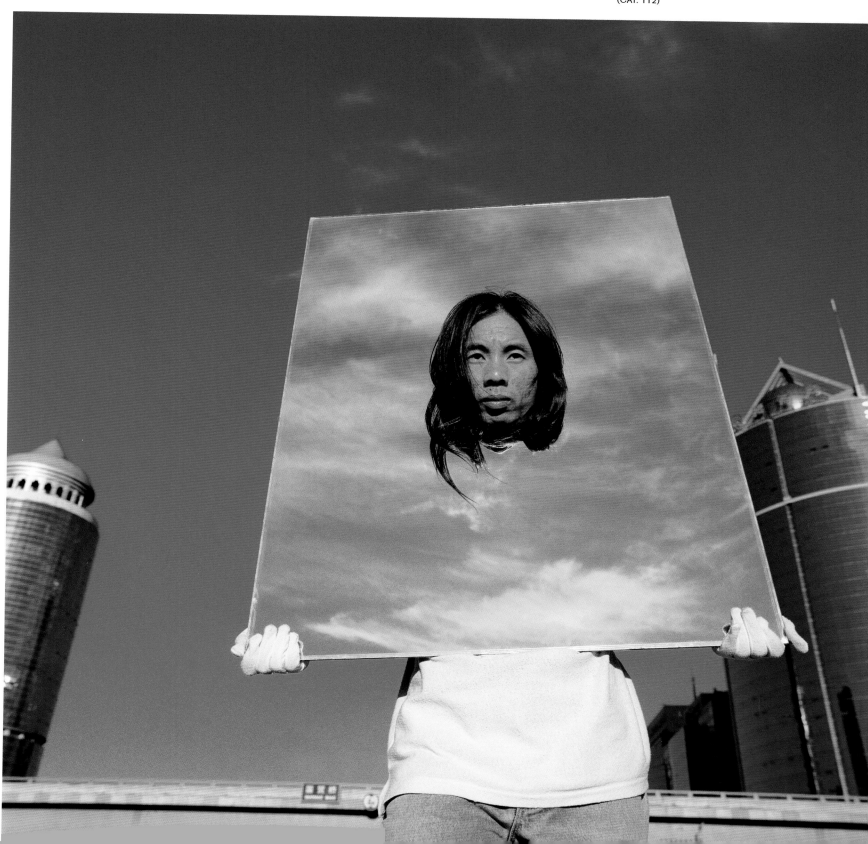

LIU WEI

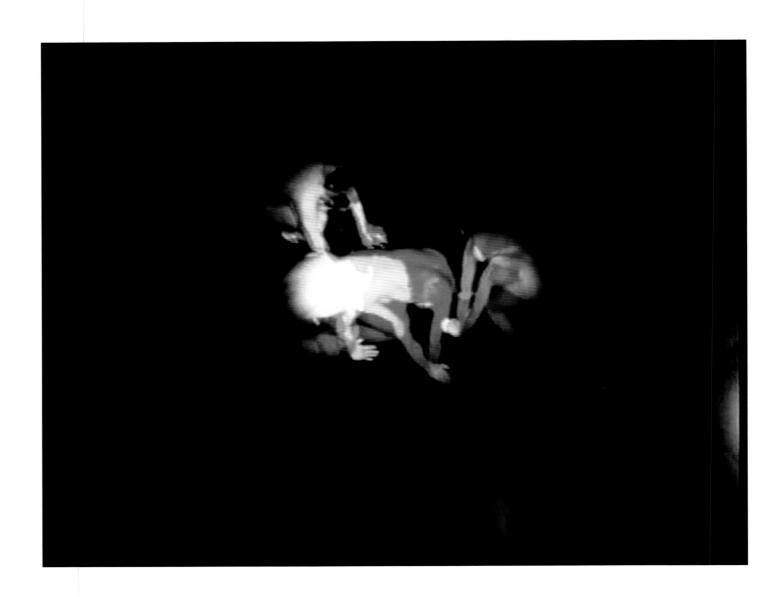

Hard to Restrain, 1999,
Video, color, sound, 4:20
minutes, Courtesy of the
artist

(CAT. 114)

QIU ZHIJIE

Tattoo 2, 1997,
Chromogenic print,
37 ¹/₄ x 46 ¹/₂ inches
(94 x 117 cm), Collection
Smart Museum of Art,
University of Chicago

(CAT. 116)

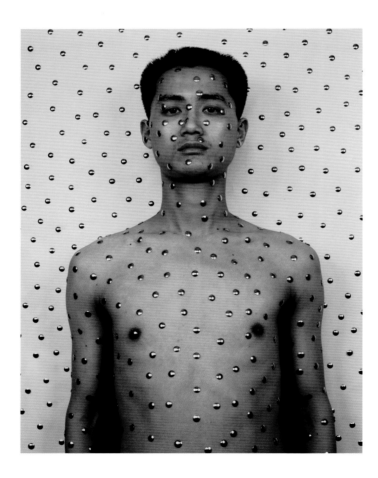

Tattoo 1, 1997,
Chromogenic print,
37 $^1/_4$ x 46 $^1/_2$ inches
(94 x 117 cm), Collection
Smart Museum of Art,
University of Chicago

(CAT. 115)

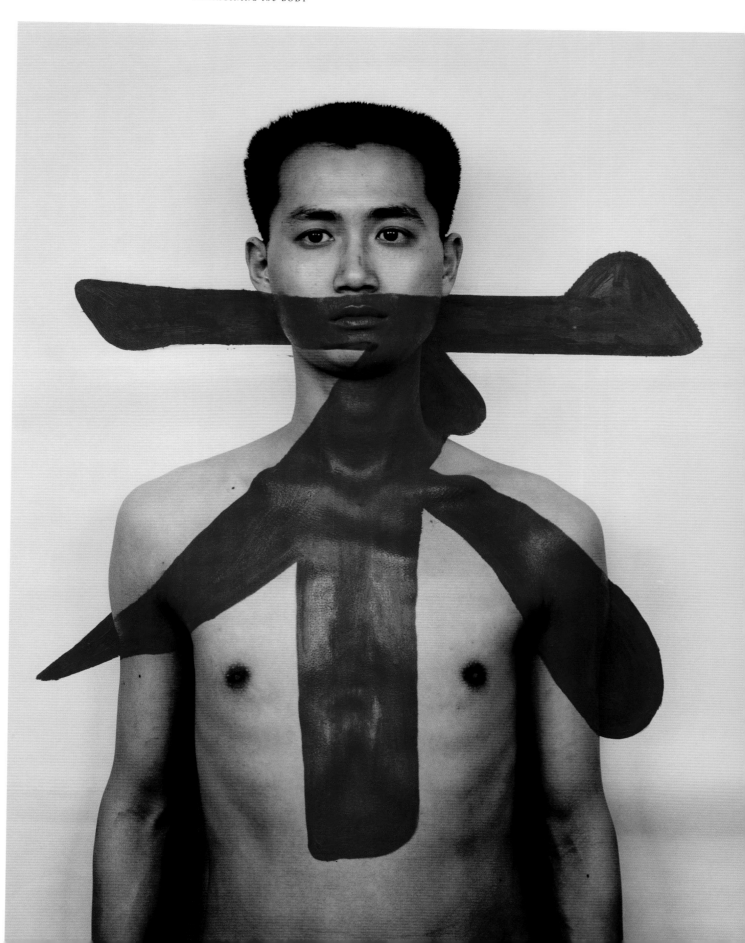

RONG RONG

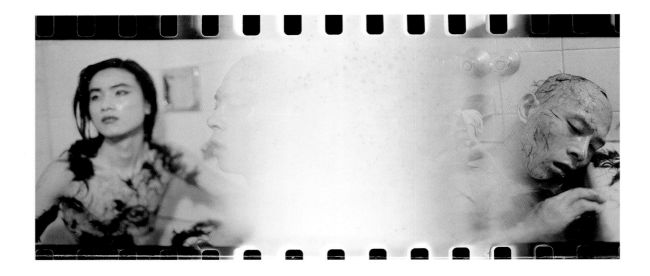

*East Village, Beijing
(1995, No. 5)*, 1995,
Gelatin silver print,
10 x 22 ¹/₂ inches
(25.4 x 57 cm),
Courtesy of the artist

(CAT. 123; photograph of
The Third Contact, per-
formed by Ma Liuming
and Zhang Huan)

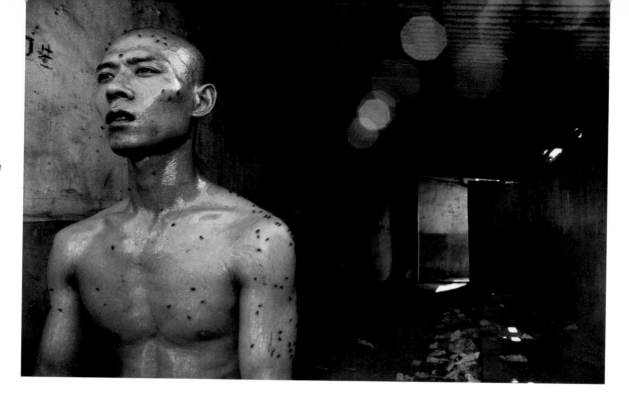

East Village, Beijing,
(1994, No. 20, 1994,
Gelatin silver print
23 ¹/₂ x 30 ¹/₄ inches
(59.7 x 76.8 cm),
Courtesy of the artist

(CAT. 119, photograph of
Twelve Square Meters,
performed by Zhang
Huan)

East Village, Beijing,
(1994, No. 46), 1994,
Gelatin silver print, 20 x
24 inches (50.8 x 61 cm),
Courtesy of the artist

(CAT. 121, photograph of
Xing Danwen photo-
graphing a performance
by Ma Liuming)

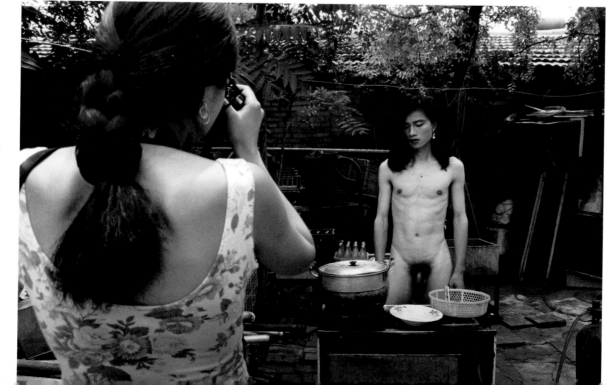

WANG GONGXIN

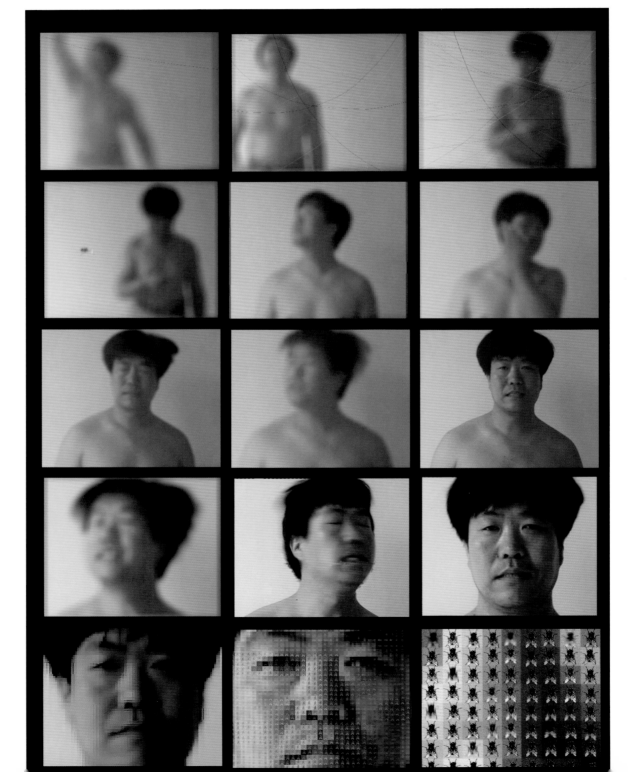

The Fly, 2001,
Video, color, sound,
4:00 minutes, Courtesy
of the artist

(CAT. 124)

WANG JIANWEI

Action, 2002, Three chromogenic prints and audio, 59 x 137 $^3/_4$ inches overall (150 x 350 cm), Courtesy of the artist

(CAT. 125)

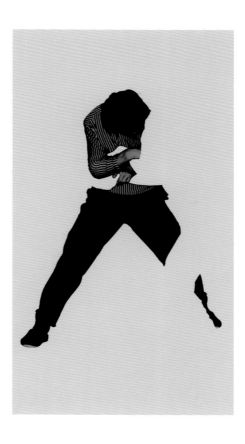 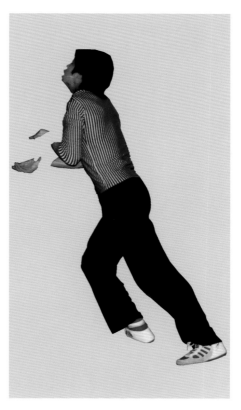

WANG WEI

1/30th of a Second Underwater, 1999, Floor installation of backlit transparencies, Dimensions variable, Courtesy of the artist

(CAT. 126)

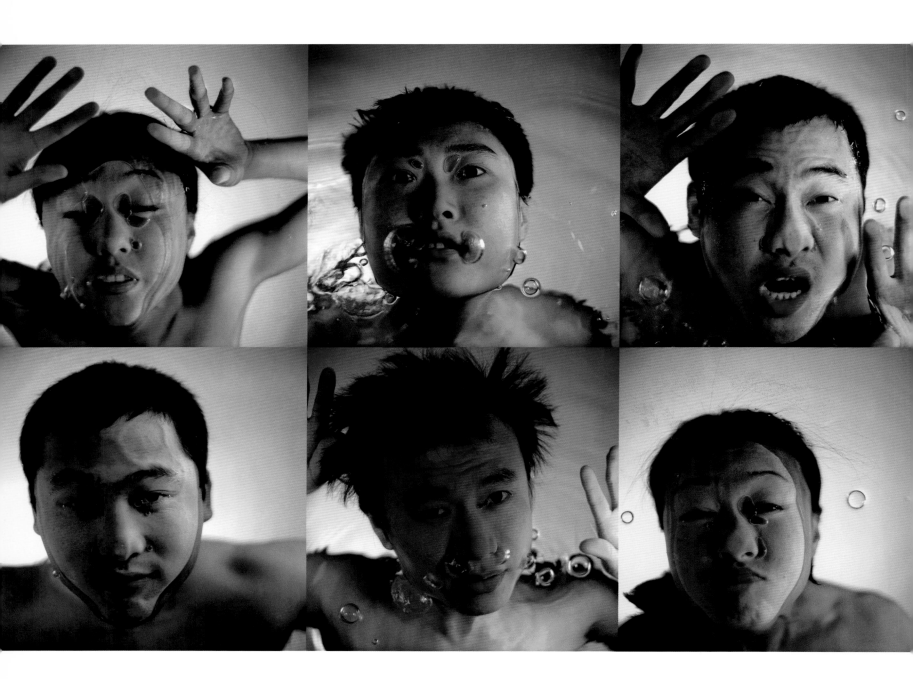

164

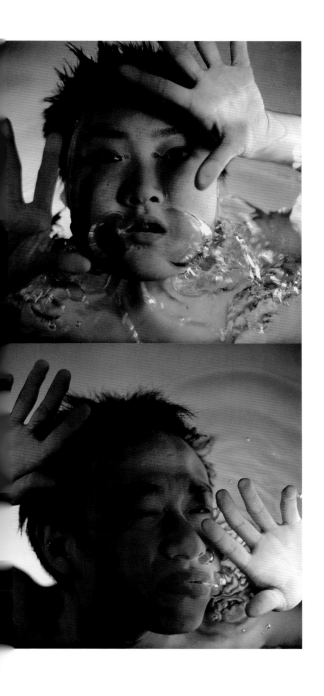

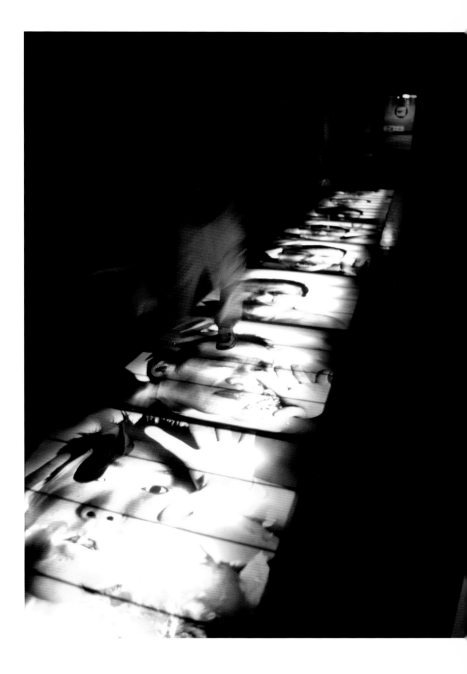

XU ZHEN

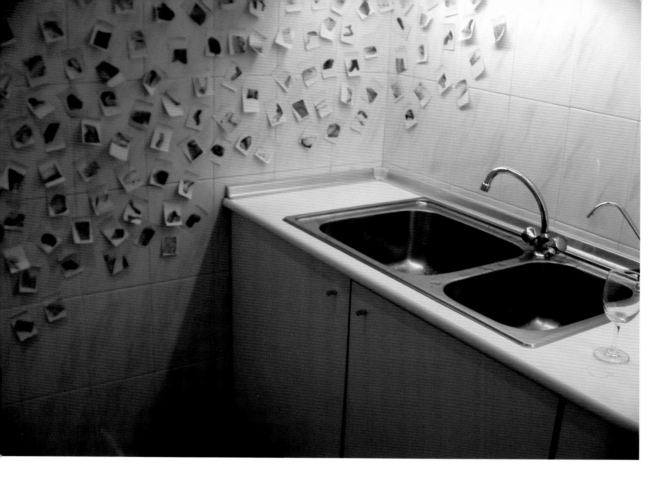

*Actually I Am Also Very
Blurred,* 2000, Installation
of photographic images
on Post-It slips,
Dimensions variable,
Courtesy of the artist and
ShanghART Gallery,
Shanghai

(CAT. 127)

ZHOU XIAOHU

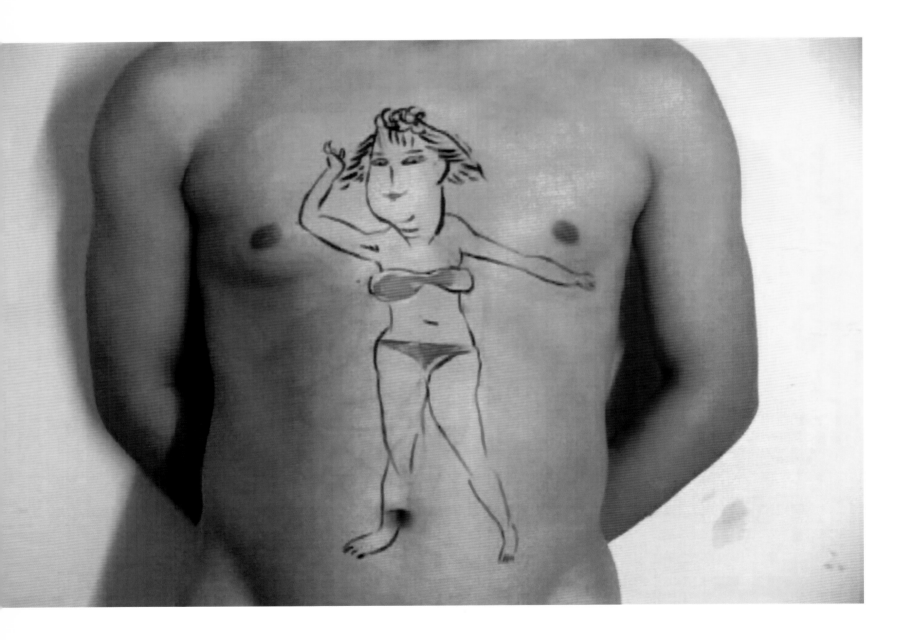

The Gooey Gentleman,
2002, Video, color,
sound, 4:37 minutes,
Courtesy of the artist

(CAT. 130)

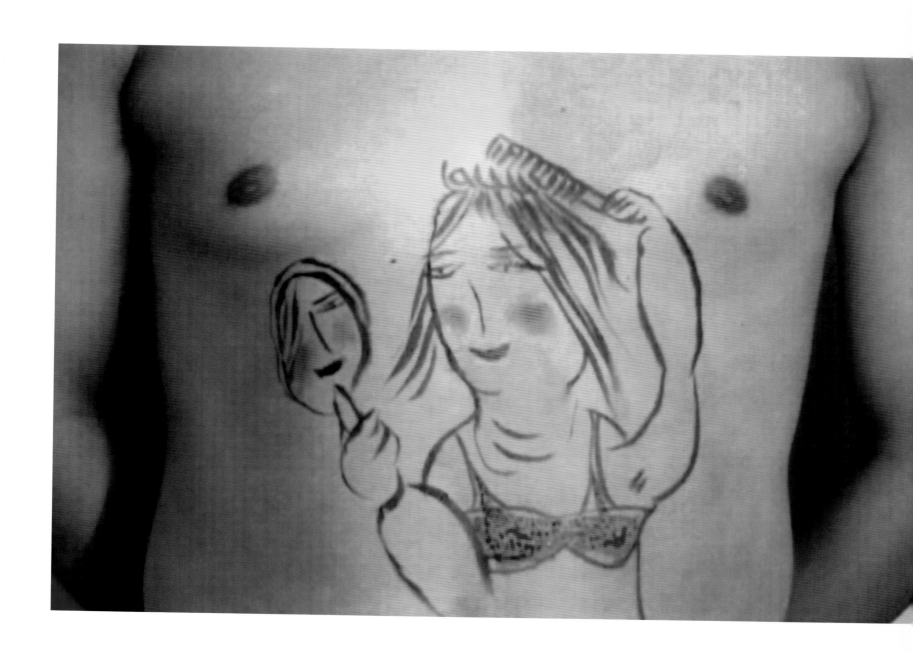

AI WEIWEI AN HONG BAI YILUO
CANG XIN CAO FEI CHEN LINGYANG
CHEN SHAOXIONG CUI XIUWEN
FENG FENG FENG MENGBO
GAOBROTHERS
GU DEXIN HAI BO HONG HAO HONG LEI
HU JIEMING HUANG YAN JIANG ZHI
SZE TSUNG LEONG LI TIANYUAN
LI WEI LIN TIANMIAO
LIU JIAN AND ZHAO QIN LIU WEI LIU WEI
LIU ZHENG LUO YONGJIN MA LIUMING
MIAO XIAOCHUN MO YI QIU ZHIJIE
RONG RONG SHENG QI SONG DONG
SUI JIANGUO, ZHAN WANG, AND YU FAN
SUN YUAN WANG GONGXIN
WANG JIANWEI WANG JIN WANG JINSONG
WANG QINGSONG WANG WEI
WANG YOUSHEN WENG FEN XING DANWEN
XIONG WENYUN XU ZHEN YANG FUDONG
YANG YONG YANG ZHENZHONG
YIN XIUZHEN ZHANG DALI ZHANG HUAN
ZHAO BANDI ZHAO LIANG
ZHAO SHAORU ZHENG GUOGU
ZHOU XIAOHU ZHU MING ZHUANG HUI

History and Memory

CANG Xin

1 *Communication (Series No. 2)*, 1999, Twelve chromogenic prints, 19 5/8 x 15 3/4 inches (50 x 40 cm), Courtesy of the artist and CourtYard Gallery, Beijing

FENG Mengbo

2 *My Private Album*, 1996, Mixed media installation including interactive CD-Rom, computer, and flat panel monitor, Dimensions variable, Courtesy of the artist

GAO Brothers
(GAO Qiang and GAO Zhen)

3 *An Installation on Tiananmen*, 1995, Chromogenic print, 59 x 42 1/2 inches (108 x 150 cm), Courtesy of the artists

HAI Bo

4 *I Am Chairman Mao's Red Guard*, 2000, Two chromogenic prints, 23 5/8 x 15 3/4 inches each (60 x 40 cm), Collection JGS, Inc.

5 *They No. 1*, 1999, Two gelatin silver prints, one vintage and one contemporary, 2 3/8 x 3 1/8 inches each (6 x 8 cm), Courtesy of the artist and CourtYard Gallery, Beijing

6 *They No. 5*, 1999, Two gelatin silver prints, one vintage and one contemporary, 3 3/16 x 4 1/2 inches each (8 x 11.4 cm), Collection Smart Museum of Art, University of Chicago

7 *They No. 6*, 1999, Two gelatin silver prints, one vintage and one contemporary, 2 3/8 x 3 1/8 inches each (6 x 8 cm), Courtesy of the artist and CourtYard Gallery, Beijing

8 *They No. 7*, 2000, Two gelatin silver prints, one vintage and one contemporary, 2 5/16 x 3 3/16 inches each (5.8 x 8 cm), Collection Smart Museum of Art, University of Chicago

HONG Lei

9 *Autumn in the Forbidden City, East Veranda*, 1997, Chromogenic print, 41 x 50 inches (104.1 x 127 cm), Collection JGS, Inc.

10 *Autumn in the Forbidden City, West Veranda*, 1997, Chromogenic print, 41 x 50 inches (104.1 x 127 cm), Collection JGS, Inc.

LIU Wei

11 *Forbidden City*, 2000, Ten chromogenic prints, 13 1/4 x 17 3/4 inches each (33.6 x 45 cm), Courtesy of the artist

LIU Zheng

12 *Clay Sculpture: Gate of Hell, Fengdu, Sichuan Province*, 1999, Gelatin silver print, 14 1/2 x 14 1/2 inches (36.8 x 36.8 cm), Courtesy of the artist and CourtYard Gallery, Beijing

13 *Clay Sculpture: The Punishment of the Wife Who Misbehaved, Houshentai, Henan Province*, 2000, Gelatin silver print, 14 1/2 x 14 1/2 inches (36.8 x 36.8 cm), Courtesy of the artist and CourtYard Gallery, Beijing

14 *Film Still, Japanese Soldiers and Chinese Captives*, 2000, Gelatin silver print, 14 1/2 x 14 1/2 inches (36.8 x 36.8 cm), Courtesy of the artist and CourtYard Gallery, Beijing

15 *Nanjing Massacre Waxwork in the Memorial Museum, Nanjing, Jiangsu Province*, 2000, Gelatin silver print, 14 1/2 x 14 1/2 inches (36.8 x 36.8 cm), Courtesy of the artist and CourtYard Gallery, Beijing

16 *Symbols of Revolution*, 1999, Gelatin silver print, 14 1/2 x 14 1/2 inches (36.8 x 36.8 cm), Courtesy of the artist and CourtYard Gallery, Beijing

MA Liuming

17 *Fen-Ma Liuming Walks on the Great Wall*, 1998, Chromogenic print, 50 x 78 3/4 inches (127 x 199.9 cm), Collection JGS, Inc.

18 *Fen-Ma Liuming Walks on the Great Wall*, 1998, Video, color, sound, 24:00 minutes, Collection Artur Walther

MIAO Xiaochun

19 *Opera*, 2003, Five chromogenic prints, 74 1/8 x 189 inches overall (189 x 480 cm), Courtesy of the artist

QIU Zhijie

20 *Prophesying Catalogue of "Pushing Back"*, 2001, Video, color, sound, 8:00 minutes, Courtesy of the artist and CourtYard Gallery, Beijing

SHENG Qi

21 *Memories (Mao)*, 2000, Chromogenic print, 47 1/4 x 31 1/2 inches (120 x 80 cm), Collection of the International Center of Photography, Purchased with funds donated by Anne and Joel Ehrenkranz, 2004

22 *Memories (Me)*, 2000, Chromogenic print, 47 1/4 x 31 1/2 inches (120 x 80 cm), Collection of the International Center of Photography, Purchased with funds donated by Anne and Joel Ehrenkranz, 2004

23 *Memories (Mother)*, 2000, Chromogenic print, 47 1/4 x 31 1/2 inches (120 x 80 cm), Collection of the International Center of Photography, Purchased with funds donated by Anne and Joel Ehrenkranz, 2004

SONG Dong

24 *Breathing Part 1 and Part 2*, 1996, Two light-box transparencies with audio CD, 62 x 96 inches each (121.9 x 243.8 cm), Collection Smart Museum of Art, University of Chicago; exhibition prints courtesy Chambers Fine Art, New York

SUI Jianguo, YU Fan, and
ZHAN Wang
(Three Man United Studio)

25 *Woman/Here*, 1995, Installation, mixed media, Dimensions variable, Courtesy of the artists

WANG Gongxin

26 *My Sun*, 2001, Video, 7:00 minutes, Courtesy of the artist

WANG Qingsong

27 *Past, Present, Future*, 2001, Three chromogenic prints, 47 1/4 x 215 1/2 inches overall (120 x 550 cm), Collection JGS, Inc.

WANG Youshen

28 *Washing: A 1941 Mass Grave in Datong*, 1995, Mixed media installation including two bathtubs and two electrical pumps, Dimensions variable, Collection Guangdong Museum of Art, Guangzhou

WENG Fen

29 *Our Future Is Not a Dream*, 2000, Video, color, sound, 12:08 minutes, Courtesy of the artist and CourtYard Gallery, Beijing

XING Danwen

30 *Born with the Cultural Revolution*, 1995, Three chromogenic prints, 21 1/2 x 64 1/2 inches overall (54.4 x 163.8 cm), Courtesy of the artist

YANG Zhenzhong

31 *922 Rice Corns*, 2000, Video, color, sound, 8:00 minutes, Courtesy of ShanghART Gallery, Shanghai

ZHAO Shaoruo

32 *In the Name of the Dictatorship of the Proletariat*, 1996, Chromogenic print, 59 1/8 x 79 5/8 inches (150 x 200 cm), Courtesy of the artist

33 *In the Name of the Market*, 1996, Chromogenic print, 59 1/8 x 79 5/8 inches (150 x 200 cm), Courtesy of the artist

ZHOU Xiaohu

34 *Utopian Machine*, 2002, Video, color, sound, 8:03 minutes, Courtesy of the artist

People and Place

AI Weiwei

35 *Seven Frames*, 1994, Gelatin silver print, 18 x 73 1/2 inches (48.6 x 186.5 cm), Courtesy of China Art Archives & Warehouse, Beijing

BAI Yiluo

36 *The People*, 2002, 1600 gelatin silver prints, sewn together, 78 3/4 x 145 3/4 inches (200 x 370 cm), Collection JGS, Inc.

CHEN Lingyang

37 *25:00, No. 2*, 2002, Rear-illuminated transparency, 22 x 68 inches (56 x 173 cm), Courtesy of China Art Archives & Warehouse, Beijing

CHEN Shaoxiong

38 *Landscape II*, 1996, Video, color, sound, 8:00 minutes, Courtesy of the artist and Vitamin Creative Space, Guangzhou

39 *Multilandscape*, 2004, Mixed media installation including photographic cutouts and video, Dimensions variable, Courtesy of the artist and Vitamin Creative Space, Guangzhou

CUI Xiuwen

40 *Ladies Room*, 2000, Video, color, sound, 6:21 minutes, Courtesy of the artist

HONG Hao

41 *Spring Festival on the River No. 2,*
 2000, Chromogenic print with
 collage, 15 x 472 1/2 inches
 (38 x 1200 cm), Collection JGS, Inc.

HU Jieming

42 *Legends of 1995-1996,* 1996,
 Video installation of photographic
 transfers on plastic sheets,
 Dimensions variable, Collection
 Guangdong Museum of Art,
 Guangzhou

43 *Outline Only,* 2000, Video, color,
 sound, 9:25 minutes, Courtesy of
 the artist and ShanghART Gallery,
 Shanghai

Sze Tsung LEONG

44 *Jiangbeicheng, Looking Towards*
 Chongqing City, Chongqing
 Municipality, 2003, Chromogenic
 print, 32 x 40 inches
 (101.6 x 81.3 cm), Courtesy
 of the artist

45 *No. 6 Huashishang Fourth Lane,*
 Chongwen District, Beijing, 2003,
 Chromogenic print, 12 x 15 inches
 (38.1 x 30.5 cm), Courtesy of
 the artist

46 *No. 19 Huashishong Third Lane,*
 Chongwen District, Beijing, 2003,
 Chromogenic print, 12 x 15 inches
 (38.1 x 30.5 cm), Courtesy of
 the artist

47 *Wangjing Xiyuan Third District,*
 Chaoyang District, Beijing, 2002,
 Chromogenic print, 12 x 15 inches
 (38.1 x 30.5 cm), Courtesy of
 the artist

48 *Xizhimen, Haidian District, Beijing,*
 2002, Chromogenic print,
 12 x 15 inches (38.1 x 30.5 cm),
 Courtesy of the artist

LI Tianyuan

49 *Tianyuan Space Station, 12*
 December 2000, 2000, Three
 chromogenic prints,
 78 1/2 x 13 1/2 inches each
 (199.4 x 34.3 cm), Collection
 JGS, Inc.

LIU Zheng

50 *Drag Queen in a Traveling*
 Troupe, 1999, Gelatin silver print,
 14 1/2 x 14 1/2 inches
 (36.8 x 36.8 cm), Courtesy
 of the artist and CourtYard
 Gallery, Beijing

51 *Qigong Performers, Mt. Wutai,*
 Shanxi Province, 1998, Gelatin
 silver print, 14 1/2 x 14 1/2 inches
 (36.8 x 36.8 cm), Courtesy of the
 artist and CourtYard Gallery, Beijing

52 *Three Elderly Entertainers,*
 Beijing, 1995, Gelatin silver print,
 14 1/2 x 14 1/2 inches
 (36.8 x 36.8 cm), Collection
 JGS, Inc.

53 *Three Women at a Country*
 Funeral, Longxian, Shaanxi
 Province, 2000, Gelatin silver
 print, 14 1/2 x 14 1/2 inches
 (36.8 x 36.8 cm), Collection
 of the International Center of
 Photography, purchased
 with funds from the acquisitions
 Committee, 2002

54 *Two Rich Men on New Year's*
 Eve, Beijing, 1999, Gelatin silver
 print, 14 1/2 x 14 1/2 inches
 (36.8 x 36.8 cm), Collection
 JGS, Inc.

LUO Yongjin

55 *Lotus Block,* 1998/2002, Sixty
 gelatin silver prints, 12 1/4 x 8 5/8
 inches each (31 x 22 cm each),
 Collection Artur Walther

RONG Rong

56 *Beijing (1996, No. 1 [Parts 1 and 2]),*
 1996, Two gelatin silver prints,
 48 x 69 1/2 inches each
 (122 x 176.5 cm), Courtesy of the
 artist

57 *Beijing (1996, No. 10 [Parts 1*
 and 2]), 1996, Two gelatin silver
 prints, 48 x 69 1/2 inches each
 (122 x 176.5 cm), Courtesy of the
 artist

58 *Beijing (1997, No. 1 [Parts 1*
 and 2]), 1997, Two gelatin silver
 prints, 48 x 69 1/2 inches each
 (122 x 176.5 cm), Courtesy of the
 artist

SONG Dong

59 *Crumpling Shanghai,* 2000, Video,
 color, sound, 16:00 minutes,
 Courtesy of the artist

60 *My Motherland Set Me Up a Stage,*
 1999, Video, color, sound, 16:00
 minutes, Courtesy of the artist

WANG Jianwei

61 *Spider,* 2004, Video, color, sound,
 11:40 minutes, Courtesy of the artist

WANG Jinsong

62 *City Wall,* 2002, Five chromogenic
 prints, 49 3/4 x 36 3/8 inches each
 (127 x 91 cm), Collection JGS Inc.

XING Danwen

63 *Scroll Series (A1),* 1999–2000,
 Chromogenic print, 8 x 100 inches
 (19 x 254 cm), Collection JGS, Inc.

64 *Scroll Series (A4),* 1999–2000,
 Chromogenic print, 8 x 100 inches
 (19 x 254 cm), Collection JGS, Inc.

65 *Scroll Series (B2),* 1999–2000,
 Chromogenic print, 8 x 100 inches
 (19 x 254 cm), Collection JGS, Inc.

XIONG Wenyun

66 *On Mount Erlang No. 1,* from the
 series *"Rainbow",* 1998,
 Chromogenic print, 31 1/2 x 31 1/2
 (80 x 80 cm), Courtesy of the artist

67 *On Mount Erlang No. 2,* from the
 series *"Rainbow",* 1998,
 Chromogenic print, 31 1/2 x 31 1/2
 (80 x 80 cm), Courtesy of the artist

68 *On Mount Erlang No. 3,* from the
 series *"Rainbow",* 1998,
 Chromogenic print, 31 1/2 x 31 1/2
 (80 x 80 cm), Courtesy of the artist

69 *On Mount Erlang No. 4,* from the
 series *"Rainbow",* 1998,
 Chromogenic print, 31 1/2 x 31 1/2
 (80 x 80 cm), Courtesy of the artist

YANG Fudong

70 *City Light,* 2000, Video, color,
 sound, 6:00 minutes, Courtesy
 ShanghART Gallery, Shanghai

71 *Don't Worry It Will Be Better*
 (No. 1), 2000, Chromogenic print,
 33 7/8 x 47 1/4 inches (86 x 120 cm),
 Courtesy ShanghART Gallery,
 Shanghai

72 *Don't Worry It Will Be Better*
 (No. 5), 2000, Chromogenic print,
 33 1/2 x 47 1/4 inches (85 x 120 cm),
 Courtesy ShanghART Gallery,
 Shanghai

YANG Yong

73 Untitled installation, 1996–2004,
 34 chromogenic prints, dimensions
 variable, Courtesy of the artist and
 ShanghART Gallery, Shanghai

ZHANG Dali

74 *Demolition: Forbidden City, Beijing,*
 1998, Chromogenic print,
 35 1/2 x 23 5/8 inches (90 x 60 cm),
 Collection Andrew Lewin

75 *Demolition: Time Plaza, Beijing,*
 1999, Chromogenic print,
 35 1/2 x 23 5/8 inches (90 x 60 cm),
 Collection JGS, Inc.

76 *Demolition: World Financial Center,*
 Beijing, 1998, Chromogenic print,
 35 1/2 x 23 5/8 inches (90 x 60 cm),
 Collection JGS, Inc.

77 *Dialogue: Full Link Plaza, Beijing,*
 1998, Chromogenic print,
 35 1/2 x 23 5/8 inches (90 x 60 cm),
 Collection JGS, Inc.

78 *Dialogue,* 2002, Three-screen DVD
 projection, Courtesy of the artist and
 CourtYard Gallery, Beijing

ZHENG Guogu

79 *Life and Dreams of Youth of*
 Yanjiang, 1995–98, Chromogenic
 print, 24 x 41 3/4 inches
 (61 x 106 cm), Collection
 Artur Walther

ZHUANG Hui

80 *Group Photo of Construction*
 Company, Henan Province, 1996,
 Chromogenic print, 15 x 120 inches
 (38 x 305 cm), Courtesy of the
 artist and CourtYard Gallery, Beijing

81 *Group Photo of Gao Village*
 Residents, Jiuzhi District, Daming
 County, Hebei Province, 1997,
 Chromogenic print, 14 x 92 1/8
 inches (38 x 234 cm), Courtesy of
 the artist and CourtYard Gallery,
 Beijing

82 *Group Photo of Military Camp*
 Officers of 51410 Army, 4th Artillery
 Division, Beiyi County, Hebei
 Province (Performance), 1997,
 Chromogenic print, 15 x 98 1/2
 inches (38 x 250 cm), Courtesy of
 the artist and CourtYard Gallery,
 Beijing

Performing the Self

AN Hong

83 *Untitled,* 1998, Chromogenic print,
 49 7/8 x 36 inches (127x 90 cm),
 Courtesy of the artist

CAO Fei

84 *Rabid Dogs,* 2002, Video, color,
 sound, 8:52 minutes, Courtesy of
 the artist and CourtYard Gallery,
 Beijing

HONG Hao

85 *I Know Mr. Gnoh,* 1998, Chromogenic print, 63 x 50 ¹/₈ inches (160 x 127 cm), Courtesy of the artist and CourtYard Gallery, Beijing

86 *Mr. Hong, Please Come In,* 1998, Chromogenic print, 54 ¹/₄ x 47 ¹/₈ inches (137.8 x 119.7 cm), Courtesy of the artist and CourtYard Gallery, Beijing

HONG Lei

87 *After Liang Kai's (Song Dynasty) Masterpiece "Sakyamuni Coming Out of Retirement",* 1998, Chromogenic print, 32 ⁵/₈ x 25 inches (83 x 66.5 cm), Courtesy of China Art Archives & Warehouse, Beijing

88 *I Dreamt of Being Killed by My Father When I Was Flying Over an Immortal Land,* 2000, Chromogenic print, 24 ³/₄ x 77 ³/₄ inches (63 x 197.5 cm), Courtesy of China Art Archives & Warehouse, Beijing

LIN Tianmiao

89 *Braiding,* 1998, Mixed media installation, 157 ¹/₂ x 98 ³/₈ inches (400 x 250 cm) Courtesy of the artist and CourtYard Gallery, Beijing

LIU Jian and ZHAO Qin

90 *I Love McDonald's,* 1998, Six chromogenic prints, 26 ³/₈ x 39 ³/₈ inches each (67 x 100 cm), Courtesy of the artists

MO Yi

91 *Front View/Rear View, Part I,* 1997, Unique photographic collage, 14 ¹/₈ x 13 ³/₄ inches (36.4 x 34.8 cm), Courtesy of the artist

92 *Front View/Rear View, Part 2,* 1997, Unique photographic collage, 5 x 7 ¹/₈ inches (12.5 x 18.5 cm), Courtesy of the artist

RONG Rong

93 *East Village, Beijing (1994, No. 70),* 1994, Gelatin silver print, 23 ¹/₄ x 30 (59.7 x 77 cm), Courtesy of the artist

SONG Dong

94 *Water Seal,* 1996, 36 chromogenic prints, 23 ⁵/₈ x 15 ³/₄ inches each (62 x 42 cm), Collection Artur Walther

SUN Yuan

95 *Shepherd,* 1998, Three chromogenic prints, 47 ¹/₄ x 31 ¹/₂ inches each (120 x 80 cm), Courtesy of the artist

WANG Jin

96 *A Chinese Dream,* 1998, Chromogenic print, 54 x 49 ¹/₂ inches (137.1 x 124.5 cm), Courtesy of the artist

WANG Qingsong

97 *Night Revels of Lao Li,* 2000, Chromogenic print, 47 ¹/₄ x 378 inches (120 x 960 cm), Collection JGS, Inc.

YANG Fudong

98 *Liu Lan,* 2003, Video, 14:00 minutes, Courtesy of ShanghART Gallery, Shanghai

YANG Zhenzhong

99 *I Will Die,* 2000–2003, Video, color, sound, 21:38 minutes, Courtesy of ShangART Gallery, Shanghai

YIN Xiuzhen

100 *Yin Xiuzhen,* 1998, Mixed media installation including ten pairs of shoes and ten chromogenic prints, Dimensions variable, Courtesy of the artist and CourtYard Gallery, Beijing

ZHANG Huan

101 *Family Tree,* 2001, Nine chromogenic prints, 50 x 40 inches each (127 x 101.6 cm), Collection JGS, Inc.

ZHAO Bandi

102 *Chinese Story,* 1999, Chromogenic print, 51 ¹/₄ x 29 ¹/₂ inches (130 x 74.5 cm), Courtesy of the artist

ZHAO Liang

103 *Social Survey,* 1998, Video, color, sound, 7:05 minutes, Courtesy of the artist

ZHU Ming

104 *May 8, 1999,* 1999, Chromogenic print, 39 ⁵/₈ x 49 ¹/₂ inches (96 x 116 cm), Courtesy of the artist

Reimagining the Body

FENG Feng

105 *Shin Brace,* 1999–2000, Photographic installation, Dimensions variable, Courtesy of the artist

GU Dexin

106 *October 31,* 1998, Two chromogenic prints, 39 ⁵/₈ x 49 ¹/₂ inches each (150 x 153 cm), Courtesy of the artist

HUANG Yan

107 *Chinese Landscape—Tattoo,* 1999, Chromogenic print, 31 ¹/₂ x 39 ³/₈ inches (80 x 100 cm), Collection Artur Walther

108 *Chinese Landscape—Tattoo,* 1999, Chromogenic print, 31 ¹/₂ x 39 ³/₈ inches (80 x 100 cm), Collection Artur Walther

109 *Chinese Landscape—Tattoo,* 1999, Chromogenic print, 31 ¹/₂ x 39 ³/₈ inches (80 x 100 cm), Collection Artur Walther

JIANG Zhi

110 *Fly Fly,* 1997, Video, 5:14 minutes, Courtesy of the artist

LI Wei

111 *Mirroring: Butchery,* 2000, Chromogenic print, 39 ²/₅ x 27 ³/₅ inches (100 x 70 cm), Courtesy of the artist

112 *Mirroring: On Coal Hill,* 2000, Chromogenic print, 39 ²/₅ x 27 ³/₅ (100 x 70 cm), Courtesy of the artist

113 *Mirroring: Tiananmen Square,* 2000, Chromogenic print, 39 ²/₅ x 27 ³/₅ inches (100 x 70 cm), Courtesy of the artist

LIU Wei

114 *Hard to Restrain,* 1999, Video, color, sound, 4:20 minutes, Courtesy of the artist

QIU Zhijie

115 *Tattoo 1,* 1997, Chromogenic print, 37 ¹/₄ x 46 ¹/₂ inches (94 x 117 cm), Collection Smart Museum of Art, University of Chicago

116 *Tattoo 2,* 1997, Chromogenic print, 37 ¹/₄ x 46 ¹/₂ inches (94 x 117 cm), Collection Smart Museum of Art, University of Chicago

117 *Washroom,* 1994, Video, color, sound, 15:30, Courtesy of the artist and CourtYard Gallery, Beijing

RONG Rong

118 *East Village, Beijing (1994, No. 18),* 24 x 20 inches (61 x 50.8), Courtesy of the artist

119 *East Viillage, Beijing (1994, No. 20),* Gelatin silver print, 23 ¹/₂ x 30 ¹/₄ inches (59.7 x 76.8 cm), Courtesy of the artist

120 *East Village, Beijing (1994, No. 34 [1–4]),* 1994, Gelatin silver print, 24 x 20 inches (50.8 x 61 cm), Courtesy of the artist

121 *East Village, Beijing (1994, No. 46),* Gelatin silver print, 20 x 24 inches (50.8 x 61 cm), Courtesy of the artist

122 *East Village, Beijing (1995, No. 3),* 1995, Gelatin silver print, 24 x 20 inches (50.8 x 61 cm), Courtesy of the artist

123 *East Village, Beijing (1995, No. 5),* 1995, Gelatin silver print, 10 x 22 ¹/₂ inches (25.4 x 57 cm), Courtesy of the artist

WANG Gongxin

124 *The Fly,* 2001, Video, color, sound, 4:00 minutes, Courtesy of the artist

WANG Jianwei

125 *Action,* 2002, Three chromogenic prints and audio, 59 x 137 ³/₄ inches overall (150 x 350 cm), Courtesy of the artist

WANG Wei

126 *1/30th of a Second Underwater,* 1999, Floor installation of backlit transparencies, Dimensions variable, Courtesy of the artist

XU Zhen

127 *Actually I Am Also Very Blurred,* 2000, Installation of photographic images on Post-It slips, Dimensions variable, Courtesy of the artist and ShanghART Gallery, Shanghai

128 *Rainbow,* 1998, Video, color, sound, 3:30 minutes, Courtesy of the artist and ShanghART Gallery, Shanghai

129 *The Problem of Colorfulness,* 2000, Three chromogenic prints, 90 x 60 inches, (228.6 x 152.4 cm), Courtesy of the artist and ShanghART Gallery, Shanghai

ZHOU Xiaohu

130 *The Gooey Gentleman,* 2002, Video, color, sound, 4:37 minutes, Courtesy of the artist

ARTISTS' INTERVIEWS

CANG Xin

Interviewed by Melissa Chiu.

MC When did you begin your performances, and at what stage did photography emerge as your chosen medium?

CX In 1993, I began working in performance. It was not like oil painting and couldn't be exhibited in conventional museums and galleries. I found that the only way for me to show my performances was through video and photographs. My earliest work was called *Trampling on the Face 1* (1994), a performance involving a bunch of plaster casts of my face laid out in an alley where I walked, destroying them. In 1996 I began the *Communication* series (CAT. 1), and this was when I began licking. At first I licked everyday things around the house, such as knives and spoons. Then three years later I began to lick places that had specific cultural meaning such as the Great Wall and the Ming Tombs. In 2000, I started doing this work abroad at exhibitions in Norway, Singapore, England, and Australia.

MC There's quite a big difference between licking everyday items in one's home and going outside to lick monuments in the public sphere. What was the motivation for this?

CX The first time I licked things it was an instinctual licking. Then later it evolved into a form of exchange. This is based on my observation that Chinese people like to eat. In any city, if there are Chinese people there will be Chinese restaurants. Chinese people and Chinese culture are connected to this sort of tangible, visceral, physical thing to the extent that you could say that happiness in China is very much about the mouth. When Chinese people speak about food, they refer to flavor, not to nutrition. It seems to me that in the West, people talk much more about nutrition—so this is an obvious difference.

MC Do you find different reactions to your licking overseas than you do here in China?

CX Chinese people are often very disturbed by these works; there's a saying in Chinese that "sickness begins in the mouth." In Europe and elsewhere, people think that my works are crazy or very special. When I do these works abroad it seems like more of an exchange, where the viewers come and talk to me and exchange thoughts. My use of the tongue also has other meanings: it has a sexual dimension to it and it is also the basis of speech. If we look at babies, even before they open their eyes, they're trying to experience the world around them by licking things. So I think it's very precious, this desire to lick and experience things with the mouth. It begins as an impulse that is instinctual, but it's gradually closed off by society as one grows up. My work tries to rediscover that kind of pure experience.

MC A regression back to your own infancy?

CX Yeah.

MC In terms of your photographs, do you see them as straight documentation of your performances, or are they conceived entirely as photographs?

CX They're the way I record my performances. It's all part of the process. My artwork is a performance, but what's left at the end is a photograph. So for me, the photograph is part of the process of realizing performance work.

CHEN Lingyang

Interviewed by Melissa Chiu.

MC You were born in 1975 and are one of the youngest artists I have interviewed. What are some of the concerns in your work that might differ from those of more senior artists?

CL I would say that I work more from an individual perspective. When I want to do something, I just do it. Technical knowledge isn't a problem. I don't understand how the equipment works, or photographic technique. I can't even turn a camera on but I don't think this is a problem.

MC Yeah, but it's interesting for people of our generation—we may not know how technology works, but we don't feel threatened by it. Younger artists may not know how to make videos, but they feel as though they see videos like MTV all the time and so it's not a big problem. That's more what I meant.

CL Actually, I didn't have a television until the late 1980s, like a lot of other people in China. This was part of the economic development of China. So to say that video is a familiar language from when I was a kid isn't exactly accurate, but my search for a form of expression has led me to use video and photographic technology. It comes quite naturally.

MC I don't imagine that you learned photography at art school, so what did you see it as offering you that other media didn't?

CL The medium always has to match the work. The first time I used photography was in the *Twelve Flower Months* (1999–2000) because I wanted to convey something different. Photography has a certain way of conveying reality in a way that other media don't, even though photography can be false and manipulated. I wanted to express time so this was the most honest, direct way to do that.

The metaphor of the flower for the female genitalia is present all around the world. In Chinese traditional philosophy, flowers represent the spirit of cultivation. One of the highest ideals is to be able to appreciate nature, but flowers are also about the cycle of life. As a woman, I can appreciate nature in aesthetic philosophy or by appreciating my own body.

MC An exhibition of this work in Beijing was closed down by the authorities. Can you talk about how you came to make this work?

CL After I graduated from the Academy [the Central Academy of Fine Arts, Beijing], I didn't have a job or anything. It was a very important creative time for me. There was a period when I worked on one piece, spending four or five months at home, working on my consciousness of the natural phenomena surrounding me. I began to think about my body too. People have a natural state and a social state. I'm pretty conscious of the idea that there's a divide between people's natural state and the persona that they must create to function in society.

MC Are you aware of some of the works that were produced in the 1970s by feminist artists in the United States? A lot of them did quite radical works about the same sort of issues that you're working on, particularly menstruation. Were they role models for you at all?

CL When I started these works I didn't really know much about the American works, but then six months into it when I came back from America I realized the similarities. I worked from my own feelings and needs rather than very diligently going through art history. When you talk about art and the fundamentals you can't start from someone else's work.

MC Feminism has had an entirely different history here in China and I think that there would probably be a tendency to see your works in the light of Chinese feminism. How do you feel about this, and what do you think about this identification?

CL I don't care if people think that I'm a feminist. I have had a hard time with people. The first time I heard this term it was used sarcastically by one of my college professors to describe a social phenomena. You often hear people say: powerful, rich women are everywhere in China now, but some of them might have a hard time finding a husband because men don't want them. China's still very much a patriarchal society, even if you look at how many upper-level cadres are female.

MC Wouldn't you say your works represent a female perspective?

CL Maybe a better way to say it would be that my works have to do with myself, and I am a woman.

MC As a young artist in Beijing, what do you think is the greatest challenge? What is the hardest for you to deal with—is the main problem getting venues to show your work or are there other concerns?

CL I feel a lot of pressure because China's still a very conservative place. My art works that show the naked body, my own body, put me in a very dangerous position. My parents have no idea that I've done any of these works, and if they did, they'd kill me. It's very, very serious.

MC And what do you mean by dangerous? Do you mean you would find it difficult to ever get a job or do you mean another sort of danger?

CL I've never had a job. Being in this society, I occupy a dangerous place. At an exhibition opening, I can feel people look at me in a strange way because I'm a woman who's gone to this point. My works require a certain kind of power, a concentration. I need to be very strong to protect my psychological health.

GU Dexin
Interviewed by Melissa Chiu.

MC Could we start at the beginning of your artistic career and talk about your training and artistic background?

GD I never went to art school. Actually, I wanted to go to art school, just like everyone else, but I realized that I didn't have to go to art school to make art. At that time in China, the most important thing was to tell the head of your family, your father, what your *goal* was going to be. I took a series of temporary jobs to allow me to buy materials to paint.

MC So when did you first use meat in your work?

GD *Hand Holding Meat* or *Hand Touching Meat* (1994), which was a photograph and a chunk of dry meat exhibited together. It was shown first in Germany in 1995, but the work began one year before.

MC So what was the idea behind using meat? Why choose meat over all other materials?

GD It's a material that is very close to human nature, to people. First of all, it approaches people on a very material level. It gets close to what people are made of: flesh.

MC But the idea of *kneading* it: in some ways there's something fetishistic about it.

GD When I was making the work, I didn't have any sort of fetishistic ideas. It was just another artwork. The work would often take a month to make and the photograph would be taken on the first day, the very first time I kneaded the meat.

MC I'm also interested in the shift from installation to your use of photography. What are the qualities about photography that attracted you?

GD It was a decision made from convenience, and out of consideration of what would be appropriate for this new work. I thought photography would be a better way to record it than painting.

MC At times your photographs of kneading meat suggest violence, or at least an undercurrent of violence.

GD I think there's definitely an element of violence, but it doesn't have as much to do with physical violence as with figurative or

emotional violence. It's power, really. Power is a fundamental aspect of human existence. Wherever you go, there are going to be certain things that are the same: certain forms of repression and expressions of power. The system in China is quite different from the system in America. But a system is still fundamentally made up of people, and my works are more mindful of people, and the relationship between individuals, the collective, or the group.

I never usually like to talk about my work. And this comes right back to the discourse of power because the *artist* is the one who is given this power to explain their works. Putting aside this power is a way of canceling this, of turning the tables. I've also never believed that I am an artist, so I don't feel the need to do things in the way that artists usually do.

MC What about—just to press you a little more—how in your work meat is often disguised to look like something else so that with time, viewers become more aware that something is rotting inside, just below the surface. This appears to be a strong metaphor in your work.

GD In choosing a material like raw meat, I'm conscious of the changes that it will go through. The process of choosing the materials (and, in turn, the nature of the materials) is all conceptually part of creating a work. They all manifest something or express something, but after the materials are put together and become a work, I leave it to the viewer to make what they will of it. Once the work is exhibited it's only the viewer's feelings that matter. When the exhibit opens, my work is over.

HAI Bo
Interviewed by Lisa Corrin.

LC What made you decide to go from painting to photography?

HB Every artist who works with painting and photography has their own way of expressing themselves using those two media. For me, painting as a visual language has certain limitations and to overcome those limitations I use photography. Painting is, by nature, limited to people who understand the medium, where photography is immediately accessible to a much wider audience. Part of the reason I like photography is that I want to create a dialogue with the average Chinese person in order to expand audience involvement in my work.

LC The body of work titled *They* (CAT. 4–8) was begun in the late 1980s and immediately broke down the boundaries between art and life insofar as you had to work very closely with people totally outside the art world who participated in this project.

HB I have great affection for the subjects of my works. They include family members, the oldest son of my oldest friend, and my neighbor. The series is about engaging with these old friends. This human contact is vital for me to work in conceptual photography. While making *They*, I realized daily life is art. The recollection of activities connected to daily life, and my relationship to the people I care about, are what have artistic value. When you separate art from that, it all becomes rather empty.

LC When you began to think in this way, were you aware of Western artists who similarly made works blurring art and life?

HB I respected Joseph Beuys and Andy Warhol, but the basis of my thinking was Chinese traditional philosophy. I am interested in what lies behind the everyday. In Chinese philosophy the natural elements of life are respected and are deeply connected to the meaning of things beyond the surface. Take water, for example. We respect its flow as a reminder that life keeps moving forward.

The evolution of my artistic attitude came to me in a very natural way. After I finished school I traveled to Tibet. Eventually I lived in Beijing, and at a certain stage I suddenly realized that it had been a long time since I had been home to my village. I began reminiscing about my childhood memories. When I went back home I was shocked by how many things I had held onto in my memory had disappeared and were now gone.

LC Did you wonder whether it was your home anymore if it didn't connect to your memory?

HB I realized that your home is really the place where your soul remains.

LC Your images are often emotionally loaded and filled with loss. That feeling is made more palpable through the use of comparison, a device that you use frequently. Contrasting two images really sharpens that distance between the past and present.

HB For me it is more a question of stopping the flow of time. That is the essence of photography. Time is constantly moving—flowing like water—and the only way you can stop a moment in time is with the camera. It is my attempt to control this passage of time.

LC How about the image of the Vietnamese border guard?

HB I really like to look at people's old photo collections. I had often visited a particular friend and had seen a photo, hanging on the wall, of a group of men who were with him in the military. I asked him, "All those friends of yours, why don't you ever call them to say 'Let's get together again?'" My friend told me there is no way to have a reunion with these guys because they all died in a car accident during the Vietnam War. The Vietnamese and Chinese were disputing the Yunnan border. His friends were in a supply truck, delivering explosives to the front where the fighting was going on, and the truck tipped over in a ravine and everyone was killed except my friend.

You look at that photo and you look at these young guys who seem so very much alive and then suddenly you are hit with this idea that they are no longer living. I wanted to create a memorial.

I asked my friend to sit for a portrait but I didn't explain what I was doing. I set up the scene as in the original photograph with the chairs exactly where they were, only this time they were empty. He was the only person in the picture with those empty chairs. I told my friend what I was doing when I took the picture. The image captures my friend in the act of remembering. I didn't tell him what to do—I purposely avoid giving my subjects very much direction—but I discovered a lot about him after I developed and printed the image.

LC You are a great storyteller. In some cases, you and your work have become the repository for personal histories. Your art defines history not by grand events but by the lives of ordinary individuals. So many of the images depict a loss of idealism and youthfulness. There are a number of pieces in which you have photographed yourself, sometimes with other people you know, sometimes with your family. How do you feel when you see these images of yourself?

HB There is a certain sadness in admitting that some things are gone forever. I am not really interested in old photographs as objects, rather I am interested in my old friends and family members in the images. Photography is the tool that allows me to remember my own childhood and my own life. This tool for remembering is also a way of thanking the people who I love and who have affected my life. The process of making the pieces can be extremely emotional for me. I do this consciously, for myself as well as for them. One of my delights in having the works collected is that I am indirectly forcing museums to memorialize my loved ones. Their lives become vehicles for expressing principles that are much bigger than a single individual. No matter where you are from, everyone has to grapple with the issues of life: what it means to love someone, and to lose someone.

HONG Lei
Interviewed by Lisa Corrin.

LC You started your artistic training not as a photographer but in applied arts.

HL Actually, as a lacquer painter. When I first got a camera I didn't think it would become a serious part of my creative activities. There are two key influences on my work: the authority of the Chinese painting tradition, and Chinese folk art.

LC In the book *Chinese Enjoying the Singing of Mountain Fires in Spring,* you wrote a fictional text that tells the story of a very famous artist who is lying on his deathbed and dreaming of artists from the distant past as well as from modern times. Part of the story is a list of artists that run through the history of Chinese art, but also includes Western artists including Lucio Fontana, Paul Klee, and Yves Klein.

HL My intention was to set up a dialogue between traditional Chinese art and the Western masters. I bring these two elements together to produce my own individual works.

LC One of your most well known works is the group of photographs called *Fall of the Forbidden City* (1997–98). *Autumn in the Forbidden City, East Veranda* (1997, CAT. 9) depicts a dead bird lying in a pool of blood with a suggestion of the palace in the background. The bird is wrapped in jewels. The image is tragic but erotic.

HL These are the first artworks in which I used photography. A friend gave me a scientific specimen. The bird is empty inside.

I wanted to make a work about five thousand years of Chinese history and its unchanging political system. China has been dominated by tyranny for thousands of year and is still a one-party system. You cannot stamp out tyranny. It still exists and the palace symbolizes its persistence. The jeweled bird represents the emperor's concubines. The concubine has been left to die, which symbolizes the suffocation of artistic expression by tyranny. Over time I have come to see the dead bird as the embodiment of my own self. In facing the world, I close my eyes tightly.

During the time this photograph was made I experienced serious personal problems and the entire world around me in China kept changing. Many beautiful traditions such as the ancient gardens were being demolished to make way for the new cities. I was really concerned about history being totally destroyed. I needed an outlet to express what I was feeling about this new reality.

LC The surface of the image incorporates scratches and paint. It looks like an old, hand-painted photograph. How do you approach the surfaces of your images? What is the connection between this process and the narrative content of the piece?

HL When the photograph is developed it doesn't express what I really want to say, so I tried to create a new kind of expressionism in my work. I see the photograph as a painting, a watercolor—the surface is literally water-like—an effect I achieve by adding a thin wash of color. I wanted it to have the appearance of diving out of the surface of water. The scratches in particular give the image the patina of history, but actually it's a totally unreal scene that I have set up.

LC Your current black-and-white works also use specimens, from dead birds to persimmons, that suggest still life. There are also elements of decontextualized Chinese landscape. Rocks or sky are reduced to inanimate objects. Focusing intensively on one element in turn gives it strong symbolic presence. The surfaces of these images are no longer lushly painted; instead they are extremely simple and come closer to classical Chinese brush and ink painting.

HL The still life is a very common subject in traditional Chinese painting. During the Song dynasty, for example, there were many Zen monks who practiced such simple approaches to this subject in painting.

LC You often create images that are intensely artificial and make them look historical. Are you trying to recuperate history by inventing it?

HL The beauty of Chinese history is irrepressible. You can't erase it, even though the people modernizing the country are doing a pretty good job of it. My job as an artist is to serve as a reminder of this past and its visual beauty. When I manufacture my images, I give that which has survived an intense visual power. The images are strongly emotional and nostalgic. It is about triggering memory as that history disappears.

LIN Tianmiao
Interviewed by Stephanie Smith.

SS When did you begin using string to wrap objects?

LT I had been living in New York with my husband, Wang Gongxin, and we moved back to Beijing in the late 1990s. I started the wrapping pieces then, shortly after our son was born.

SS Why did you choose that particular activity at that moment?

LT Before I started wrapping things, I was using cotton thread to make these perfectly round balls, and at the beginning I thought "Oh, this is ridiculous, it's so boring, what am I doing?" and then slowly I got into the rhythm of it and realized it was relaxing and gave me the opportunity to think about all sorts of other things.

SS Where did you find the objects you wrapped? Did you have them around you in your house, or did you go out and find them?

LT I've never used things that are far removed from my everyday life. I like that tactile feeling you have for objects that you touch and use and work with every day, things that you can just reach out and grab without even thinking about it.

SS After wrapping objects, you began making self-portraits adorned with balls of string. What led to this change?

LT I've always been interested in women and the feminine; all of my work is closely linked to my own life. I started the self-portrait work not long after I had my son, and I was thinking about the instinctual relationship between mother and child. Frogs, for instance, lay many eggs and then leave their tadpoles, while human beings have this extraordinary attachment to their offspring. This basic aspect of maternity was part of what I was exploring in those self-portraits.

There was one girl in my school when I was little. She left school every day at 10:00, which was very mysterious. It seemed extraordinary that she would leave school like that. Where did she go? We started a rumor that she lived in a special cave and would go home every day at 10:00 to lay an egg. We were all terrified of this little girl. It made a strong impression.

SS Do you think of the balls that you make as eggs?

LT Yes.

SS The activity of making those balls seems like a way to get a bit of yourself back and to create some distance between yourself and your child. The process allows your mind to go other places and also seems a way to create boundaries: it's an activity that's yours only. Is that part of what you were exploring in the self-portraits?

LT Yes, that's right. Even if I was doing it unconsciously, when I think about it of course I was protecting something of my own that wasn't "mommy-life."

Braiding (1998, CAT. 89) continues that idea. When I started making the braid I just kept going, and when I finished it was 300 meters long. It wasn't like I deliberately set out to get to 300 meters, that's just what it evolved into, and it was shortened later. In the front of the piece there's a massive self-portrait with no hair. The portrait is deliberately blurred. When you look you confront an almost iconic woman. You have no idea of her age or cultural background. All of that is blurred, in the same way that there's a certain universality to that stage at which a woman starts a family. I wanted to draw the viewer into the portrait, so string is tied into little knots on the surface and goes through the image and becomes part of the braid in the back. I used those knots as a way to focus the viewer's attention on the face through the three-dimensionality of the installation. I was thinking about the course of a woman's life. All these activities of family and motherhood just go on and on, and I wanted to emphasize this continuity.

SS The braid seems like such a heavy thing. Were you depicting something that weighs you down?

LT The braid gets thinner and finer and by the end it just fades out; it doesn't always stay heavy. There's also no real middle: it's all a lot of work and then finally it fades. Still I want to be clear that I see the string as something positive. It's not that these daily rituals aren't rewarding. There's a beauty and strength in the string. It goes from the front to the back and that three-dimensionality is full of the richness of life.

SS What's the physical relationship between the braid and the monitor at the end, which shows hands in the process of making the braid? Does the thread actually go into the back of the monitor?

LT My dream was always to have the monitor in the floor, so you'd see the string and then the surface of the monitor.

SS What about using a projection down onto the floor?

LT Really it has to come from the earth. The fact that it's coming from the ground elevates it from the personal to the more human, instinctual level.

ss I'd like to backtrack a bit. What was your initial artistic training?

LT I never really went to school for art, although my father is a traditional Chinese painter. Before we moved to New York in 1988, I wasn't making art, but I got quickly absorbed in it in New York; I'd see three exhibitions a week and my husband was always talking about what he and other artists were doing. It was a natural evolution and I slowly decided it was time to make my own artwork.

I remember Andy Warhol's movies. I didn't have a natural affinity for his painting but I loved his films. I remember spending hours at the Museum of Modern Art watching Warhol films, since there were so many little details on which I could focus. In his film work he expressed something very personal and very precise.

At the same time I was particularly fascinated by two women artists. I was impressed by Ann Hamilton's focus, and the way she was totally caught up in the craft of making her work. I was also impressed by how Barbara Kruger could be such an outspoken critic of her own society that she almost went overboard. That gave me the feeling that I had a role to play in society. Kruger had just taken for herself this role as a societal critic. No one told her she should do this. At that time my English wasn't very good and I was struggling with the phrasing. Every time I would figure out what one of her works said I was shocked by it. How could this woman be so tough?

Kiki Smith was also important in terms of the intensity with which she was able to show different kinds of relationships among family members. That intensity is very much the same kind of feeling I wanted to explore in my own work.

ss Were you making work in New York, or just looking?

LT I was just looking. The wrapping pieces were my first works.

ss Your photographs are beautiful and technically accomplished. How did you learn to make photographs? Did you teach yourself?

LT Yes, and my husband helped me learn some technical details. I experimented a lot. For every photo you see, I made many others. Even in the earliest wrapping works I also used video or photography when I showed them since I like the relationship between the actual object and the image.

MA Liuming
Interviewed by Melissa Chiu.

MC It is clear from your photographs that performance plays a key role in your early photographs. Can you talk about your performances?

ML I began performing again in 1993 when I arrived in Beijing. (I had stopped in 1989.) I moved into the East Village not knowing that other artists were there, and then we all stumbled upon each other. Performance wasn't really known then. My performance in

the East Village was one of the first. After my performance and Zhang Huan's at the China Art Gallery for his graduation, people began to think about performance art.

MC What about your alter-ego Fen-Ma Liuming? Why did you develop this idea?

ML One day, we were together with some girls who were randomly taking pictures and swapping clothes amongst themselves. When the pictures were developed they looked at them and said, "This guy, Ma, he really looks like a woman." At that time I wasn't thinking about art, but this incident was one influence on the Fen-Ma works. I looked at the picture and thought it would be an interesting path to explore. Another influence at the time was my experiences in public places such as the bus or the public showers. I often heard people ask whether I was a man or a woman. I began to think this was an idea I could use in performance art, because up to this point in China there had never really been a body-based performance art. The next step for this work was to invite a specially trained cosmetician to help make me up, and I selected a set of women's clothing. I also commissioned a commercial photographer to come and take pictures of me. These are the works in the Fen-Ma Liuming series (1993–ongoing, CAT. 17, 18). The thinking behind this work was just quite simply to appear as a woman. I think that the work actually fooled a lot of people, because when it was produced I wasn't well-known and a lot of people thought I was a woman.

MC And was that very much your intention, to fool people?

ML I never had any desire to change my gender. By wearing women's clothes I started to realize that it really wasn't the most interesting way to talk about what I wanted to talk about. So I started to retain a made-up female face while also showing my male body. I gave this character the name Fen-Ma Liuming. I've been using this character for the last nine years, and I think it has a literary quality because it is a hero or a main character that appears in a variety of different settings.

MC I'm interested in hearing more about how performance art developed here in China. Performance art is always cited as one of the more "experimental" art forms, and as the medium that is most frequently banned here in China. Also, how did you come to terms with this, since we always hear about performances in the early-to- mid-1990s being banned or subjected to government censorship?

ML Performance art was easily picked up by younger artists because it was an easy and direct way to express yourself. It also doesn't require many years of training like painting, so it's very immediate. Lots of problems come from doing performance art. One of the main issues is where it will take place. If you're going to be nude, it's not possible in certain contexts. It won't work. I think that only

in doing performance art for all these years have I started to come to understand some things about China. The government is concerned with sex and politics, so if your work has to do with either of these things you're going to run into some problems. Sex has kind of always been under wraps, or taboo, and is not actively discussed.

We started doing naked performance art for two reasons: firstly, it hadn't been done before, and secondly, it was a new visual language. It also fits in very well with the instinctual drives of the young performance artist. It's a natural gravitation. When I first came to the East Village I felt utterly free and thought that I could do anything, so we were doing performances all the time. But then in 1994 I was arrested and taken by the police after a performance by Zhang Huan. This was the first of a three-day schedule of performances: Zhang Huan was on the first day and I was meant to be on the second, with Zhu Ming on the third. After that the authorities wanted to find a lot of other artists in the East Village but they all ran away.

MC So after that was it a challenge to perform again? Did you think about other art forms?

ML No, I kept thinking about performance art, but my beliefs about performance art changed, as did those of many around me. I think it was at this moment that people moved from the idea of performance toward documentation, be it a video or a photograph. The idea behind recording performances was to be able to show them in the future. Actually at that point we didn't realize that what we were creating would become valuable.

MC What about the tension between performance and documentation? Do you see the photographs and videos as artworks in themselves, or purely as documentation of your performances?

ML In my portfolio, I have things that I consider as documentation and others that I would classify as works of art. Take, for example, the work I did on the Great Wall, *Fen-Ma Liuming Walks on the Great Wall* (1998). I invited a commercial artist to help shoot the photographs. He made decisions about where the pictures would be taken and in what order they would be exhibited. These were artistic decisions about the arrangement of the documentation. When I show these photographs and videotapes I almost always exhibit them as being done by a performance artist, not as a video artist or photographer. I don't want to say, "I'm a photographer, these are my works of photography." The fundamental problem of performance art is how to document it. This is an issue that can't be avoided.

SONG Dong and YIN Xiuzhen
Interviewed by Melissa Chiu.

MC Both of you use such vastly different media, including installation, photography, video, and performance. What have been some of the major influences on your work?

YXZ No one artist really influences me; it is more a process of finding something that attracts me and then I'll just do it. Photography is just one element of my artistic practice. Song Dong has done more multimedia works than I have. One of the best examples of my approach would be *Soft Poetry,* which was the first video I ever made. I saw Song Dong's videos and thought that it was something I should try.

SD It is hard to categorize my work by media, or by the way I show my art. My work is based on my own life and hence on human experience. One focus, you could say, is emotion. For instance, I have been using my family as a subject of my work for a long time. Although one might say that family is a very private matter, I use it to explore a public idea of family. *Family Member Photo Studio* (1998) is one such work. When I showed this in Beijing at the Contemporary Art Gallery, I projected the video onto the wall and asked members of the audience to stand in front of the projected image so that they merged with images of my family to create a new identity.

MC What about your collaboration on *Chopsticks* (2002)? Yin Xiuzhen, this was one of the few times you used video.

YXZ It was like a new toy. We recorded the same time, place, and situation, but with two different views. This has given me a new respect for video and made me think about doing more photography as well. In the future, I would like to be able to manipulate and edit the videos more.

MC Song Dong, some of your early video works document performances, such as *Breathing Part I* (1996, CAT. 24), the work that you did at Tiananmen Square. Is there a difference in your mind between works that record performances and those conceived specifically as art in their own right?

SD Recording performances is an important element of some of my videos because people cannot go back to see them. Art is about creating an experience. *Breathing* was not like other performances, with people standing around waiting to see what's happening. I did it without any audience. Having a lot of people around would have influenced my concentration. I prefer to have an audience that randomly passes by.

MC Let's talk about you both living in Beijing, because it strikes me that one of the similarities between your works is that they're so much about the experience of living in the city. Yin Xiuzhen, your works have often commented upon the destruction of the *hutongs* in Beijing and you've used roof tiles from old Beijing buildings. Song Dong, Tiananmen Square has been the site for some of your works. To what extent do you think living in Beijing has influenced your work?

YXZ Beijing is a part of my life: I grew up there, I work there, and I live there. But everything is changing. In three years our house will be demolished and we will have to move. In the past twenty years, we have seen the continuous disappearance of history and memory in

China. I wasn't really interested in architecture before, but when I began to see buildings being torn down I started to pay attention to it. The traditional buildings were replaced by huge, uniform apartment buildings. Most people are quite happy to live in them because they have their own toilet, kitchen, and shower. We can understand it, since in our *hutong* we have to share a bathroom and toilet. But I really started to enjoy this old way of living, especially since I started to travel abroad: in fact, the more I travel, the more I have fond memories of our gray, dark, narrow alley.

SD Yes, when we travel, we realize how important Beijing is to us. The bottom line is that we like Beijing. The city has changed a lot, and my work has also constantly changed.

MC So let us return to this idea of photography and video in China. What initially attracted you to these media?

SD I think they're convenient media. They're tools, really. It's easy to take a photograph just as it is to make a video. I can record what I am doing immediately.

YXZ You also don't need a large space. They're so easy to store. When I do installations, I need a huge space to store them. Photographs are much easier in this way. Also, for Song Dong, his work is a process of recording the moment and video allows him to do this.

MC You have both given quite pragmatic reasons for using these media. Are there any aesthetic qualities that you prefer over, say, painting or sculpture?

SD Since human beings started making art, they have always tried to portray reality as closely as possible.

MC Interesting, but wouldn't you say that in Chinese art there's a very different notion of realism than in Western art? Do you consider realism an important part of your work?

SD No, not in my work, but I think others use these media as a way of achieving realism. I think that photography is better than video. There's more imagination involved. For example, my water performance lasted about an hour, and the photographic work *Printing on Water* [also known as *Water Seal*] (1996, CAT. 94), doesn't represent the whole thing, but it seems better to show the photographs than the video. The thirty-six photographs that comprise this work have more visual impact than the video, especially in the way I arranged them in a grid. You can see them as a group.

WANG Jianwei
Interviewed by Melissa Chiu.

MC Let us begin with some of the ideas behind the transition in your work from paintings in the 1980s to installation practice in the 1990s, and, more recently, to photography and video. Can you talk about how you came to change media over this period?

WJ If you look at artists of my generation, including Xu Bing, Cai Guo-Qiang, and Zhang Peili, they all have a background in painting, although they don't paint now. It's just the way the educational system was at that time. In fact, the art academy system remains the same, even now. The reasons I changed media were also related to the overall feeling of the late 1980s, when materials and ideas from abroad held an incredible allure because China had been closed to the outside for so long. In a matter of a few years, I and my peers had read huge amounts of Western art history and philosophy: all absorbed at lightening speed. Even when I was in college, I didn't read as much. Every day involved crazy amounts of reading. Kafka and Borges were the most influential writers, while others such as Sartre also held appeal.

MC One of your most significant photographic works is *Circulation: Sowing and Harvesting* (1993–94). It resembles more of a scientific experiment with documentary photographs of wheat fields. How did you work with the farmers?

WJ The work is connected to my personal history: after I finished high school I was sent to the countryside in Sichuan, where I was a peasant for two years. For *Circulation*, I proposed that a group of farmers plant seeds that were only one year old, instead of the two-year-old seeds that they usually used. The local peasants doubted that this would work, so I signed a contract saying that we'd share the risk. If their seeds didn't produce, I would compensate them for their loss, and if there was an extraordinary harvest we'd split the profits. I had one Chinese acre to work with, about half of the farmers' plot. The harvest was very successful. I can't say whether it was the power of science or the power of art, though.

MC What about your use of photography and video, which are often seen as more "objective" and "scientific" media? Was this behind your decision?

WJ Sure, when I started, but at this point in my art production materials are not important in the slightest. Artistic thinking is what is most important. If you're determined, you can use the most traditional media to express interesting artistic ideas.

MC And what about your project *[Living] Elsewhere* (1998), which has a documentary quality to it?

WJ It originated as a documentary. It was based on the villas erected so quickly, almost in a heartbeat, which you often see on the road from the city to the airport. But a lot of them were never used or were destroyed. I wanted to see what life was like in these villas that had lain empty for up to seven years, to see what existence these people had been eking out in the shadow of such magnificent palaces. I became interested in these places because they were so close to where I was actually stationed when I was sent to the countryside. When I went back though, it was completely

different. I found out that the people living in the villas were from all over Sichuan. They lived in a very gray space. They were peasants whose land is constantly encroached upon by cities, so they move into the cities to build houses. They're neither urban residents nor peasants.

MC How receptive were the residents to your filming?

WJ In the first month I didn't take a single photo. The peasants were afraid that I was from a television station. They didn't have any water or electricity and they were afraid that if they were shown on television, the owner of the villas would come and evict them. I think my experience as a peasant for two years was pretty important to this project. I also think that peasants in China still have a certain romantic notion of "the intellectual youth" from the days of the Cultural Revolution.

MC The time that you spent in the country as a youth was obviously a formative experience for your artwork. (In fact, a lot of other artists have spoken about the Cultural Revolution as an influence.) But I can also see references to the films from this period in your work. Is this true?

WJ Contemporary art, as we all know, was something that began in China after the reforms of 1979. A large group went to study abroad and these artists spent time learning Western techniques and ideas and bringing them back to China. We got to the late 1990s and I think people wanted to start thinking about how to use things from our own culture to make art. Actually, for my generation, history is constituted in a very visual way. And by this I mean that our sense of history comes from propaganda movies. Regardless of what I think about the world now, my basic understanding—and that of my generation—was constituted in a very real way by these movies. So you could say, "Sure, we've changed, we're different now," but it doesn't change the fact that they educated us and were very influential when I was growing up. Although they were political, we watched them so many times that they became more than propaganda. These films informed our aesthetic visions in a very real way.

WANG Jinsong
Interviewed by Stephanie Smith

SS You started out studying traditional ink painting. Could you tell me about your background and training as an artist?

WJ I studied Chinese ink painting in school and then in the early 1990s I started making oil paintings. In the mid-1990s I began making photographs. But these aren't discrete periods; I work in all three media.

SS In many of those early oil paintings you depict crowds of people but leave at least one figure that is simply a white silhouette without any detail.

WJ I always left a blank figure in those paintings. It's a space to project your imagination, and maybe yourself, into the work, since that figure could be anyone.

SS The style of these is fairly realistic, in a way that's quite different from traditional ink painting: it's closer to photographic representations. Did these works lead you into your photographic work?

WJ I started out by taking pictures in preparation for my paintings, and then I began using the photographs themselves for my work.

SS You also used video during the mid-1990s to document performances. When you started working with video, were you inspired by some of the other Chinese artists who were making and showing video then or by artists from the West?

WJ I watched TV every day, which is a form of video, and I knew about a few Western video artists who were shown here or who I read about in magazines (now I know many more, of course). I traveled for several months in Europe in 1993, when my paintings were in the *China Avant-Garde* show, and that gave me a chance to see a lot of work. The most exciting thing to me was seeing the variety of media that artists were using to express their ideas.

SS Let's discuss the photographs, starting with your first major photographic work, *Standard Family* (1996), which is a large grid made up of family portraits of parents and the one child they are allowed by Chinese government policy. Do you intend this work as a critique?

WJ The work raises questions for the audience to think about, but it doesn't take a position one way or the other. The single-child family could be a good thing or a bad thing.

SS One of the choices you've made in much of your photography is to use the grid format to organize groups of smaller photographs into one larger image.

WJ In China there is a saying that repetition is power. That's part of the work, but it's not just about repetition. The portraits are similar but different, which allows the viewer to make comparisons.

SS That gets back to what you said about using the work to raise questions rather than to take a position. There's no way that all the families that you depict could all have the same experience of that policy, and by showing us a range of families who present themselves to your camera in different ways, you give viewers prompts for their own speculation. Of course viewers also might make many other kinds of comparisons, for instance between these pictures and portraits of their own families.

I'm curious about your production process. Did you create the master version of the piece by making a grid of actual photographs and then rephotographing it, or by scanning the photographs to make a digital image which you then printed?

WJ I made it digitally.

ss *Standard Family* exists in several different sizes, including one very large image. Scale changes the way viewers experience the image; do you think that one size is more effective than another?

WJ The smaller one is easier for people to collect or have in their homes.

ss After *Standard Family* and *Parents* (1999), you started exploring changes in urban China: not what's happened to the family, but what's happening to the city. You made one photographic grid work that documents the Chinese character for "demolition" marked on old buildings all over Beijing.

WJ It's a symbol of official power and also a beautiful mark.

ss But it's not just any symbol, it's the character for "demolition," so it also indicates the pace and extent of the change in the city as things are destroyed and built. That's also suggested by *City Wall* (2002, CAT. 62), which is a grid of black-and-white pictures of modern structures, along with scattered color images of people, parks, and traditional buildings, as well as a few blank spaces. Why the mix?

WJ Every day I experience the city and its architecture. Life in traditional architecture—the *hutongs*—isn't real life any more, it's like a postcard. At the same time, modern buildings may not seem real, either. They're fantastic, like Las Vegas, but still the modern city has less color than the hidden ancient city within it. I took the photographs out the window while driving around Beijing (you spend lot of time stuck in traffic these days).

ss Did you photograph any specific modern buildings?

WJ No, I didn't pick any particular buildings. I was just driving the ring roads in Beijing.

ss Are the gaps in the grid like the blank silhouettes you used in your earlier paintings: spaces for the viewers to project their own imagination or their ideas about the city into your image?

WJ I think about them in two ways. One is to imagine that the film wasn't exposed on that image, so a blank space was left. The other is exactly what you said about the earlier work.

WANG Qingsong
Interviewed by Melissa Chiu.

MC I know that you studied at the Sichuan Academy, which has a good reputation for painting. Can you explain how you came to produce photographs almost exclusively?

WQ Up until 1996 I was making oil paintings and treating them more like a diary in which I recorded what was going on in my life at the time. But after this, I observed that China was changing so much, so quickly that I felt as if I had to express my ideas and feelings about these rapid changes. I think that photographs are a better way to do this. But I didn't take photographs at the very beginning,

I tried collage first: combining different images and ideas into one picture.

MC So were there any other qualities besides the speed of photography that interested you?

WQ I selected photography because I think photographs have the appearance of truth. People seem to trust photographs better. Say, for example, in the liberation years, people felt certain heroes were doing a lot of good deeds because there were photographs recording them.

MC Do you think that this relationship between political history and photography has had a direct impact on your work?

WQ I don't think it's the political dimension but rather the cultural and social changes that have influenced my work. On the surface, modernization is quick, but it seems to be eroding the country as well. It is one thing to wish for modernization, but what about the modernization of our minds? It all seems very superficial. For example, on the streets in Beijing you often see big banners saying, "Whatever New York has, we Chinese also can have." People dream of having a good house and living as one does in the West.

MC In your photographs from 1999 titled *Requesting Buddha No. 1*, we see symbols of this consumer dream in the inclusion of foreign items such as Coca-Cola and McDonald's.

MC I want to show this blind admiration toward Western culture and commerce. In China, for example, if children study well, their parents would say, "If you receive a good score, I will take you to McDonald's." In the West, McDonald's is nothing but a fast-food retailer, but here in China it means something else. It's a place where people want to celebrate birthdays.

MC Works such as *Big Bathhouse* (2000), and *Looking for Fun* (2000) are more recognizably Chinese. Are they based on a specific image or idea?

WQ Every day we meet many difficulties and contradictions, so people who want to avoid problems go to saunas and pubs to enjoy themselves. They are looking for superficial pleasure. And it's really true, if you go to the sauna in China it's another way of saying you are going to a brothel. I have been doing a lot of storytelling scenes based on observations from daily life.

MC But there is something very theatrical about them.

WQ They do have a sense of performance to them. I want to use this heightened theatricality to increase people's understanding of what our daily life looks like, and to introduce satire, too. I'm critical of the superficial lifestyle. China is losing its special characteristics. In the past, when you went to Shanghai or Guangzhou they had unique qualities, but now they all look the same.

MC What about the references to a classical Chinese tradition in *Night Revels of Lao Li* (2000)? What kind of story are you trying to tell?

WQ The *Night Revels of Lao Li* is based on the Tang dynasty painting, *Night Revels of Han Xizai*. The post-Tang dynasty was a time when the old country was destroyed and a new country was being established, so I think it's very similar to the Chinese situation now. We're in an age of transformation. Han Xizai was an official in the court but the emperor didn't trust him. He had to pretend to enjoy himself and do nothing to betray the country. There are many classical history books and notes about this painting. I adapted these passages for my photograph.

WANG Youshen
Interviewed by Melissa Chiu.

MC Where did you go to art school? Did you specialize in any particular discipline?

WY I began my training at the College of the Arts, Beijing Central Art Academy, when I was sixteen years old. After graduating from the College, I continued my study at the Beijing Central Art Academy in the Folk Art Department and majored in illustration and graphics from 1984 to 1988.

MC Has this focus on folk art, illustration, and graphics had any bearing on the kind of work you produce today?

WY Certainly, I have been influenced by the technical art training I received at the Central Academy, but I would prefer to say that I benefited more from the unique environment of the Art Academy itself. The 1980s was a very important period in Chinese history because economic reform prompted a change of ideology and a great openness in art.

From 1980 to 1988 I was a student, and had the opportunity to study classical, modern, and contemporary art. I was a teenager at the time and it had a strong impact both on my art and on the formation of my personal philosophy. It was during these years that the 1985 Chinese Art Movement reached its climax. Some of my classmates and friends were involved in this movement and I came to change my attitude from merely thinking about it to being actively involved. The 1985 Art Movement was about fresh contemporary art and subverted the art training of the Academy. It changed my artistic philosophy forever.

MC Some of your projects have evolved directly out of your work at the *Beijing Youth Daily* newspaper. What are your views of the newspaper as a medium for the showing of artwork?

WY I have been interested in printed material for many years. One of my earlier works was titled *The Portrait Series* and was concerned with the relationship between text and image. I personally think that text and image combined are the most powerful tools of com-munication within a high-tech society. No one can avoid their impact. I have been working with newspapers for a long time and have always wanted to include them in my art. Newspapers are means for communicating with a vast audience. As a medium for artworks, they can have the same impact as showing in the museum—perhaps even a stronger impact. It's also a new way of exhibiting artwork in China.

MC Apart from the exhibition of work in the *Beijing Youth Daily*, you have also used the newspaper as raw material for your own work. I am thinking in particular of the *Newspaper* series (1993)—for example, the installation in which you covered a portion of the Great Wall with sheets from one issue of the *Beijing Youth Daily*. In another you printed an issue directly onto fabric, transforming curtains, clothes, and even bed sheets.

WY In my mind this work can be shown in the museum as well as outside the museum. For example, the Great Wall piece was not only an art project but very importantly it was initially designed as an advertisement for the *Beijing Youth Daily*. The newspaper not only provided the workers and financial support, but also spent 60,000 yuan to publish the work in a major Chinese newspaper.

MC So you do distinguish between your work as an artist and the work you do for the newspaper?

WY Both are very closely related to one another. In my daily activities I see myself as having three roles: firstly, as a clerk who has a daily office job; secondly, as an artist who makes work; and thirdly, as an art designer for a newspaper who creates work to promote newspaper sales.

MC All of your recent works using newspaper have been installations.

WY I consider installation a direct medium. Advertising after all has to have a strong impact. This is what the Great Wall was about—it is a signpost with all of the necessary characteristics to make people take notice. My experience of art practice has led me to believe that the use of materials in installation work allows an audience to engage with the concept of the work. Successful art, then, is that which uses materials in relation to the ideas expressed. The production, installation, display, and articulation of each artwork are also important.

MC The work you recently exhibited at the *New Asian Art Show* in Osaka and Tokyo [in 1995] was a firm political statement referring to the Sino-Japanese war. What kind of issues did you intend to raise in the work?

WY The work *Washing: 1941, Datong, Ten Thousand Men in a Ditch* [also known as *Washing: A 1941 Mass Grave in Datong* (CAT. 28)] refers to an historical topic and yet one that is relevant to many people in 1995, with the worldwide celebration of "remem-

brance": the fiftieth anniversary of the victory against fascism. Fifty years after the Second World War, the Japanese invasion has remained a nightmare for the Chinese people as well as people living in the Asia-Pacific region. Perhaps because of this history, Japan proposed the *New Asian Art Show*.

MC What kind of historical sources did you draw upon in the conception of this work?

WY In this work I used two original photographs which came from my reading of reports. The first covered an incident during the war where hundreds of thousands of Chinese were buried alive by the Japanese in Datong in 1941. This report occupied a whole page of the newspaper and detailed the findings of a Chinese researcher working on the recovery of the remains. One photograph featured the Chinese researcher washing a skull from the site; the second came from a report about Japanese outrage over the invasion in China.

MC Earlier, you spoke of the significance of materials in the relative success or failure of an installation. In *Washing: 1941, Datong, Ten Thousand Men in a Ditch,* how do the materials signify the issues you wanted to raise?

WY Physically the work consisted of two baths and two sets of shower equipment. The baths were covered by two groups of positive and negative images which were relatively grainy because the original photography was very small and it had to be enlarged substantially to cover the surface area of each bath. In the exhibition, the water was recycled through the shower equipment while washing the photographs in the bath. This physical washing of the images causes them to eventually disappear. In other words, the water washes the image away, just as time has washed people's memories clear of the atrocity that occurred fifty years ago.

XING Danwen
Interviewed by Lisa Corrin.

LC Can you tell me how you started your career as a photographer?

XD In 1989, I bought my own second-hand camera. That April I was in a demonstration in front of Tiananmen Square. After the schools closed and everybody left I decided to travel outside Beijing. I learned how to use the camera on that trip. Before 1992 I was mostly shooting street photography, catching the moment.

LC The body of work that transformed your relationship to the camera was a series of images taken of coal miners in Northwest China. Your photographs captured an important transitional moment in recent Chinese history.

XD After my trip to Northwest China, I decided to photograph people of the 1960s generation, of the Cultural Revolution. My interest was in identity—my identity—and also women's issues.

LC Perhaps the most iconic image you created is the triptych *Born With the Cultural Revolution* (1995, CAT. 30). It depicts a nude pregnant woman surrounded by photographs of Mao.

XD In my friend's apartment there were a lot of pictures of Mao. For our generation, Mao was our grandfather, an icon who filled us with respect and love. In 1995, after a period of intense cultural transition, China started to open up about a lot of issues and we were all quite confused. My friend had contradictory feelings about how she lived, her expectations, her future. The images behind her date from the Cultural Revolution and suggest that her identity has been formed against the backdrop of that history. My friend was born in 1966 at the beginning of the Cultural Revolution and was also from X'ian. Somehow the work is connected deeply to my own identity because I was born in 1967.

At the time that I took this photograph, I was questioning what it meant to be a woman sexually, professionally, and socially. People born during the Cultural Revolution were not really educated about sexuality or gender. There was little discussion of the intimate relationships between men and women. You didn't see this reflected in film, for example. Women never thought about their individuality because we all felt that we belonged to a unit: a family unit, a community unit, a social and political unit.

Under Mao, there was no separation between the private world of the individual, the family, and the body and the public political realm. The body of the woman in the photograph becomes a landscape within the context of political images. The angle I chose distorts my friend's body. It was her first baby, so she was excited about being a mother, but also confused. I feel her body doesn't really express happiness.

LC Were you aware of Western photography that focused on the female nude?

XD Not at that time. I hadn't seen a lot of photographs and I didn't know much. I continued to take images of my women friends. I photographed them in their private spaces engaging in activities that a male photographer would not have had access to in China.

LC The photographs are sensual, but not erotic. They are not about objectifying women but about using the body to reveal an inner state. Is that accurate?

XD Yes.

LC You left China for years to live in Europe and New York. How did this change your relationship to the camera?

XD I not only wanted to capture what I saw, but also to manipulate and control the medium. I used the image to express ideas. I was interested in film at the time and it had a great influence on me.

LC What were you trying to achieve in the recent *Scroll* series

(1999–2000, CAT. 63–65)? The scroll form is like the movement of film through the spool and is very cinematic.

XD I didn't want to reproduce a Chinese scroll; instead I wanted to connect photography to film. I had to plan each image very carefully. I wanted to make a panorama that I constructed rather than one constructed by the camera. This creates a narrative. These works made me even more interested in film and so I started to make videos. I continue to be interested in the formation of identity and its connection to historic memory.

LC Are you spending a lot of time thinking about the changes happening in China right now?

XD Yes, I am focusing on the subject of urbanism and modernity. Change is happening so quickly. Sometimes you go away and when you return you get lost because you don't recognize the streets. You have such a strange feeling because when you go to these huge new residential areas with their concrete high-rises, the streets are very wide. Now they're planting some small trees, but a short time ago the landscape was pure concrete. During the day when the sun was very bright, very pale and strong, you didn't know where you were. Places that were green fields in the countryside suddenly became part of the city.

XU Zhen
Interviewed by Stephanie Smith

SS You were one of the curators of a huge exhibition, *Art for Sale,* that was held in a shopping mall in Shanghai in 1999. You were very young then and you helped create a smart, inventive exhibition that's now one of the best-known of the experimental art exhibitions that were so important in Shanghai and Beijing in the late 1990s.

XZ Yes, it was the first exhibition I curated; I did it with several others. It was important at the time, although as time passes I'm sure that there will be many others.

SS Like many of the artists in the show, you also contributed a multiple that was sold in the front section of the exhibition, which was set up like a supermarket.

XZ Yes, I made a balloon with two mouthpieces, so two people could blow together and exchange air.

SS It makes me think of *From Inside the Body* (1999), your video of two people sniffing each other.

XZ People are always looking for something—looking for money, looking for houses, whatever—but they don't actually know what kind of thing they want. I was thinking about that when I made this artwork. So in the video, two people smell each other's bodies in a search for something. Maybe those things they think they want are all in their minds, and can't ever really be found.

SS Let's talk about another work, *Actually I Am Also Very Blurred* (2000, CAT. 127). It's an installation of images of body parts printed onto Post-It notes and mounted on gallery walls. How do you want the audience to interact with the work? Do you want people to handle the notes?

XZ Sometimes they fall down, and people put them back up.

SS But is that part of your intention for the piece? Do you want people to rearrange the images?

XZ I don't really care. If they fall down, people can stick them back up. It's ok; people can touch the notes. It's a natural impulse since the notes are so familiar from everyday life.

SS Since the notes lose their stickiness over time, are there several sets so that one set could be used in one place, and another for the next presentation?

XZ I have thousands of these images on my computer, so I can choose some of them for one space and some for another, depending on the needs of the exhibition space. For instance, once I put them in the bathroom of an office.

SS So you change the piece to fit each space.

XZ Yes.

SS Where do you get the images?

XZ From the Web. All of the images are from sex sites, but they're not necessarily explicit. Any part of the body can be erotic; for instance some people think arms are sexual.

SS Why did you decide to depict parts rather than the whole body?

XZ If you look at only part of the body, it leaves more for you to imagine. When people look at these pictures maybe they'll imagine a whole person for themselves using these fragments.

SS That's something like the function of pornography in general: the photograph is a trigger for a fantasy about some kind of idealized interaction with the depicted person. Here you're giving the viewer less to work with, and more at the same time; maybe viewers will be tempted to construct an image of their perfect Frankenstein lover out of your Post-its. Could you explain the title, *Actually I Am Also Very Blurred*?

XZ Since I'm only giving fragments of the body, the audience can't see the whole picture. They can only imagine the whole for themselves, and imagination is never clear: it's blurred. Maybe all these pictures are of one person. Maybe not. Maybe they depict thousands of people. None of these possibilities are limited. The audience can come up with their own interpretation without binding themselves or the piece to one meaning.

ss Also, the images themselves aren't clear; your prints are slightly fuzzy.

xz That's partly because I make them on my own printer at home.

ZHAO Bandi
Interviewed by Melissa Chiu.

MC Some of your best-known works involve self-portraits in photographs that include captions about life in China. Can you tell us about why you began to use images of yourself in this context?

ZB It's a very important aspect of my works that I include images of myself. I'm referring to the tradition of Chinese socialist propaganda posters that I grew up with. I use the works to change my role and create a new persona. The propaganda posters tell you what you can and cannot do, and you're the educated one, the student, in relation to these works. Everyone in China is familiar with this medium, so I thought about turning it around to see what it's like to be on the other side of propaganda. I don't think there's much creativity in terms of the substance of these works since they're all very basic social axioms, almost like rules such as "Don't smoke in a movie theatre," "Don't eat all the time." I don't think that I am creating a new and necessarily interesting vocabulary, but rather, I use what's already there. Although I hate advertising, I use its vocabulary and form.

MC What do you think you're trying to teach people with your own slogans?

ZB I don't want to teach people, since adversity is sometimes a better teacher.

MC And what about the use of the stuffed toy panda bear in your works? The panda has been used as a national symbol of China, but a toy panda is often your only companion in the posters.

ZB Yes, I was thinking about how to implement these works in a Chinese context, and the idea of using the panda came to me because it makes the entire project appear more tender and soft. If it were just me trying to educate the people, the reaction might not be as positive, but if I have a panda, which is so cute, I thought it might be easier. I first used the panda in 1996.

MC So are your messages directed to Chinese audiences?

ZB Yes, they are not for foreign audiences at all. My works are an entirely Chinese experiment. But, you know, when they were included in the 1999 Venice Biennale, things changed.

MC The characters in your photographs all speak with some sort of message and you say you don't want to teach people things, so where do you get the ideas for these sayings?

ZB Sometimes it's theft, and sometimes I have an idea for an image and I ask people's opinions. In others, I've just copied something, or changed something that I originally saw on the street based on what the government is saying. In 1996 I created two to three hundred big posters in the subway about laid-off workers. The union contacted me and wanted me to meet with the workers. The unionists thought that my posters were sympathetic and they wanted to work with me. Other works have been about AIDS. When the Family Planning Commission came to Beijing with UNESCO I worked with them to do a series of posters about safe sex. This was risky, but an adventurous decision that I think was worthwhile. It was also an experiment to see how far an artist could go within the confines of society, and test the limits of what is appropriate. You can't understand my works by looking at them separately. They have to be seen in context, including relations with the arts community, the government, and other social relationships. You have to be mindful of the tradition of propaganda posters in China as well.

MC When you exhibit your works outside of China do you think they still hold similar references?

ZB There are significant differences. One example is my work about quitting smoking. In China people treat the work seriously as a real advertisement, but in a place like Norway where people are pretty used to "quit smoking" advertisements, people thought it was a big joke when I showed it. In China people see the posters as something that should educate them, something they should take seriously.

MC Do you remember these posters from your childhood too? You were born in 1966, so some of your early experiences would have been during the Cultural Revolution.

ZB I don't remember anything apart from propaganda posters. This has become a visual language that I'm very familiar with. Slogans such as "Never forget the class struggle" were popular during my childhood.

TRANSLATION AND TRANSCRIPTION CREDITS

MELISSA CHIU:
Interviews conducted in Beijing in 2002
except as noted.
Philip Tinari,
primary translator.
Roberta Winters,
transcription assistance.
Song Dong and Yin Xiuzhen
interview translated with assistance from
Christophe Mao (New York, 2002).
Wang Qingsong
interview translated with assistance from
Zhang Fang.
A longer version
of Chiu's 1996 interview
with Wang Youshen first appeared
in *Art AsiaPacific*
vol. 2 (1996), 50–54.

LISA CORRIN:
Hai Bo interview
translated by Meg Maggio (Beijing, 2003).
Hong Lei interview
translated by Beatrice Leanza (Beijing, 2003).

STEPHANIE SMITH:
Lin Tianmiao interview
translated by Meg Maggio (Beijing, 2003).
Wang Jinsong interview
translated by Lin Xiaodong (Beijing, 2003).
Xu Zhen interview
translated by Vicky Jin (Shanghai, 2003).
Thanks to Staci Boris;
BizArts; CourtYard Gallery, Beijing; and
ShanghART Gallery, Shanghai
for their assistance.

ARTISTS' BIOGRAPHIES

Ai Weiwei
Lives in Beijing

1957
Born in Beijing

1978
Studied at Beijing Film Academy

1981
Attended Art Students League, New York

Attended Parsons School of Design, New York

Selected Exhibitions
1979
The Third Stars Art Exhibition (perimeter), National Art Gallery, Beijing

1999
Aperto All Over, The 48th Venice Biennale

2000
Fuck Off, Eastlink Gallery, Shanghai

2002
Reinterpretation: A Decade of Experimental Chinese Art, 1990–2000, The First Guangzhou Triennial, Guangdong Museum of Art, Guangzhou

AN Hong
Lives in Beijing

1963
Born in Beijing

1985
Graduated from Central Academy of Arts and Design, Beijing

Selected Exhibitions
1996
In the Name of Art, Liuhaisu Museum, Shanghai

Reality, Contemporary, Future, International Art Museum, Beijing

1997
The Fourth Lyon Biennial of Contemporary Art

1998
It's Me: An Aspect of Chinese Contemporary Art in the 90s, Imperial Ancestral Temple, Forbidden City, Beijing

1999
Food for Thought: Insight into Chinese Contemporary Art, De Witte Dame, Eindhoven, the Netherlands (coproduced with Canvas Foundation, Amsterdam; Royal Tropical Institute, Amsterdam; MU Art Foundation/Arctic Foundation, Eindhoven; and Canvas Foundation, Amsterdam)

BAI Yiluo
Lives in Beijing

1968
Born in Luoyang, Henan province

Selected Exhibitions
2001
Visibility, China Art and Archives Warehouse, Beijing

2002
Pingyao International Photography Festival

Run Jump Crawl Walk, East Modern Art Center, Beijing

Self-Talking, China Art Archives & Warehouse, Beijing

2003
Lifetime, Beijing Tokyo Art Projects, Beijing

CANG Xin
Lives in Beijing

1967
Born in Suihua, Heilongjiang province

1988
Studied at Tianjin Academy of Music, Tianjin

Selected Exhibitions
2000
House, Home, Family, 4/F Yuexing Furniture Corporation, Shanghai

2001
Hot Pot, Kunsternes Haus, Oslo

2002
Pingyao International Photography Festival

Reinterpretation: A Decade of Experimental Chinese Art, 1990–2000, The First Guangzhou Triennial, Guangdong Museum of Art, Guangzhou

(The World May Be) Fantastic, The Biennale of Sydney

2004
Over One Billion Served: Conceptual Photography from the People's Republic of China, Museum of Contemporary Art, Denver

CAO Fei
Lives in Guangzhou

1978
Born in Guangzhou.

2001
Graduated from Guangzhou Academy of Fine Arts

Selected Exhibitions
2000
Fuck Off, Eastlink Gallery, Shanghai

2001
Living in Time, Hamburger Bahnhof Museum of Contemporary Art, Berlin

Virtual Future, Guangdong Museum of Art, Guangzhou

2002
Pause, The Fourth Kwangju Biennial, Kwangju, Korea

Pingyao International Photography Festival

Reinterpretation: A Decade of Experimental Chinese Art, 1990–2000, The First Guangzhou Triennial, Guangdong Museum of Art, Guangzhou

2003
Alors, la Chine?, Centre Pompidou, Paris

Dreams and Conflicts: The Dictatorship of the Viewer, The 50th Venice Biennale

Zooming into Focus: Contemporary Chinese Photography from the Haudenschild Collection, San Diego State University Art Gallery

2004
China Now, The Museum of Modern Art, New York.

CHEN Lingyang
Lives in Guangzhou

1975
Born in Zhejiang province

1999
Graduated from Central Academy of Fine Arts, Beijing

Selected Exhibitions
1998
Paradise or Lost Paradise, Central Academy of Fine Arts Gallery, Beijing

1999
Post-Sense Sensibility: Distorted Bodies and Delusion, Basement of Building No. 2, Peony Residential District, Beijing

Supermarket, Shanghai Square Shopping Center

2000
Fuck Off, Eastlink Gallery, Shanghai

2001
Cross Pressures: Contemporary Photography and Video from Beijing, Oulu Art Museum, Oulu, Finland, and Finnish Museum of Contemporary Photography, Helsinki

Next Generation / Contemporary Asian Art, Passage de Retz, Paris

Visibility, China Art Archives & Warehouse, Beijing

CHEN Shaoxiong
Lives in Guangzhou

1962
Born in Shantou, Guangdong province

1984
Graduated from Guangzhou Fine Art Academy, Guangdong province

Selected Exhibitions
1997
Another Long March: Chinese Conceptual and Installation Art in the Nineties, Fundament Foundation, Breda, the Netherlands

Cities on the Move, CAPC, Bordeaux; PS1 Contemporary Art Center, New York; Louisiana Museum, Humlebaek, Denmark; Hayward Gallery, London, Museum of Modern Art, Helsinki; Bangkok

1998
16th World-Wide Video Festival, Amsterdam

2001
Living in Time: Contemporary Artists from China, Hamburger Bahnhof Museum of Contemporary Art, Berlin

CUI Xiuwen
Lives in Beijing

[n.d.]
Born in Haerbin, Heilongjiang province

1990
Graduated from Northeast Normal University, Haerbin, Heilongjiang province

1996
Graduated from the Central Academy of Fine Arts, Beijing

Selected Exhibitions
2001
Cross Pressures: Contemporary Photography and Video from Beijing, Oulu Art Museum, Oulu, Finland, and Finnish Museum of Contemporary Photography, Helsinki

2002
Reinterpretation: A Decade of Experimental Chinese Art, 1990–2000, The First Guangzhou Triennial, Guangdong Museum of Art, Guangzhou

Run Jump Crawl Walk, East Modern Art Center, Beijing

2003
Alors, la Chine? Centre Pompidou, Paris

Peripheries Become Center, The First Prague Biennale

FENG Feng
Lives in Guangzhou

1966
Born in Harbin, Heilongjiang province

1991
Graduated from Guangzhou Academy of Fine Arts, Guangzhou

Selected Exhibitions
2000
Society: The Second Academic Invitational Exhibition, Upriver Gallery, Chengdu, Sichuan province

2001
Urban Slang: Contemporary Art from the Pearl River Delta, He Xiangning Museum, Shenzhen

Virtual Future, Guangdong Museum of Art, Guangzhou

2002
Pause, The Fourth Kwangju Biennial, Kwangju, Korea

Reinterpretation: A Decade of Experimental Chinese Art, 1990–2000, The First Guangzhou Triennial, Guangdong Museum of Art, Guangzhou

FENG Mengbo
Lives in Beijing

1966
Born in Beijing

1985
Graduated from Beijing School of Arts and Crafts

1991
Graduated from Central Academy of Fine Arts, Beijing

Selected Exhibitions
1993
China's New Art, Post-1989, Hanart Gallery and Hong Kong Arts Centre

Mao Goes Pop: China Post-1989, Museum of Contemporary Art, Sydney

The 45th Venice Biennale

1997
Another Long March: Chinese Conceptual Art and Installation Art in the Nineties, Foundament Foundation, Breda, the Netherlands

Documenta IX, Kassel, Germany

The Fourth Lyon Biennial of Contemporary Art

1999
The First Fukuoka Asian Art Triennale, Fukuoka Asian Art Museum

2002
Documenta X, Kassel, Germany

Q4U, The Renaissance Society at the University of Chicago

Reinterpretation: A Decade of Experimental Chinese Art, 1990–2000, The First Guangzhou Triennial, Guangdong Museum of Art, Guangzhou

2003
Alors, la Chine?, Centre Pompidou, Paris

Past Virtualized—Future Cloned: Feng Mengbo 1994–2003, Museum of Contemporary Art, Taipei

GAO Brothers
Both live in Beijing

Gao Qiang
1962
Born in Jinan

1985
Graduated from Qufu Normal University, Shangdong province

Gao Zhen
1956
Born in Jinan

1981
Graduated from Shangdong Institute of Art and Design, Shangdong province

Selected Exhibitions
1989
China Avant-Garde, National Art Gallery, Beijing

1992
The First Guangzhou Biennial: Oil Paintings in the Nineties, Guangdong Exhibition Center, Guangzhou

2000
China Avant-garde Artists Documents, Fukuoka Art Museum, Japan

House, Home, Family, 4/F Yuexing Furniture Corporation, Shanghai

2002
Reinterpretation: A Decade of Experimental Chinese Art, 1990–2000, The First Guangzhou Triennial, Guangdong Museum of Art, Guangzhou

GU Dexin
Lives in Beijing

1962
Born in Beijing

Selected Exhibitions
1989
China Avant-Garde, National Art Gallery, Beijing

Magiciens de la Terre, Centre Pompidou, Paris

1993
China's New Art, Post-1989, Hanart Gallery and Hong Kong Arts Centre

1995
Identity and Alterity, The 46th Venice Biennale

1997
Another Long March: Chinese Conceptual Art and Installation Art in the Nineties, Foundament Foundation, Breda, the Netherlands

1998
Inside Out: New Chinese Art, Asia Society, New York and San Francisco Museum of Modern Art (copresented in New York at PS 1 Contemporary Art Center)

2000
Fuck Off, Eastlink Gallery, Shanghai

2001
Living in Time: Contemporary Artists from China, Hamburger Bahnhof Museum of Contemporary Art, Berlin

2002
Pause: The Fourth Kwangju Biennial, Kwangju, Korea

Reinterpretation: A Decade of Experimental Chinese Art, 1990–2000, The First Guangzhou Triennial, Guangdong Museum of Art, Guangzhou

HAI Bo
Lives in Beijing

1962
Born in Changchun, Jinlin province

1984
Graduated from Jinlin Art Institute, Changchun, Jinlin province

Selected Exhibitions
2000
House, Home, Family, 4/F Yuexing Furniture Corporation, Shanghai

Shanghai Spirit: The Third Shanghai Biennale, Shanghai Art Museum

2001
Plateau of Humankind, The 49th Venice Biennale

2002
Pingyao International Photography Festival

Reinterpretation: A Decade of Experimental Chinese Art, 1990–2000, The First Guangzhou Triennial, Guangdong Museum of Art, Guangzhou

HONG Hao
Lives in Beijing

1965
Born in Beijing

1989
Graduated from Central Academy of Fine Arts, Beijing

Selected Exhibitions
1993
China's New Art, Post-1989, Hanart Gallery and Hong Kong Arts Centre

Mao Goes Pop: China Post-1989, Museum of Contemporary Art, Sydney

1998
Inside Out: New Chinese Art, Asia Society, New York and San Francisco Museum of Modern Art (copresented in New York at PS 1 Contemporary Art Center)

1999
Love: Chinese Contemporary Photography and Video—International Arts Festival, Tachikawa, Japan

Revolutionary Capitals: Beijing–London, Institute of Contemporary Art, London

2000
Shanghai Spirit: The Third Shanghai Biennale, Shanghai Art Museum

2002
Reinterpretation: A Decade of Experimental Chinese Art, 1990–2000, The First Guangzhou Triennial, Guangdong Museum of Art, Guangzhou

HONG Lei
Lives in Beijing

1960
Born in Changzhou, Jiangsu province

1987
Graduated from Nanjing Academy of Arts, Nanjing, Jiangsu province

1993
Studied at Central Academy of Fine Arts, Beijing

Selected Exhibitions
1992
The First Guangzhou Biennial: Oil Paintings in the 90s, Guangdong Exhibition Center, Guangzhou

1999
Love: Chinese Contemporary Photography and Video—International Arts Festival, Tachikawa, Japan

2000
From Inside the Body, ISE Foundation, New York

2001
Cross Pressures: Contemporary Photography and Video from Beijing, Oulu Art Museum, Oulu, Finland, and Finnish Museum of Contemporary Photography, Helsinki

2002
Pingyao International Photography Festival

2003
Alors, la Chine?, Centre Pompidou, Paris

Pingyao International Photography Festival

HU Jieming
Lives in Shanghai

1957
Born in Shanghai

1984
Graduated from Shanghai Light Industry Technical College

Selected Exhibitions
2000
House, Home, Family, 4/F Yuexing Furniture Corporation, Shanghai

Raft of the Medusa, Asian Contemporary Art Centre, Vancouver

2001
010101: Art in Technological Times, San Francisco Museum of Modern Art

Hot Pot, Kunstnernes Haus, Oslo

Living in Time: Contemporary Artists from China, Hamburger Bahnhof Museum of Contemporary Art, Berlin

2002
Art in General's Fourth Annual Video Marathon, New York

Reinterpretation: A Decade of Experimental Chinese Art, 1990–2000, The First Guangzhou Triennial, Guangdong Museum of Art, Guangzhou

HUANG Yan
Lives in Beijing and Jilin

1966
Born in Jilin province

1987
Graduated from Changchun Normal University, Changchun, Jilin province

Selected Exhibitions
1988
The Image of the Object, Art Gallery of Dongbei Normal University, Changchun, China

1992
The First Guangzhou Biennial: Oil Paintings in the 90s, Guangdong Exhibition Center, Guangzhou

1993
Mao Goes Pop: China Post-1989, Museum of Contemporary Art, Sydney

1998
Persistent Deviation / Corruptionists, Basement of the Association of Chinese Literature Building, Beijing

2001
Hot Pot, Kunsternes Haus, Oslo

2002
Reinterpretation: A Decade of Experimental Chinese Art, 1990–2000, The First Guangzhou Triennial, Guangdong Museum of Art, Guangzhou

JIANG Zhi
Lives in Shenzhen

1971
Born in Yuanjiang, Hunan province

1995
Graduated from National Academy of Fine Arts, Hangzhou

Selected Exhibitions
1999
Post-Sense Sensibility: Distorted Bodies and Delusion, Basement of Building No. 2, Peony Residential District, Beijing

Revolutionary Capitals: Beijing–London, Institute of Contemporary Art, London

2001
Non-Linear Narrative, Gallery of National Academy of Fine Arts, Hangzhou

2002
Pause: The Fourth Kwangju Biennial, Kwangju, Korea

Reinterpretation: A Decade of Experimental Chinese Art, 1990–2000, The First Guangzhou Triennial, Guangdong Museum of Art, Guangzhou

Sze Tsung LEONG
Lives in Beijing and New York

1970
Born in Mexico City

1993
Graduated from University of California at Berkeley

1998
Graduated from Harvard University

Selected Exhibitions
1999
A Polder for Seclusion in the New York Bay, Frederieke Taylor/TZ Art, New York

2002
Painting as Paradox, Artists' Space, New York

Shopping: A Century of Consumer Culture, Schirn Kunsthalle, Frankfurt, and Tate Liverpool

Li Tianyuan
Lives in Beijing

1965
Born in Beijing

1988
Graduated from Central Academy of Fine Arts, Beijing

Selected Exhibitions
1993
Li Tianyuan Painting, National Art Gallery, Beijing

The Second Chinese Oil Painting Annual Exhibition, National Art Gallery, Beijing

1995
Chinese Oil Painting From Modernism to Post-Modernism, Brussels

1998
It's Me: An Aspect of Chinese Contemporary Art in the 90s, Imperial Ancestral Temple, Forbidden City, Beijing

2002
Pingyao International Photography Festival

LI Wei
Lives in Beijing

1970
Born in 1970, Hubei province

1993
Studied at Eastern Cultural Institute, Beijing

Selected Exhibitions
2000
Shanghai Spirit: The Third Shanghai Biennale, Shanghai Art Museum

2001
Constructed Reality—Beijing/Hong Kong Conceptual Photography, Hong Kong Arts Centre

2002
Pingyao International Photography Festival

2003
Asia Art Now, Seoul, Korea

Peripheries Become Center, The First Prague Biennale

LIN Tianmiao
Lives in Beijing

1961
Born in Taiyuan, Shanxi province

1984
Graduated from Capital Normal University, Beijing

1989
Studied at the Art Students League, New York

Selected Exhibitions
1997
Bound: Unbound 1995–97, Gallery of the Central Academy of Fine Arts, Beijing

1998
Inside Out: New Chinese Art, Asia Society, New York and San Francisco Museum of Modern Art (copresented in New York at PS 1 Contemporary Art Center)

1999
Revolutionary Capitals: Beijing–London, Institute of Contemporary Art, London

Gate of the New Century, Chengdu Modern Art Museum, Chengdu, Sichuan province

2000
House, Home, Family, 4/F Yuexing Furniture Corporation, Shanghai

2001
Broken Image, Cleveland Center for Contemporary Art

Translated Acts: Body and Performance Art From East Asia, Haus der Kulturen der Welt, Berlin, and Queens Museum of Art, New York

LIU Jian
Lives in Nanjing

1969
Born in Yancheng, Jiang Su province

1993
Graduated from Nanjing Art Institute

Selected Exhibitions
1998
Persistent Deviation / Corruptionists, Basement of the Association of Chinese Literature Building, Beijing

It's Me: An Aspect of Chinese Contemporary Art in the 90s, Imperial Ancestral Temple, Forbidden City, Beijing

1999
Ooh, La, La, Kitsch!, TEDA Contemporary Art Museum, Tianjin

2000
The Berlin International Media Art Festival, Berlin

2001
Experimental Media Arts Festival, Melbourne

2002
International Documentary Film Festival, Amsterdam

New York Video Festival, Film Society of Lincoln Center, New York

Reinterpretation: A Decade of Experimental Chinese Art, 1990–2000, The First Guangzhou Triennial, Guangdong Museum of Art, Guangzhou

2003
Banquete, Centre of Contemporary Art Palau de la Virreina of Barcelona; Center for Art and Media (ZKM), Karlsruhe; and Medialab Madrid

LIU Wei
Lives in Beijing

1965
Born in Beijing

1989
Graduated from Central Academy of Fine Arts, Beijing

Selected Exhibitions
1991
Liu Wei and Fang Lijun,
Beijing Art Museum

1993
China Avant-Garde, Haus
der Kulturen der Welt,
Berlin (coproduced with
Kunsthal Rotterdam;
Museum of Modern Art,
Oxford; and Kunsthallen
Brandts Klædefabrik,
Odense, Denmark)

*Mao Goes Pop: China
Post-1989,* Museum of
Contemporary Art,
Sydney

1995
*Identity and Alterity, The
46th Venice Biennale*

1998
*Inside Out: New Chinese
Art,* Asia Society, New
York and San Francisco
Museum of Modern Art
(copresented in New York
at PS 1 Contemporary Art
Center)

2004
*Over One Billion Served:
Conceptual Photography
from the People's
Republic of China,*
Museum of Contemporary
Art, Denver

LIU Wei
Lives in Beijing

1972
Born in Beijing

1996
Graduated from the
National Academy of Fine
Arts, Beijing

Selected Exhibitions
1999
Supermarket, Shanghai
Square Shopping Center

*Revolutionary Capitals:
Beijing–London,* Institute
of Contemporary Art,
London

*Post-Sense Sensibility:
Distorted Bodies and
Delusion,* Basement of
Building No. 2, Peony
Residential District,
Beijing

2000
*Berlin International Media
Art Festival,* Berlin

*Experimental Media Arts
Festival,* Melbourne

House, Home, Family, 4/F
Yuexing Furniture
Corporation, Shanghai

2001
Non-Linear Narrative,
Gallery of National
Academy of Fine Arts,
Hangzhou

2002
*Reinterpretation: A
Decade of Experimental
Chinese Art, 1990–2000,
The First Guangzhou
Triennial,* Guangdong
Museum of Art,
Guangzhou

Too Much Flavor, 3H Art
Center, Shanghai

LIU Zheng
Lives in Beijing

1969
Born in Wuqiang, Hebei
province

1991
Graduated from Beijing
Technology Institute,
Beijing

Selected Exhibitions
1997
*Contemporary
Photography from the
People's Republic of
China,* Neuer Kunstverein,
Berlin

1999
*Transience: Chinese
Experimental Chinese Art
at the End of the
Twentieth Century,* Smart
Museum of Art, University
of Chicago

2003
*Dreams and Conflicts:
The Dictatorship of the
Viewer, The 50th Venice
Biennale*

LUO Yongjin
Lives in Shanghai

1960
Born in Beijing

1982
Graduated from University
of Foreign Languages of
the People's Liberation
Army, Luoyang

1985–86
Studied at Zhejiang
Academy of Fine Arts,
Hangzhou

1992
Graduated from
Guangzhou Academy of
Fine Arts

Selected Exhibitions
1999
Fixed Transience, Eastlink
Gallery, Shanghai

2001
*The Anamorphic City,
Yipin International
Photography Festival,*
Dongying

*Chinese Cities Planning
Exhibition,* Chengdu
Modern Art Museum

Hot Pot, Kunstnernes
Haus, Oslo

*Strategies Against
Architecture II,*
Stabilimento Teseco, Pisa

2002
*Pingyao International
Photography Festival*

*Urban Creation, The
Fourth International
Shanghai Biennale,*
Shanghai Art Museum

MA Liuming
Lives in Beijing

1969
Born in Huangshi, Hubei
province

1991
Graduated from Hubei
Academy of Fine Arts,
Wuhan, Hubei province

Selected Exhibitions
1992
*The First Guangzhou
Biennial: Oil Painting in
the Nineties,* Guangdong
Exhibition Center,
Guangzhou

1997
*Another Long March:
Chinese Conceptual Art
and Installation Art in the
Nineties,* Foundament
Foundation, Breda, the
Netherlands

1998
*Inside Out: New Chinese
Art,* Asia Society, New
York and San Francisco
Museum of Modern Art
(copresented in New York
at PS 1 Contemporary Art
Center)

1999
*Aperto Over All, The 48th
Venice Biennale*

2001
Hot Pot, Kunstnernes
Haus, Oslo

*Translated Acts: Body
and Performance Art
From East Asia,* Haus der
Kulturen der Welt, Berlin,
and Queens Museum of
Art, New York

2002
*Pingyao International
Photography Festival*

*Reinterpretation: A
Decade of Experimental
Chinese Art, 1990–2000,
The First Guangzhou
Triennial,* Guangdong
Museum of Art,
Guangzhou

MIAO Xiaochun
Lives in Beijing

1964
Born in Wuxi, Jiangsu
province

1986
Graduated from Nangjing
University

1989
Graduated from Central
Academy of Fine Arts,
Beijing

1995–99
Studied at
Kunsthochschule Kassel,
Germany

Selected Exhibitions
2001
*From East to West and
Back to East,* Museum of
the Central Academy of
Fine Arts, Beijing

2002
*China: Tradition and
Modern,* Ludwig Museum,
Cologne

*Chinese Contemporary
Art,* Museum of
Contemporary Art, Zagreb

Fantasia, East Modern Art
Center, Beijing

*Media City Seoul 2002,
The Second Seoul
International Media Art
Biennale*

*Urban Creation, The
Fourth International
Shanghai Biennale,*
Shanghai Art Museum

MO Yi
Lives in Tianjin

1958
Born in Tibet

Selected Exhibitions
1998
*Contemporary
Photography from the
People's Republic of
China,* Neuer Berliner
Kunstverein, Berlin

1999
*Transience: Chinese
Experimental Art at the
End of the Twentieth
Century,* Smart Museum
of Art, University of
Chicago

2001
Oneself, Shandong
International Museum,
Ji'nan

2002
*Reinterpretation: A
Decade of Experimental
Chinese Art 1990-2000,
The First Guangzhou
Triennial,* Guangdong
Museum of Art,
Guangzhou

QIU Zhijie
Lives in Beijing

1969
Born in Fujian province

1992
Graduated from Zhejiang
Academy of Fine Arts,
Hangzhou

Selected Exhibitions
1993
*China's New Art, Post-
1989,* Hanart Gallery and
Hong Kong Arts Centre

1997
*Contemporary
Photography from the
People's Republic of
China,* Neuer Berliner
Kunstverein, Berlin

1998
*Inside Out: New Chinese
Art,* Asia Society, New
York and San Francisco
Museum of Modern Art
(copresented in New York
at PS 1 Contemporary Art
Center)

*It's Me: An Aspect of
Chinese Contemporary
Art in the 90s,* Imperial
Ancestral Temple,
Forbidden City, Beijing

1999
*Post-Sense Sensibility:
Distorted Bodies and
Delusion*, Basement of
Building No. 2, Peony
Residential District,
Beijing

*Revolutionary Capitals:
Beijing–London*, Institute
of Contemporary Art,
London

*Transience: Chinese
Experimental Art at the
End of the Twentieth
Century*, Smart Museum
of Art, University of
Chicago

2001
*Translated Acts: Body
and Performance Art
From East Asia*, Haus der
Kulturen der Welt, Berlin
and Queens Museum of
Art, New York

2002
*Pingyao International
Photography Festival*

*Reinterpretation: A
Decade of Experimental
Chinese Art, 1990–2000,
The First Guangzhou
Triennial*, Guangdong
Museum of Art,
Guangzhou

RONG Rong
Lives in Beijing

1968
Born in Zhangzhou, Fujian
province

1988
Graduated from Fujian
School of Art and Design,
Fujian province

1993
Studied at Central
Institute of Art and
Design, Beijing

Selected Exhibitions
1997
*Contemporary
Photography from the
People's Republic of
China*, Neuer Berliner
Kunstverein, Berlin

1999
*Love: Chinese
Contemporary
Photography and Video—
International Arts Festival*,
Tachikawa, Japan

*Transience: Chinese
Experimental Art at the
End of the Twentieth
Century*, Smart Museum
of Art, University of
Chicago

2000
From Inside the Body,
ISE Foundation, New York

Fuck Off, Eastlink Gallery,
Shanghai

2002
*Reinterpretation: A
Decade of Experimental
Chinese Art, 1990–2000,
The First Guangzhou
Triennial*, Guangdong
Museum of Art,
Guangzhou

SHENG Qi
Lives in Beijing

1965
Born in Anhui province

1988
Graduated from the
Central Academy of Art
and Design, Beijing

1989–1992
Lived and worked in Italy

1998
Graduated from Central
Saint Martin's College of
Art and Design, London

Selected Exhibitions
1989
China Avant-Garde,
National Art Gallery,
Beijing

1993
China Avant-Garde, Haus
der Kulturen der Welt,
Berlin (coproduced with
Kunsthal Rotterdam;
Museum of Modern Art,
Oxford; and Kunsthallen
Brandts Klædefabrik,
Odense, Denmark)

1998
*Inside Out: New Chinese
Art*, Asia Society, New
York and San Francisco
Museum of Modern Art
(copresented in New York
at PS 1 Contemporary Art
Center)

2004
*Over One Billion Served:
Conceptual Photography
from the People's
Republic of China*,
Museum of Contemporary
Art, Denver

SONG Dong
Lives in Beijing

1966
Born in Beijing

1989
Graduated from Capital
Normal University, Beijing

Selected Exhibitions
1994
*Another Lesson: Do You
Want to Play with Me?*
Gallery of the Central
Academy of Fine Arts,
Beijing

1998
*Inside Out: New Chinese
Art*, Asia Society, New
York and San Francisco
Museum of Modern Art
(copresented in New York
at PS 1 Contemporary Art
Center)

*It's Me: An Aspect of
Chinese Contemporary
Art in the 90s*, Imperial
Ancestral Temple,
Forbidden City, Beijing

1999
Cities on the Move,
CAPC, Bordeaux; PS1
Contemporary Art Center,
New York; Louisiana
Museum, Humlebaek,
Denmark; Hayward
Gallery, London, Museum
of Modern Art, Helsinki;
Bangkok

Supermarket, Shanghai
Square Shopping Center

*Transience: Chinese
Experimental Art at the
End of the Twentieth
Century*, Smart Museum
of Art, University of
Chicago

2000
*"Canceled": Exhibiting
Experimental Art in
China*, Smart Museum of
Art, University of Chicago

Fuck Off, Eastlink Gallery,
Shanghai

2001
*Living in Time:
Contemporary Artists
from China*, Hamburger
Bahnhof Museum of
Contemporary Art, Berlin

*Pause: The Fourth
Kwangju Biennial*,
Kwangju, Korea

*The Fourth Asia-Pacific
Triennial of Contemporary
Art*, Queensland Art
Gallery, Brisbane

2002
*Reinterpretation: A
Decade of Experimental
Chinese Art, 1990–2000,
The First Guangzhou
Triennial*, Guangdong
Museum of Art,
Guangzhou

SUI Jianguo
Lives in Beijing

1956
Born in Qingdao,
Shandong province

1989
Graduated from Central
Academy of Fine Arts,
Beijing

Selected Exhibitions
1993
*China's New Art, Post-
1989*, Hanart Gallery and
Hong Kong Arts Centre

1994
Memory of Space, Gallery
of the Central Academy
of Fine Arts, Beijing

*Transience: Chinese
Experimental Art at the
End of the Twentieth
Century*, Smart Museum
of Art, University of
Chicago

2000
*Shanghai Spirit: The
Third Shanghai Biennale*,
Shanghai Art Museum

2002
*Reinterpretation: A
Decade of Experimental
Chinese Art, 1990–2000,
The First Guangzhou
Triennial*, Guangdong
Museum of Art,
Guangzhou

SUN Yuan
Lives in Beijing

1972
Born in Beijing

1995
Graduated from Central
Academy of Fine Arts,
Beijing

Selected Exhibitions
1999
*Post-Sense Sensibility:
Distorted Bodies and
Delusion*, Basement of
Building No. 2, Peony
Residential District,
Beijing

2000
Fuck Off, Eastlink Gallery,
Shanghai

*Infatuated with Injury:
Open Studio Exhibition
No. 2*, Research Institute
of Sculpture, Beijing

2001
*Yokohama 2001:
International Triennial of
Contemporary Art*,
Yokohama

Women/Here,
Contemporary Art
Museum, Beijing

1999
*Transience: Chinese
Experimental Art at the
End of the Twentieth
Century*, Smart Museum
of Art, University of
Chicago

2000
*Shanghai Spirit: The
Third Shanghai Biennale*,
Shanghai Art Museum

2002
*Reinterpretation: A
Decade of Experimental
Chinese Art, 1990–2000,
The First Guangzhou
Triennial*, Guangdong
Museum of Art,
Guangzhou

WANG Gongxin
Lives in Beijing

1960
Born in Beijing, China

1982
Graduated from Normal
University, Beijing

Selected Exhibitions
1996
Image and Phenomena,
Gallery of the China
National Academy of Fine
Arts, Hangzhou

1997
Myth Powder No. 1,
Gallery of the Central
Academy of Fine Arts,
Beijing

2000
*18th World-Wide Video
Festival*, Amsterdam

2001
Living in Time,
Hamburger Bahnhof
Museum of Contemporary
Art, Berlin

*Plateau of Humankind,
The 49th Venice Biennale*

*Translated Acts: Body
and Performance Art
From East Asia*, Haus der
Kulturen der Welt, Berlin,
and Queens Museum of
Art, New York

*The 25th Sao Paulo
Biennial*

2002
*Reinterpretation: A
Decade of Experimental
Chinese Art, 1990–2000,
The First Guangzhou
Triennial*, Guangdong
Museum of Art,
Guangzhou

WANG Jianwei
Lives in Beijing

1958
Born in Shuining, Sichuan province

1988
Graduated from Zhejiang Academy of Fine Arts, Hangzhou

Selected Exhibitions
1995
The First Kwangju Biennial, Kwangju, Korea

1996
The Second Asia-Pacific Triennial of Contemporary Art, Queensland Art Gallery, Brisbane

1997
Documenta X, Kassel, Germany

1998
Cities on the Move, CAPC, Bordeaux; PS1 Contemporary Art Center, New York; Louisiana Museum, Humlebaek, Denmark; Hayward Gallery, London, Museum of Modern Art, Helsinki; Bangkok

1999
Revolutionary Capitals: Beijing–London, Institute of Contemporary Art, London

2001
Translated Acts: Body and Performance Art From East Asia, Haus der Kulturen der Welt, Berlin, and Queens Museum of Art, New York

2002
Reinterpretation: A Decade of Experimental Chinese Art, 1990–2000, The First Guangzhou Triennial, Guangdong Museum of Art, Guangzhou

WANG Jin
Lives in Beijing

1962
Born in Datong, Liaoning province

1987
Graduated from Zhejiang Academy of Fine Arts, Hangzhou

Selected Exhibitions
1997
Crack in the Continent, Watari Museum of Contemporary Art, Tokyo

1998
Inside Out: New Chinese Art, Asia Society, New York and San Francisco Museum of Modern Art (copresented in New York at PS 1 Contemporary Art Center)

1999
Transience: Chinese Experimental Art at the End of the Twentieth Century, Smart Museum of Art, University of Chicago

Aperto All Over, The 48th Venice Biennale

2002
Reinterpretation: A Decade of Experimental Chinese Art, 1990–2000, The First Guangzhou Triennial, Guangdong Museum of Art, Guangzhou

WANG Jinsong
Lives in Beijing

1963
Born in Heilongjiang province

1987
Graduated from Zhejiang Academy of Fine Arts, Hangzhou

Selected Exhibitions
1991
New Generation, China History Museum, Beijing

1992
The First Guangzhou Biennial: Oil Painting from the 90s, Guangzhou Exhibition Center, Guangzhou

1993
China Avant-Garde, Haus der Kulturen der Welt, Berlin (coproduced with Kunsthal Rotterdam; Museum of Modern Art, Oxford; and Kunsthallen Brandts Klædefabrik, Odense, Denmark)

China's New Art, Post-1989, Hong Kong Arts Centre

1998
Inside Out: New Chinese Art, Asia Society, New York and San Francisco Museum of Modern Art (copresented in New York at PS 1 Contemporary Art Center)

1999
Revolutionary Capitals: Beijing–London, Institute of Contemporary Art, London

2000
House, Home, Family, 4/F Yuexing Furniture Corporation, Shanghai

2002
Reinterpretation: A Decade of Experimental Chinese Art, 1990–2000, The First Guangzhou Triennial, Guangdong Museum of Art, Guangzhou

2004
Over One Billion Served: Conceptual Photography from the People's Republic of China, Museum of Contemporary Art, Denver

WANG Qingsong
Lives in Beijing

1966
Born in Heilongjiang province

1991
Graduated from the Sichuan Academy of Fine Arts

Selected Exhibitions
1999
Ooh, La, La, Kitsch!, TEDA Contemporary Art Museum, Tianjin

2000
Man + Space, The Third Kwangju Biennial, Kwangju, Korea

2001
Cross Pressures: Contemporary Photography and Video from Beijing, Oulu Art Museum, Oulu, Finland, and Finnish Museum of Contemporary Photography, Helsinki

2002
Run Jump Crawl Walk, East Modern Art Center, Beijing

Pingyao International Photography Festival

2003
Peripheries Become Center, The First Prague Biennale

2004
Over One Billion Served: Conceptual Photography from the People's Republic of China, Museum of Contemporary Art, Denver

WANG Wei
Lives in Beijing

1972
Born in Beijing

1996
Graduated from Central Academy of Fine Arts, Beijing

Selected Exhibitions
1999
Post-Sense Sensibility: Distorted Bodies and Delusion, Basement of Building No. 2, Peony Residential District, Beijing

Revolutionary Capitals: Beijing–London, Institute of Contemporary Art, London

2000
House, Home, Family, 4/F Yuexing Furniture Corporation, Shanghai

2001
Exposure: Recent Chinese Photography from the Collection of the Smart Museum of Art, Smart Museum of Art, University of Chicago

2002
Reinterpretation: A Decade of Experimental Chinese Art, 1990-2000, The First Guangzhou Triennial, Guangdong Museum of Art, Guangzhou

WANG Youshen
Lives in Beijing

1964
Born in Beijing

1988
Graduated from the Central Academy of Fine Arts, Beijing

Selected Exhibitions
1989
China Avant-Garde, National Art Gallery, Beijing

1993
China's New Art, Post-1989, Hanart Gallery and Hong Kong Arts Centre

Mao Goes Pop: China Post-1989, Museum of Contemporary Art, Sydney

The 45th Venice Biennale

1997
Another Long March: Chinese Conceptual Art and Installation Art in the Nineties, Foundament Foundation, Breda, the Netherlands

1998
Cities on the Move, CAPC, Bordeaux; PS1 Contemporary Art Center, New York; Louisiana Museum, Humlebaek, Denmark; Hayward Gallery, London, Museum of Modern Art, Helsinki; Bangkok

Wang Youshen: Washing—Darkroom, Art Gallery of New South Wales, Sydney

2002
Pingyao International Photography Festival

Reinterpretation: A Decade of Experimental Chinese Art, 1990–2000, The First Guangzhou Triennial, Guangdong Museum of Art, Guangzhou

WENG Fen
Lives in Haikou

1961
Born in Hainan

1985
Graduated from Guangzhou Academy of Fine Arts

Selected Exhibitions
1999
Post-Sense Sensibility: Distorted Bodies and Delusion, Basement of Building No. 2, Peony Residential District, Beijing

2000
China Avant-garde Artists Documents Exhibition, Fukuoka Museum of Art

House, Home, Family, 4/F Yuexing Furniture Corporation, Shanghai

2002
Pingyao International Photography Festival

Reinterpretation: A Decade of Experimental Chinese Art, 1990–2000, The First Guangzhou Triennial, Guangdong Museum of Art, Guangzhou

Urban Creation, the Fourth Shanghai Biennale, Shanghai Art Museum

Too Much Flavor, 3H Art Center, Shanghai

2003
Zooming into Focus: Contemporary Chinese Photography from the Haudenschild Collection, San Diego State University Art Gallery

XING Danwen
Lives in Beijing

1967
Born in Xi'an, Shanxi province

1992
Graduated from the Central Academy of Fine Arts, Beijing

2001
Graduated from School of Visual Arts, New York

Selected Exhibitions
1995
China's New Photography, Tokyo Gallery, Tokyo

1999
Transience: Chinese Experimental Art at the End of the Twentieth Century, Smart Museum of Art, University of Chicago

Revolutionary Capitals: Beijing–London, Institute of Contemporary Art, London

2001
Living in Time: Contemporary Artists from China, Hamburger Bahnhof Museum for Contemporary Art, Berlin

2002
Reinterpretation: A Decade of Experimental Chinese Art, 1990–2000, The First Guangzhou Triennial, Guangdong Museum of Art, Guangzhou

XIONG Wenyun
Lives in Japan and China

1953
Born in Chongqing, Sichuan province

1983
Graduated from Art Institute of Sichuan province

1994
Graduated from Tsukuba University, Japan

Selected Exhibitions
1979
Sichuan Art Exhibition, Sichuan province

1984
Sixth Art Exhibition of Excellent Chinese Works, China Art Museum, Beijing

1989
Fifth IMA Exhibition of the International Art Association, Nagatanigawa Gallery, Tokyo

1998
Dislocation, China Art Museum, Beijing

1999
Tachikawa International Art Festival, Tokyo

2002
Floating Rainbow, Fujikawa Gallery, Osaka

XU Zhen
Lives in Shanghai

1977
Born in Shanghai

1996
Graduated from Shanghai School of Arts and Crafts, China

Selected Exhibitions
1999
Food for Thought: Insight into Chinese Contemporary Art, De Witte Dame, Eindhoven, the Netherlands (coproduced with Canvas Foundation, Amsterdam; Royal Tropical Institute, Amsterdam; MU Art Foundation/Arctic Foundation, Eindhoven; and Canvas Foundation, Amsterdam)

Supermarket, Shanghai Square Shopping Center

2000
From Inside the Body, ISE Foundation, New York

Fuck Off, Eastlink Gallery, Shanghai

2001
Living in Time: Contemporary Artists from China, Hamburger Bahnhof Museum for Contemporary Art, Berlin

Plateau of Humankind, The 49th Venice Biennale

2002
Art in General's 4th Annual Video Marathon, New York

Reinterpretation: A Decade of Experimental Chinese Art, 1990–2000, The First Guangzhou Triennial, Guangdong Museum of Art, Guangzhou

2003
Zooming into Focus: Contemporary Chinese Photography from the Haudenschild Collection, San Diego State University Art Gallery

YANG Fudong
Lives in Shanghai

1971
Born in Beijing

1995
Graduated from China National Academy of Fine Arts, Hangzhou

Selected Exhibitions
1999
Post-Sense Sensibility: Distorted Bodies and Delusion, Basement of Building No. 2, Peony Residential District, Beijing

Supermarket, Shanghai Square Shopping Center

2000
Fuck Off, Eastlink Gallery, Shanghai

2002
Run Jump Crawl Walk, East Modern Art Center, Beijing

Art in General's 4th Annual Video Marathon, New York

Documenta XI, Kassel, Germany

Reinterpretation: A Decade of Experimental Chinese Art, 1990–2000, The First Guangzhou Triennial, Guangdong Museum of Art, Guangzhou

Urban Creation, the Fourth Shanghai Biennale, Shanghai Art Museum

2003
Dreams and Conflicts: The Dictatorship of the Viewer, The 50th Venice Biennale

Zooming into Focus: Contemporary Chinese Photography from the Haudenschild Collection, San Diego State University Art Gallery

YANG Yong
Lives in Shenzen

1975
Born in Sichuan

1995
Graduated from Sichuan Art Institute

Selected Exhibitions
1999
Cities on the Move, CAPC, Bordeaux; PS1 Contemporary Art Center, New York; Louisiana Museum, Humlebaek, Denmark; Hayward Gallery, London, Museum of Modern Art, Helsinki; Bangkok

Post-Sense Sensibility: Distorted Bodies and Delusion, Basement of Building No. 2, Peony Residential District, Beijing

2000
Fuck Off, Eastlink Gallery, Shanghai

2001
Urban Slang: Chinese Contemporary Art of Zhujiang Delta, He Xiangning Art Museum, Shenzhen

2002
Pause: The Fourth Kwangju Biennial, Kwangju, Korea

Pingyao International Photography Festival

2003
Zooming into Focus: Contemporary Chinese Photography from the Haudenschild Collection, San Diego State University Art Gallery

YANG Zhenzong
Lives in Shanghai

1968
Born Hangzhou, Zhjiang province

1990
Graduated from Zhejiang Institute of Silk Technology, Hangzhou

1993
Studied at Zhajiang Academyu of Fine Arts, Hangzhou

Selected Exhibitions
1996
Image and Phenomenon, Art Gallery of the China National Academy of Fine Arts, Hangzhou

1999
Supermarket, Shanghai Square Shopping Center

2000
Fuck Off, Eastlink Gallery, Shanghai

House, Home, Family, 4/F Yuexing Furniture Corporation, Shanghai

2001
Living in Time, Hamburger Bahnhof Museum of Contemporary Art, Berlin

2002
Reinterpretation: A Decade of Experimental Chinese Art, 1990–2000, The First Guangzhou Triennial, Guangdong Museum of Art, Guangzhou

2003
Zooming into Focus: Contemporary Chinese Photography from the Haudenschild Collection, San Diego State University Art Gallery

YIN Xiuzhen
Lives in Beijing

1963
Born in Beijing

1989
Graduated from Capital Normal University, Beijing

Selected Exhibitions
1995
Installations, Contemporary Art Museum, Beijing

1997
Another Long March: Chinese Conceptual Art and Installation Art in the Nineties, Foundament Foundation, Breda, the Netherlands

Cities on the Move, CAPC, Bordeaux; PS1 Contemporary Art Center, New York; Louisiana Museum, Humlebaek, Denmark; Hayward Gallery, London, Museum of Modern Art, Helsinki; Bangkok

1998
Inside Out: New Chinese Art, Asia Society, New York and San Francisco Museum of Modern Art (copresented in New York at PS 1 Contemporary Art Center)

1999
The Third Asia-Pacific Triennial of Contemporary Art, Queensland Art Gallery, Brisbane

Transience: Chinese Experimental Art at the End of the Twentieth Century, Smart Museum of Art, University of Chicago

2001
Living in Time, Hamburger Bahnhof Museum of Contemporary Art, Berlin

2002
Pause: The Fourth Kwangju Biennial, Kwangju, Korea

Reinterpretation: A Decade of Experimental Chinese Art, 1990–2000, The First Guangzhou Triennial, Guangdong Museum of Art, Guangzhou

2003
How Latitudes Become Form: Art in a Global Age, Walker Art Center, Minneapolis

Time After Time, Yerba Buena Art Center, San Francisco

YU Fan
Lives in Beijing

1966
Born in Qingdao, Shandong province

1988
Graduated from Shandong Art Institute, Qingdao

1992
Graduated from Central Academy of Fine Arts, Beijing

Selected Exhibitions
1994
Woman/Here, Contemporary Art Museum, Beijing

1995
Reality Present and Future, the International Art Palace, Holiday Inn Crowne Plaza, Beijing

1999
Transience: Chinese Experimental Art at the End of the Twentieth Century, Smart Museum of Art, University of Chicago

2000
I Live at 2208, Where Do You Live?, Passage Gallery, Central Academy of Fine Arts, Beijing

2002
Reinterpretation: A Decade of Experimental Chinese Art, 1990–2000, The First Guangzhou Triennial, Guangdong Museum of Art, Guangzhou

ZHAN Wang
Lives in Beijing

1962
Born in Beijing

1988
Graduated from Central Academy of Fine Arts, Beijing

Selected Exhibitions
1991
New Generation, China History Museum, Beijing

1994
Woman/Here, Contemporary Art Museum, Beijing

1998
Cities on the Move, CAPC, Bordeaux; PS1 Contemporary Art Center, New York; Louisiana Museum, Humlebaek, Denmark; Hayward Gallery, London, Museum of Modern Art, Helsinki; Bangkok

1999
Transience: Chinese Experimental Art at the End of the Twentieth Century, Smart Museum of Art, University of Chicago

2000
Shanghai Spirit: The Third Shanghai Biennale, Shanghai Art Museum

2002
Reinterpretation: A Decade of Experimental Chinese Art, 1990–2000, The First Guangzhou Triennial, Guangdong Museum of Art, Guangzhou

ZHANG Dali
Lives in Beijing

1963
Born in Harbin, Heilongjiang province

1987
Graduated from Central Academy of Art and Design, Beijing

Selected Exhibitions
1999
Revolutionary Capitals: Beijing–London, Institute of Contemporary Art, London

Food for Thought: Insight into Chinese Contemporary Art, De Witte Dame, Eindhoven, the Netherlands (coproduced with Canvas Foundation, Amsterdam; Royal Tropical Institute, Amsterdam; MU Art Foundation/Arctic Foundation, Eindhoven; and Canvas Foundation, Amsterdam)

2000
Fuck Off, Eastlink Gallery, Shanghai

2001
Cross Pressures: Contemporary Photography and Video from Beijing, Oulu Art Museum, Oulu, Finland, and Finnish Museum of Contemporary Photography, Helsinki

2002
Reinterpretation: A Decade of Experimental Chinese Art, 1990–2000, The First Guangzhou Triennial, Guangdong Museum of Art, Guangzhou

2004
Over One Billion Served: Conceptual Photography from the People's Republic of China, Museum of Contemporary Art, Denver

ZHANG Huan
Lives in New York

1965
Born in Anyang, Henan province

1993
Graduated from Central Academy of Fine Arts, Beijing

1988
Graduated from He Nan University, Kai Feng, Henan province

Selected Exhibitions
1998
Inside Out: New Chinese Art, Asia Society, New York and San Francisco Museum of Modern Art (copresented in New York at PS 1 Contemporary Art Center)

In Your Face, Andy Warhol Museum, Pittsburgh

1999
Aperto All Over, The 48th Venice Biennale

Transience: Chinese Experimental Art at the End of the Twentieth Century, Smart Museum of Art, University of Chicago

2001
Translated Acts: Body and Performance Art From East Asia, Haus der Kulturen der Welt, Berlin, and Queens Museum of Art, New York

2002
Whitney Biennial, Whitney Museum of American Art, New York

ZHAO Bandi
Lives in Beijing

1966
Born in Beijing

1988
Graduated from Central Academy of Fine Arts, Beijing

Selected Exhibitions
1996
Sydney Biennial, Art Gallery of New South Wales

1999
Aperto All Over, The 48th Venice Biennale

Revolutionary Capitals: Beijing–London, Institute of Contemporary Art, London

2000
Shanghai Spirit: The Third Shanghai Biennale, Shanghai Art Museum

2001
Cross Pressures: Contemporary Photography and Video from Beijing, Oulu Art Museum, Oulu, Finland, and Finnish Museum of Contemporary Photography, Helsinki

2002
Reinterpretation: A Decade of Experimental Chinese Art, 1990–2000, The First Guangzhou Triennial, Guangdong Museum of Art, Guangzhou

2003
Zooming into Focus: Contemporary Chinese Photography from the Haudenschild Collection, San Diego State University Art Gallery

2004
Over One Billion Served: Conceptual Photography from the People's Republic of China, Museum of Contemporary Art, Denver

ZHAO Liang
Lives in Beijing

1971
Born in Dandong, Lioning province

1992
Graduated from Lu Xun Academyu of Fine Arts, Sneyang, Liaoning pvoince

Selected Exhibitions
1998
16th World Wide Video Festival, Amersterdam

Persistent Deviation / Corruptionists, Basement of the Association of Chinese Literature Building, Beijing

2001
8th New York Underground Film Festival, New York

2002
IV International Independent Film Festival, Buenos Aires

2003
How Latitudes Become Form: Art in a Global Age, Walker Art Center, Minneapolis

ZHAO Qin
Lives in Nanjing

1967
Born in Xuzhou, Jiangsu province

1989
Graduated from Nanjing Art College

Selected Exhibitions
1998
It's Me: An Aspect of Chinese Contemporary Art in the 90s, Imperial Ancestral Temple, Forbidden City, Beijing

1999
Ooh, La, La, Kitsch!, TEDA Contemporary Art Museum, Tianjin

ZHAO Shaoruo
Lives in Espoo, Finland

1962
Born in China

1989
Graduated from Central Academy of Fine Arts, Beijing

1998
Cities on the Move, CAPC, Bordeaux; PS1 Contemporary Art Center, New York; Louisiana Museum, Humlebaek, Denmark; Hayward Gallery, London, Museum of Modern Art, Helsinki; Bangkok

1999
Food for Thought: Insight into Chinese Contemporary Art, De Witte Dame, Eindhoven, the Netherlands (coproduced with Canvas Foundation, Amsterdam; Royal Tropical Institute, Amsterdam; MU Art Foundation/Arctic Foundation, Eindhoven; and Canvas Foundation, Amsterdam)

Serendipity: Photography, Video, Experimental Film and Multimedia Installation from Asia, Japanese Foundation Forum, Tokyo, Japan

2001
Cross Pressures: Contemporary Photography and Video from Beijing, Oulu Art Museum, Oulu, Finland, and Finnish Museum of Contemporary Photography, Helsinki

2003
A Strange Heaven— Contemporary Chinese Photography, Rudolfinum Art Museum, Prague

From China with Art, Indonesian National Gallery, Jakarta

ZHENG Guogu
Lives in Yangjiang, Guangdong province

1970
Born in Yangjiang

1992
Graduated from Guangzhou Academy of Fine Art

Selected Exhibitions
1997
Contemporary Photography from the People's Republic of China, Neuer Berliner Kunstverein, Berlin

1998
Cities on the Move, CAPC, Bordeaux; PS1 Contemporary Art Center, New York; Louisiana Museum, Humlebaek, Denmark; Hayward Gallery, London, Museum of Modern Art, Helsinki; Bangkok

1999
Love: Chinese Contemporary Photography and Video— International Arts Festival, Tachikawa, Japan

Post-Sense Sensibility: Distorted Bodies and Delusion, Basement of Building No. 2, Peony Residential District, Beijing

Supermarket, Shanghai Square Shopping Center

2000
Fuck Off, Eastlink Gallery, Shanghai

2001
Cross Pressures: Contemporary Photography and Video from Beijing, Oulu Art Museum, Oulu, Finland, and Finnish Museum of Contemporary Photography, Helsinki

Hot Pot, Kunsternes Haus, Oslo

Urban Slang: Chinese Contemporary Art of Zhujiang Delta, He Xiangning Art Museum, Shenzhen

2002
Pause: The Fourth Kwangju Biennial, Kwangju, Korea

Urban Creation, The Fourth International Shanghai Biennale, Shanghai Art Museum

2003
Dreams and Conflicts: The Dictatorship of the Viewer, The 50th Venice Biennale

Zooming into Focus: Contemporary Chinese Photography from the Haudenschild Collection, San Diego State University Art Gallery

ZHOU Xiaohu
Lives in Beijing and Changzhou

1960
Born in Changzhou, Jiangsu province

1989
Graduated from the Sichuan Academy of Fine Arts

Selected Exhibitions
1996
In the Name of Art, Liu Haisu Museum of Art, Shanghai

2000
Shanghai Spirit: The Third Shanghai Biennale, Shanghai Art Museum

2001
Living in Time, Hamburger Bahnhof Museum of Contemporary Art, Berlin

Non-Linear Narrative, Gallery of National Academy of Fine Arts, Hangzhou

2002
Art in General's 4th Annual Video Marathon, New York

Reinterpretation: A Decade of Experimental Chinese Art, 1990–2000, The First Guangzhou Triennial, Guangdong Museum of Art, Guangzhou

Too Much Flavor, 3H Art Center, Shanghai

2003
A Strange Heaven— Contemporary Chinese Photography, Rudolfinum Art Museum, Prague

2004
Fly Utopia!, Transmediale '04, Haus der Kulturen der Welt, Berlin

ZHU Ming
Lives in Beijing

1972
Born in Changsha, Hunan province

Selected Exhibitions
1993
China Avant-Garde, Haus der Kulturen der Welt, Berlin (coproduced with Kunsthal Rotterdam; Museum of Modern Art, Oxford; and Kunsthallen Brandts Klædefabrik, Odense, Denmark)

Zhu Ming Modern Art Exhibition, National Art Gallery, Beijing

2000
Fuck Off, Eastlink Gallery, Shanghai

2004
Over One Billion Served: Conceptual Photography from the People's Republic of China, Museum of Contemporary Art, Denver

ZHUANG Hui
Lives in Beijing

1963
Born in Yumen, Gansu province

Selected Exhibitions
1997
Contemporary Photography from the People's Republic of China, Neuer Berliner Kunstverein, Berlin

1999
Aperto All Over, The 48th Venice Biennale

2001
Cross Pressures: Contemporary Photography and Video from Beijing, Oulu Art Museum, Oulu, Finland, and Finnish Museum of Contemporary Photography, Helsinki

2002
Reinterpretation: A Decade of Experimental Chinese Art, 1990–2000, The First Guangzhou Triennial, Guangdong Museum of Art, Guangzhou

Run Jump Crawl Walk, East Modern Center, Beijing

ARTISTS' STATEMENTS

AI Weiwei

Photography as a practice is no longer about recording reality, but has become reality itself. The image has become a vehicle and has assumed a fundamental material meaning; for example, size, depth, and verisimilitude point to different meanings it might contain. When we discuss photography, we seek to understand the object and the subtle connection between the object and its meaning. There arises in the image a division between its truth and its potential as an important object of reference, and in this division, the image once again becomes reality itself.

The notion of image as reality gives photography another layer of meaning, which, like all of our knowledge, remains specious. Deciding whether or not to believe the information carried in images does not assuage our doubt of the feelings and possibilities brought on by images. Analysis of light, density, and numbers make rationality and emotion dissociate in their dependence on and alienation from reality.

When photography is liberated from technological and documentary roles, it becomes a possibility derived from fleeting reality. This transition makes photography into a more meaningful human activity. It becomes a form of existence that reveals, like all other human activities, impassable obstacles in our life, memory, and perception. Living is but an uncontested reality, and production is another reality that has no true connection with this reality. Both are looking for miracles, raising new questions of meaning one by one. As an intermediary, photography propels life and perception into hitherto foreign struggles.

AN Hong

The *Buddha Series,* a photography and performance work, strongly critiques contemporary society. It reflects on how Buddhism is misunderstood today, and shows how this misunderstanding is integrated into the current economic and cultural dimensions of our lives. I felt compelled to mix a cocktail comprising Buddha and sex, Buddha and marriage, Buddha and pleasure-seeking, and Buddha and popular entertainment.

In 1997, I began using photography for the *Buddha Series;* this was my first use of photographic techniques. The works were completed on site without any technological aid from computers. The water Buddha (CAT. 83), representative work in the *Buddha Series,* conveys an extreme sense of narcissism.

"Buddha" may be the last to peep into my frivolous, unprincipled, and unrestricted life. "Buddha" may be the humor that is needed to alleviate my bitter life. "Buddha" may be the alibi that I use to avoid love and hate and crime and punishment. Above all, "Buddha" may be the last monarch who blesses and protects our paths toward a life of kitsch.

Thus, in the name of "Buddha," I produced the series of color photographs: *Buddha Cures Venereal Diseases, Buddha's One Night Stand, Joyful Buddha, Buddha's Love-Giving Project.* I made these to pay homage to "Buddha." A joke.

BAI Yiluo

On *The People* (CAT. 36): This work concerns my own experiences. I used to work in a photo studio where I would take ID photos. To ensure that I produced the desired results, I would always shoot two negatives. One would be given to the customer, while the other was to be thrown away. However, rather than discarding the second negative, I would keep it for myself. At the time, I didn't give it too much thought. Only later, when I was producing artwork, did I feel compelled to use this collection of images.

The basic materials of this work include photo paper and thread. First I print the small ID photos, then I tear the paper backing off of each. Afterward I crumple and iron each photograph so that cracks appear on the surface. In the last step, the photos are threaded together to achieve the final product. Because the entire process involves only primitive, manual work, it can be somewhat tedious. However, it is the only procedure that affords me an understanding of people. I believe that art originates from life.

CANG Xin

All things—with or without life—have a certain kind of memory. Things with or without life can store information.

We should return ourselves to a more pure and original state. In ancient times, sages derived power from the unity between themselves and the animate world, as well from their as ascetic practices in the wilderness.

We should pursue "supernatural individuality." Our inner selves hold a certain hidden principle that guides the mysterious actions of natural things, man-made objects, animal worlds, and people. We all live in specific spiritual and historical situations that mold our behavior.

Performance artists are like wizards. This can be attributed to their combination of spirituality and physicality.

CAO Fei

On *Rabid Dogs* (CAT. 84): We love whips. We need to worry. We don't dare to bark, and we work tamely, faithfully, and patiently like dogs. We do everything our boss asks, getting his point brightly and in no time. We are surely poor dogs, willing to act as animals and locked in the cage of modernization. When will we have the courage to bite our bosses ruthlessly, taking off our masks, peeling off our fur, and becoming a group of real rabid dogs?

CHEN Lingyang

On *25:00, No. 2* (CAT. 37): This "giantess" is not really very brave, and so she will only freely change her size and make these kinds of gestures when the clock strikes 25:00.
Very often, the real world and the male world get mixed up in my mind. They both come from outside me; they both exist very forcefully, with initiative, power, and aggression. Facing these two worlds, I often feel that I am weak and helpless, and don't know what to do. But just being alive means that I cannot avoid them, not even for one day. I wish that every day there could be a certain time like 25:00, when I could become as large as I like, and do whatever I want.

CHEN Shaoxiong

Just as a person can't jump into the same river twice, I'll never see the same scenery while looking out my window. Everything in this city is temporary: streets, buildings, shopping centers, train stations, airport, transit ways, trees, road markers, even the crowds. Nothing is fixed; things change as easily as a telephone number.
I use my photography to fix these moving objects, and then I reinsert them into the background. These moments and things either meet or by-pass each other in this world; it doesn't really matter which. I would like to replay this chaotic logic, these uncontrollable rules, and this confusing magic. I have a passion for this world; I have to record what I have seen. As a witness, I would like to keep the memory of my life inside my small-scale country, or to build a monument for this ever-changing city.
Seeing scenery through a window is a kind of tourism. When my works are put into an exhibition in a foreign country, they become its opposite: a city that travels.

CUI Xiuwen

My creative work is based on the problems surrounding female existence in our society. For example, in *Ladies Room* (CAT. 40), my subject was a group of women in the washroom of a posh Beijing nightclub who were engaged in providing "night service" there.
The washroom is a public space for women, but those who engage in "night service" transform the meaning and function of this space, giving it a kind of collective feminine spirit. Each woman's private secrets are revealed in this space. Yet to people outside, it brims with unknown possibilities. Superficially, I have videotaped the condition of these women, but I am more concerned with the underlying social construction of their condition, as well as with the ways that people interpret this work from cultural, historical, and economic positions. I chose video as my medium because its ability to depict time and space most clearly conveys the content of my work.

FENG Feng

On *Shin Brace* (CAT. 105): The relationship between steel and flesh is very direct. There is nothing ambiguous about it. It is like the relationship between medicine and biology, science and humanity, the culture of the West and the East, the male and female sexes. These kinds of relationships are equally absolute. The power we sense here imposes a shock on our senses, but the same kind of shock can be comforting. It allows us to exist safely, joyfully even, within a soul-stirring state. We trust in, take perverse pleasure in, and even admire this kind of injury, almost as a cure or salvation. This is what really shocks us. It is like that long piece of hard steel piercing the flesh. We see the reaction of the flesh, how swiftly it closes around the steel pin, producing a thick scab, how it is raised from the skin as if posed on the brink of an anticipated climax.

FENG Mengbo

My Private Album (CAT. 2) is my first interactive CD-ROM. Apart from the technical reasons for using this medium, I wanted to give my audience greater freedom to manipulate my work. I felt that an interactive work would help me break free of the constrictions of a linear narrative and bring the work closer to reproducing the palimpsest nature of memory itself. I have created three works entitled *My Private Album*. The first was a set of engravings, the second, made in 1991–92, was an installation consisting of handmade paper and netting. This is my third attempt, and further evidence of my fixated pursuit of this topic.

When looking through my family's photographs, I discovered as I wiped off the dust of years that these pictures still move me deeply. I've looked through the photo albums of many other families. They share many similarities: the people in the pictures are wearing the same kind of clothes, their faces are decked in similar smiles, their bodies cast even what seem to be the same kind of shadows. Those similarities astounded me. In every image of a family gathering something has changed. Perhaps one of the older people has passed away and one of their offspring has become head of that family. And there's always a new child or two. In the time that's elapsed between pictures being taken, the children grow with remarkable speed; the elder brother's jacket is handed down to the younger brother; the newly married elder sister is now pregnant with her own child.

I am tired of art that strains to be new and different. I also despise those who pursue aestheticism. All of that affected posing pales into insignificance in the face of life itself. My art is concerned with the commonplace lives of ordinary people. I'm fascinated by the fact that despite all of its travails, humankind battles on for survival and struggles to maintain its basic dignity, ever hopeful and often humorous. I've always been partial to works that express a spirit of optimism. Now my parents are sitting in front of my computer. They move the mouse with hands made coarse and clumsy by a lifetime of work, transfixed by the photographs that appear on the screen before them. Sometimes their eyes fill with tears. When I tell them that this CD-ROM is going to be shown at exhibitions in Europe and the United States, they ask in wonderment whether something like this can be regarded as art. What can I say? My CD is more of a family history than a work of art. It is an audiovisual document. Every family can produce its own *Private Album*. Mine is just an example of the most ordinary kind of family. But perhaps it's that very ordinariness that I treasure so much. And all I can do is present it humbly to others through my work. My CD is interactive; it's not a work made for the imposing walls of an art gallery. It's in an accessible format that anyone can use. Through it I extend an invitation to you to experience it in the whimsical manner in which I have produced it. Perhaps in the future all of our memories will speak to each other in this way, gradually forming an opaque mass, at once both chaotic and inclusive.

GAO Brothers
(GAO Zhen and GAO Qiang)

Thus far, our photographic work can be divided into four categories. The first is real-life documentary work, in which we are the discoverers of a unique problem and a unique perspective. Photography here merely serves as a means to objectively document our discoveries. The second type is a by-product of our performance pieces. The singular nature of performance art necessitates the existence of this type of photography. The third type is staged photography, which entails the arrangement of props and human actions for the sake of photography. The fourth type uses computers to process the photographic images from the previous three categories, thereby eventually yielding a digitized photography.

An Installation on Tiananmen (CAT. 3), photographed in Beijing in 1995, falls into the first category. It is one part of our series of Chairman Mao portraits in Tiananmen Square, which were photographed with ascending increments in an upward angle of view. Since 1949 Mao has been a deified figure; his portrait hangs high in Tiananmen Square and is viewed from below by tens of thousands of people in China. When photographing *Installation on Tiananmen Square,* we consciously exaggerated the upward angle of view to a degree of absurdity.

FENG Mengbo

My Private Album (CAT. 2) is my first interactive CD-ROM. Apart from the technical reasons for using this medium, I wanted to give my audience greater freedom to manipulate my work. I felt that an interactive work would help me break free of the constrictions of a linear narrative and bring the work closer to reproducing the palimpsest nature of memory itself. I have created three works entitled *My Private Album*. The first was a set of engravings, the second, made in 1991–92, was an installation consisting of handmade paper and netting. This is my third attempt, and further evidence of my fixated pursuit of this topic.

When looking through my family's photographs, I discovered as I wiped off the dust of years that these pictures still move me deeply. I've looked through the photo albums of many other families. They share many similarities: the people in the pictures are wearing the same kind of clothes, their faces are decked in similar smiles, their bodies cast even what seem to be the same kind of shadows. Those similarities astounded me. In every image of a family gathering something has changed. Perhaps one of the older people has passed away and one of their offspring has become head of that family. And there's always a new child or two. In the time that's elapsed between pictures being taken, the children grow with remarkable speed; the elder brother's jacket is handed down to the younger brother; the newly married elder sister is now pregnant with her own child.

I am tired of art that strains to be new and different. I also despise those who pursue aestheticism. All of that affected posing pales into insignificance in the face of life itself. My art is concerned with the commonplace lives of ordinary people. I'm fascinated by the fact that despite all of its travails, humankind battles on for survival and struggles to maintain its basic dignity, ever hopeful and often humorous. I've always been partial to works that express a spirit of optimism. Now my parents are sitting in front of my computer. They move the mouse with hands made coarse and clumsy by a lifetime of work, transfixed by the photographs that appear on the screen before them. Sometimes their eyes fill with tears. When I tell them that this CD-ROM is going to be shown at exhibitions in Europe and the United States, they ask in wonderment whether something like this can be regarded as art. What can I say? My CD is more of a family history than a work of art. It is an audiovisual document. Every family can produce its own *Private Album*. Mine is just an example of the most ordinary kind of family. But perhaps it's that very ordinariness that I treasure so much. And all I can do is present it humbly to others through my work.

My CD is interactive; it's not a work made for the imposing walls of an art gallery. It's in an accessible format that anyone can use. Through it I extend an invitation to you to experience it in the whimsical manner in which I have produced it. Perhaps in the future all of our memories will speak to each other in this way, gradually forming an opaque mass, at once both chaotic and inclusive.

GAO Brothers
(GAO Zhen and GAO Qiang)

Thus far, our photographic work can be divided into four categories. The first is real-life documentary work, in which we are the discoverers of a unique problem and a unique perspective. Photography here merely serves as a means to objectively document our discoveries. The second type is a by-product of our performance pieces. The singular nature of performance art necessitates the existence of this type of photography. The third type is staged photography, which entails the arrangement of props and human actions for the sake of photography. The fourth type uses computers to process the photographic images from the previous three categories, thereby eventually yielding a digitized photography.

An Installation on Tiananmen (CAT. 3), photographed in Beijing in 1995, falls into the first category. It is one part of our series of Chairman Mao portraits in Tiananmen Square, which were photographed with ascending increments in an upward angle of view. Since 1949 Mao has been a deified figure; his portrait hangs high in Tiananmen Square and is viewed from below by tens of thousands of people in China. When photographing *Installation on Tiananmen Square,* we consciously exaggerated the upward angle of view to a degree of absurdity.

CAO Fei

On *Rabid Dogs* (CAT. 84): We love whips. We need to worry. We don't dare to bark, and we work tamely, faithfully, and patiently like dogs. We do everything our boss asks, getting his point brightly and in no time. We are surely poor dogs, willing to act as animals and locked in the cage of modernization. When will we have the courage to bite our bosses ruthlessly, taking off our masks, peeling off our fur, and becoming a group of real rabid dogs?

CHEN Lingyang

On *25:00, No. 2* (CAT. 37): This "giantess" is not really very brave, and so she will only freely change her size and make these kinds of gestures when the clock strikes 25:00.

Very often, the real world and the male world get mixed up in my mind. They both come from outside me; they both exist very forcefully, with initiative, power, and aggression. Facing these two worlds, I often feel that I am weak and helpless, and don't know what to do. But just being alive means that I cannot avoid them, not even for one day. I wish that every day there could be a certain time like 25:00, when I could become as large as I like, and do whatever I want.

CHEN Shaoxiong

Just as a person can't jump into the same river twice, I'll never see the same scenery while looking out my window. Everything in this city is temporary: streets, buildings, shopping centers, train stations, airport, transit ways, trees, road markers, even the crowds. Nothing is fixed; things change as easily as a telephone number.

I use my photography to fix these moving objects, and then I reinsert them into the background. These moments and things either meet or by-pass each other in this world; it doesn't really matter which. I would like to replay this chaotic logic, these uncontrollable rules, and this confusing magic. I have a passion for this world; I have to record what I have seen. As a witness, I would like to keep the memory of my life inside my small-scale country, or to build a monument for this ever-changing city.

Seeing scenery through a window is a kind of tourism. When my works are put into an exhibition in a foreign country, they become its opposite: a city that travels.

CUI Xiuwen

My creative work is based on the problems surrounding female existence in our society. For example, in *Ladies Room* (CAT. 40), my subject was a group of women in the washroom of a posh Beijing nightclub who were engaged in providing "night service" there.

The washroom is a public space for women, but those who engage in "night service" transform the meaning and function of this space, giving it a kind of collective feminine spirit. Each woman's private secrets are revealed in this space. Yet to people outside, it brims with unknown possibilities. Superficially, I have videotaped the condition of these women, but I am more concerned with the underlying social construction of their condition, as well as with the ways that people interpret this work from cultural, historical, and economic positions. I chose video as my medium because its ability to depict time and space most clearly conveys the content of my work.

FENG Feng

On *Shin Brace* (CAT. 105): The relationship between steel and flesh is very direct. There is nothing ambiguous about it. It is like the relationship between medicine and biology, science and humanity, the culture of the West and the East, the male and female sexes. These kinds of relationships are equally absolute. The power we sense here imposes a shock on our senses, but the same kind of shock can be comforting. It allows us to exist safely, joyfully even, within a soul-stirring state. We trust in, take perverse pleasure in, and even admire this kind of injury, almost as a cure or salvation. This is what really shocks us. It is like that long piece of hard steel piercing the flesh. We see the reaction of the flesh, how swiftly it closes around the steel pin, producing a thick scab, how it is raised from the skin as if posed on the brink of an anticipated climax.

HAI Bo

I often spend time recalling past days. This purely private and indescribable state has become an important part of my spiritual life. As time has passed, the power of these recollections has become so strong that I've had no choice but to find a way to express them.

The photographs in the *They* series (CAT. 4–8) result from my work over the past few years. Most of the people in them are close to me. By restaging old photographs and strictly adhering to the way they look (for example the people in them must stay in the same positions), I mean not only to show the changes that have taken place in people and society, over time; even more importantly, I mean to re-create the past, if only in that moment when the shutter snaps. I am enchanted by the fragrance of time.

To find a compelling photograph and then to seek out the people in it may be a more meaningful process than making the photo itself. When you are immersed in life and time, art is actually very insignificant.

I like concise and simple works of art, some aspects of which fuse with ordinary experience. I believe good art is born on this line between art and non-art. These photographic works are products of this belief. I hope that they approach my ideal by piercing theoretical fog and aesthetic technicalities to enter people's hearts.

HONG Hao

In the middle 1980s I was a student at the Central Art Academy in Beijing. It was at this time that I began experimenting with photographic media. This may well have been a reaction to the expressionistic restrictions that prevailed at the academy at that time. My early works were all executed in black-and-white. The first reason for this was simply financial, as color photography was substantially more expensive as a process. The second, and more important, reason was one of photographic taste. I had long admired the photographers who formed the tradition that I was entering.

In 1998, I finished the series of self-portraits *Mr. Gnoh and Mr. Hong* (see CAT. 85), which I wore a wig and used computer technology to change my eye color to blue. I changed my family name into Gnoh from Hong by reversing the order of the Arabic characters. In this way I combined the East and the West and tried to create a culturally awkward juxtaposition. In the works *I Usually Wait Under the Arched Roof for Sunshine* (1998) and *Mr. Hong, Please Come In* (1998, CAT. 86), I placed myself in a resplendent setting, acting as a leisurec successor to luxury. By shifting my identity and environment throughout this series, I portray the search for self-identity and reality.

Between 1999 and 2000 I made a work called *Spring Festival on the River No. 2* (CAT. 41) as a reinterpretation of the famous classical art piece of the same name done by Zhang Zeduan. I photographed the street scenery of Beijing, using one axis known to the Chinese as the "dragon pulse" (East-West axis) and Tiananmen Square as photographic roots. By developing this visual index, the images represent elements of the scenery while allowing viewers to revisit their own experience of this city's pulse.

HONG Lei

I still cannot forget the cultural glory of our ancestors, which I first witnessed as a child. I am troubled and angry about the destruction of this heritage, which I see in my everyday life. It is as if this ancient civilization has collapsed in an instant in front of my eyes. This is unbearable and unstoppable.

My art exists in my dreams, so the process of making art is like sleepwalking and I can assume many different identities. I can be distraught or indignant. I can be a deity or a prostitute. I can scream or cry. I roam within five thousand years of civilization, dreaming a sad dream so that I can escape the turmoil of reality. I hereby proclaim that I am terrified of globalization and abhor it.

HU Jieming

Whether willingly or not, we are all deluged with information. We will face increasingly vast and complex amounts of images, data, symbols, and codes that will usurp the voices of reality. In a time and space where information incessantly accumulates and circulates, television and the Internet are the indisputable heroes. When confronted with so much information, it is legitimate to question our judgment and ability to articulate a response.

Planning for *Legends of 1999–2000* (2001) began in April, 1999. [This work is closely related to *Legends of 1995–1996* (CAT. 42), the work included in this exhibition.] The work uses the television programs (including satellite television) and Internet information that Chinese audiences saw from noon, December 31, 1999 to noon, January 1, 2000. This information was made into 20 x 30 centimeter photographs, which were then reproduced onto 90 x 500 centimeter transparencies. The transparencies were used to form a labyrinth of information, seven meters wide, eight meters long, and five meters high. Sounds from various channels are broadcast above the labyrinth.

We must all face the problem of maintaining independent thinking in the information era. The modern information network influences how people obtain and judge information, and even how they assess their daily lives. Mediated information incessantly invades our space of thought. Is it a pleasure or a horror?

Sze Tsung LEONG

It is often what is not visible that is the most present, the most significant, the most poignant. It is in this sense that my work is not so much about representing objects, but about depicting space, absence, and disappearance. I am interested in how empty spaces are filled with that which is just barely or not seen: the residues of time, the traces left by lives and societies, the absence of past forms and events, the disappearance of histories. I have explored these ideas in different mediums that reveal different manifestations of absence and disappearance. Specifically in my photographic work, I have explored the effects of absence and disappearance in cities.

The most explicit space for the physical unfolding of history is the city. It is the built manifestation of a society's self-perception, priorities, and beliefs. So, what does it mean when urban fabrics disappear? What does it mean when the physical evidence of history, in the form of historic buildings and urban patterns, are destroyed? What does it mean when new environments are constructed from nothing? What do these events say about how a society views itself, how it lets itself be viewed, and how it lets itself be shaped?

As a result of China's recent economic transformation, entire urban fabrics, sometimes even entire cities, are in the process of being completely erased. The resulting emptiness is indistinguishable from new, previously undeveloped land readied for construction. On both types of sites, new developments, urban districts, and cities, are created *ex nihilo*. My photographs depict these processes and spaces: demolition abetting the disappearance of history, construction sites containing the impending future, new developments built on the absence of history.

Even though these photographs are taken in China, they are not specifically about China. They are about urban erasure, historical absence, and new development, of which China may currently have some of the clearest and perhaps some of the most extreme manifestations. Around the globe, these processes have culminated in luxury apartments, tennis courts, supermarkets, shopping centers, driveways, office parks, strip malls, widened roads, and parking lots.

HUANG Yan

On *Chinese Landscape—Tattoo* (CAT. 107–109): Mountains and rivers are my ways of reasoning; mountains and rivers are proof of my emotional expression; mountains and rivers are places where my heart and soul find peace; mountains and rivers are sites where my physical body belongs; mountains and rivers are my refusals of worldly desires; mountains and rivers are the actual release of my inner Zen. I paint mountains and rivers; I am an avant-garde ink painter who paints mountains and rivers on my body. In the world of vanity where I reside, in the humble room that I live in, I am not a swordsman, I am not a gambler, I am not a blind man. In the time when fallen flowers are carried by flowing water, in the time when people forget each other, I only paint mountains and rivers; I only scribble aimlessly on my body; this is enough, this is my emotional expression. I believe in instinct, I believe in mountains and rivers, I kill time in mountains and rivers.

JIANG Zhi

On *Fly Fly* (CAT. 110): Man often lives like a slave submitted to himself and his surroundings. This humble life, lived in solitude, silence, fantasy, weariness, and passion is sometimes so overwhelming that at times we really just want to fly. It's one way to transcend. Can we really escape this gravity and lift ourselves up? Which direction will we choose to fly?

LI Tianyuan

The world is invigorated by change. Through disintegration, integration, and revival, the world transforms fantasy into reality. In response, we seek a new artistic language with which to express ourselves. Sometimes it is as difficult to change the structure of one's thoughts as it is to change a stone, but sometimes one's thoughts are as fragile as an egg. I like to express double messages in my works. A balanced image is composed of two opposite forces caught in a balance between mobility and stillness. Since ancient times, Chinese people have compared the elements of the world in such terms, as Yin and Yang mutually exerting effects on one another.

Talent and beauty may only emerge through a process of rebirth and recycling. Disintegration is creation. It can release energy, as in childbirth or an atomic explosion. The three episodes of human life can release large amounts of energy and create beauty through the interaction of Yin and Yang. The process may be difficult but is not impossible: for instance, oil and water don't usually mix well, but the Tibetans manage it by merging oil with red tea.

Art is one person's perspective on the world.

LI Wei

I started working on *Mirroring* (CAT. 111–113) in 2000. I made a 17 x 19 centimeter, oval-shaped hole in the center of a mirror and wore it around my neck. The mirror reflects all types of environments and realities. I hope the mirror can capture myriad social conditions. The juxtaposition of my head and an illusionary reality, as represented in the mirror, forms an even more absurd illusionary reality, from which we can neither escape nor awaken. Perhaps we should flee from the earth like children!

LIN Tianmiao

My thoughts about thread:
Thread can change the value of things, turning the useful into futile, and futile into useful.
Thread can both collect and break up power.
Thread can represent gender and change identity.
Thread is both real and imaginary.
Thread is sensitive and sharp.
Thread is a process, something you go through.

On *Braiding* (CAT. 89): The 4 x 2.5 meter digital photograph is an out-of-focus portrait of a figure. On the face, thousands of ends of threads extend through the photograph and are plaited into a large thick braid behind the image. The braid, thinner and longer, only has three threads left at the end, which are drawn to the screen of a small TV on the floor. The image on the screen depicts a pair of hands continually braiding the three threads.

LIU Jian and ZHAO Qin

We have always sought to use the most accessible and direct means of conveying our opinions about our time and society. Thus, we chose an informal, light-hearted manner of photography to depict the events in the world according to our own perspective. This process is joyful and charming as well as sincere and genuine. We hope that the audience can empathize with our cheerful feelings and feel as though they are communicating with two artists who love life and feel a sense of social responsibility.

Modern society, replete with a surplus of information through movies, newspapers, magazines, radio, and the Internet, stimulates us from all perspectives. We make many different choices in our lives: some become white-collar workers, some enter the IT world, some win the lottery, some become millionaires, some live in luxury, some marry socialites, some attend exotic banquets; yet, there are those who are laid off, repair bicycles, sell lunch boxes, live on welfare, find jobs, date, see the doctor. No matter what, life goes on. No matter what, life is right here, right in front of our eyes. No matter what, we need to live life with courage.

We locate art here, too, within the happy and courageous life. Life is art itself. A person who loves art loves life. With great enthusiasm, we have reproduced various kinds of people and events in our lives. With joyful knowledge, we express our artistic desire: art comes from the masses to the masses. We hope that our art can add spice to people's cultural lives and suit everyone's tastes, thus helping them to live their lives with flavor each and every day.

LIU Wei

On *Forbidden City* (CAT. 11): I was born in the time of Cultural Revolution, and my life as a child was full of images of combat. One of my favorite childhood memories is of playing with puppets. In fact, the puppets unconsciously conveyed the emotions and stories of the puppeteers.

The puppets in my Forbidden City photographs are not the puppets that lit up my childhood. They are no longer the players in the show; they no longer only bring to life past stories. Instead, puppets and humans mirror each other. The grand Forbidden City provides the arena for the puppets to act out the manipulated fate of human beings. The scenes not only illustrate apathy, lying hearts, and emotional intrigue, but also remind us of the uncontrollable fates locked into such scenes.

China is experiencing a tremendous change that has exerted great influences on Chinese people and confronted them with physical and psychological pressures. When we are obsessed with vehement struggles, do we control the games of combat, or vice versa?

LIU Wei

Underneath lively, extravagant, noisy, and even funny surfaces, there is sometimes deep tragedy. In my video *Hard to Restrain* (CAT. 114), the images of tumbling and crawling human bodies are analogous to animals. The tiny people tracked by spotlights force the viewer's gaze to become a superior, detached, god-like, and voyeuristic kind of gaze. As a language for illusionary expression, video allows me to effectively develop a humorous narrative.

LIU Zheng

I have worked during an exceptional period (from roughly 1990 to the present) of radical and unprecedented change in the Chinese contemporary art scene. These years have also seen a new level of maturity in Chinese art circles. The shock waves of Deng's policies of opening and reform and their effect on peoples' ideology is fully reflected in contemporary artworks from the mainland. Photography, like other forms of art, went through a period of hard yet much-needed transition. During these years, the dominant role of news photography in China began to crumble, and the importance of traditional salon photography was also significantly weakened. Humanized and personalized works started to have an impact. It was in this context that, in 1996, I started the private journal *New Photography* with some of my friends. We all felt that a new era was coming. I was driven by a powerful instinctual force, which slowly evolved into a set of personal beliefs. For many years, it was this set of personal beliefs that helped me overcome numerous difficulties. *The Chinese* is the fruit of my own personal struggle (CAT. 12–16, 50–54)

The 130-plus photos in the series *The Chinese* were shot from 1994 to 2001, as I traveled in China. These trips gave me ample time to reflect on my own situation and beliefs. My photographic journey started with a Chinese traditional religious belief, Taoism. Like most Chinese, I remain a person without any religious belief. In the course of photographing, I met people of various religious beliefs: Taoists, Buddhists, Muslims, and Christians among others. The pictures about religion confirmed my personal search. I was analyzing myself by shooting photos, like an amnesiac trying to find his identity and trace his past. It was a painful process. Later, I decided that such obsessive curiosity could result in severe harm. While shooting photographs around the theme of death, I was deeply disturbed by what I witnessed. The vulnerability and uncertainty of life left me pessimistic and often depressed. I wouldn't say I am particularly courageous—with the curiosity of a child, I opened a box that never should have been opened, and that others might be unwilling ever to open in their lives. There are too many such boxes in China. People are accustomed to their existence, but few care what they hold. It seems that people no longer have such curiosity.

By 1996 I realized I had little time for my creative work and eventually quit my job as a photojournalist to work as a full-time artist. Within one year, I completed the Peking Opera-inspired photo tableaux works as part of a long-term project titled *Three Realms (Heaven, Earth, and Hell)*. Works such as *The Monkey King Fights the White Boned Demon* come from this period. From then on, the relationship between my oeuvre as an artist and traditional Chinese culture began to develop and grow. Later, I put aside work on this project to return to *The Chinese* and resume my travels. I felt freer in completing the latter part of *The Chinese* series. For the first time, scenes from nature and non-figurative subjects appeared in my pictures, and the contradictions between life and death, the imaginary and real world, and truth and falsehood became less pronounced in my work. I believe I became more relaxed in my exploration of the spiritual world of the Chinese people.

Since 2001 I've traveled less. My journey in search of my own "reality" in *The Chinese* has now ended. Today I devote my time to resuming my work on the *Three Realms*. I continue to search for my own artistic language and experiment with various technical issues as a photographer, a process often more exhausting and depressing than my earlier work shooting *The Chinese*. I think I'm finally solving various technical problems in realizing my vision through photography. My latest work, *Four Beauties,* is like a door to me. I know what lies in the room behind that door, and it draws me in. All I want to do now is to continue this journey toward new works.

I have no plans to leave China and my compatriots and countrymen, who are the rightful owners and audience for my work. Today art seems far removed from this land and its people. I sincerely hope that the situation will take a turn for the better soon.

LUO Yongjin

Around us, the scale of building construction becomes larger and larger and its environmental impact becomes more and more significant. Huge new construction projects take place before we can adapt to the changes that the old ones brought us.

We live in an era of great changes. These changes affect our thoughts, values, fashion senses and lifestyles. These changes cannot simply be judged with words like "good" or "bad", nor can they be represented by a single photograph. To record the scale of buildings as well as their details and textures, I combine images of many sections of buildings. When I photograph, I constantly move the camera angle and viewpoint. I take pictures of the same building in different stages of construction and then combine them. In this way, the work develops in stages, just as the buildings do. The end result is an irregular and disorganized mixture that is neither contemporary nor ancient, neither new nor old. This kind of work puzzles many people. As a famous lyric says, "It is not that I don't understand; the world changes too quickly."

MA Liuming

"Fen-Ma Liuming" is the character—with an effeminate face and a man's body—that I have enacted constantly in my performances. In China "Fen" is a feminine name that has the same pronunciation as the character for "separate." I combined "Fen" and "Ma Liuming" to create a new name so as to separate the character from reality.

In many of my performances the title is *Fen-Ma Liuming in/at (place)* to emphasize Fen-Ma Liuming's embodied image and to show its appearance in different places: in a room, in the countryside, in an art museum, in ancient surroundings (see CAT. 17, 18), etc. The performances are recorded through photography. Sometimes a photographer is invited; sometimes I take the photos myself or ask the audience to take them, as in the case of the performances where they come and have a picture taken with Fen Ma Liuming.

From 1993 to 1996 I employed a more narrative and symbolic style in my performances. Fen-Ma Liuming moves silently and the audience watches quietly as well. In the 1997 performance *Fen-Ma Liuming in Breda* I became more aware of the relationship between the performance and the audience, and also of the accidental events that occur during the process of the performance. Stemming from this concept, I carried out this performance in many countries, each time adapting to the situation and the surroundings of the performance space. In 1999 I let Fen-Ma Liuming perform the acts of sleeping and sitting, and invited the audience to press the shutter of the camera themselves and have their picture taken with Fen-Ma Liuming. In 2000 I let Fen-Ma Liuming really sleep (Fen-Ma Liuming had a sleeping pill before the performance). This performance created an even greater space for the audience and emphasized an abstract quality. All the performances in which the audience interacts have been recorded on video and photo so that they can be shown to a wider audience.

MIAO Xiaochun

Photography was invented for the purpose of recording objective truth. However, while using this medium, especially using it as a medium of artistic expression, one will discover that photography does not completely record reality. Any photograph can only depict a certain section of the world, with a certain width and a certain length. This is not to be considered solely a limitation, for it can be used to emphasize the importance of a part of the scene and its implied meanings. Photography can only record a split-second record of time; nevertheless, it makes that second eternal. A black-and-white photograph may be untruthful, but it transforms the colorful world into black, white, and gray in an abstract way, presents us with an unusual view of the world, and can bring us much joy.

Photography's untruthfulness arises primarily from our subjective choices. When we hold up a camera to photograph a scene, it is guaranteed that some concept is guiding our fingers. Otherwise, why is this scene, and not another scene, to be photographed? Why is the shutter pushed down at this split second and not another? Even a photograph taken without any obvious purpose might express the concept that subjective choice is wrong and should be abandoned. Choice is always involved. From this perspective, all photography is conceptual photography. On the other hand, even if a photograph is a conceptual work; it still records something with camera and film. Even if the appearance is changed and it is difficult to recognize, it still records something in the world. Thus all photography, including our so-called conceptual photography, is at one level documentary. We only divide photography into inaccurate categories for the convenience of discussion; in actuality these two cannot be separated, nor are they antagonistic. Photography combines objective recording and subjective choice, which intensifies the expressive power of the work. We use this feature to either directly or indirectly express thoughts and feelings that might only be incompletely expressed by language or through some other media, or that cannot be expressed by language at all. This is the power of photography.

It may not seem necessary to discuss the size of photographic work. Small ones are delicate, large ones are striking, and each scale is unique in its own ways. But it has become an aesthetic issue that needs close attention. Today photographs are getting bigger and bigger, a phenomenon prompted in part by large exhibitions. In the 1960s and 1970s, most photographic work was displayed in so-called photography salons, where delicate photographs were appreciated and praised. Moreover, it was difficult to produce large photographs. Later a vast amount of photo-based artwork entered art galleries. With gigantic paintings, installations, and sculptures displayed within vast museums, photographic work was driven to enlarge its size and volume. After the emergence of digital printing in the 1980s and 1990s, this became an easier task. All of a sudden, photographs were huge. The questions then became: how big is big, and what kind of image quality is acceptable for an audience?

Some artists do not care too much about image quality in a traditional sense, or if they do care, they do not have the ability to deal with both scale and quality. This kind of work is already accepted as long as it is meaningful. Other artists insist on using large cameras and negatives, which results in high image quality in the traditional sense even though the resulting photographs are over two or three meters. The works of Jeff Wall, Andreas Gursky, and Thomas Ruff are of this kind. A new photographic language is developed, and such photographs will probably be displayed to an audience in gigantic galleries where all their fine details can be seen. In this sense, the end result of this kind of photograph is already known while the work is still nascent. This is the exact opposite of "expanded" photographs with a poor image quality. Small reproductions of this kind of photograph will lose a lot of detail, even effect the expression of meanings. But you cannot have both, and artists need to decide which one they want. If an audience already knows the meaning of a small photograph after seeing the good-quality reproduction, then seeing the original work afterward will not bring much joy; for large photographs, it is better to see the originals. This is the return to an artist's hard work, and also to the pleasure of being part of an audience. Otherwise, why go out of your way to see an art exhibition?

MO Yi

On *Front View/Rear View* (CAT. 91, 92): An emotionally touching, even life-changing event is never to be forgotten.

In 1997, on the anniversary of *that date*, I finally recalled and commemorated it through the format of self-portraiture. The darkness in the picture, the object that covers my body, the grotesque image of just a back without a face: all of this mirrors my experience and emotions during the eight years since that day. The pressures imposed upon my feelings and emotions expedited these self-portrait works; everything came simply and easily.

QIU Zhijie

I began using photography in 1993, primarily because at that time there were few opportunities for exhibiting contemporary art in mainland China. In most cases, contemporary art could not be shown in exhibition halls; images of art were accessible only via publications. Installations were temporary because storage facilities were rare; once works were photographed, they would be disassembled and discarded. As a result, I was forced to shift my focus to photography.

The *Tattoo* series (1994, CAT. 115, 116) focuses on the problematic relationship between an image and its background. A balanced relationship between the two is one of the prerequisites of traditional portraiture. In this series, the two find a common ground. By transforming into the same Chinese character, the image and the background mingle and the expected distance between the two disappears. The substance of the subject, the weight of the person, and the physicality of the figure all dissolve. The subject is powerless to act because he is nothing more than an image. The only thing remaining is a flat surface onto which anyone can scrawl. This series is a response to the futility and drowning of the individual brought about by the onslaught of the Chinese media culture, which began to develop during the 1990s.

RONG Rong

Question: What is photography?
Photography leaves me dumfounded.
What more can I say?!
What's left of the world is merely a
picture or two.

SHENG Qi

On *Memories* (CAT. 21–23): The record
of my left hand records *Me* from 1965
to the present.
The imperfect left hand + old photos . . .
is me.
This is the collection of my memories,
all of the images of my life.
The imperfect left hand + old photos . . .
is me.

SONG Dong

Medical examiners have a simple method for determining whether a human being is alive: by placing a cold piece of glass in front of a person's mouth, they can conclude from any trace of breath left on the glass if the person is indeed alive. When I was a child, I would stand in front of the glass windows in our house and breathe against them. When the house was cold, my breath would immediately leave behind a fogged surface on which I could draw pictures with my fingers. Breath itself is a form of water. It is moisture that is visible in the air, and retains human warmth.

In January of 1996, right after the New Year, I performed *Breathing* (CAT. 24). Initially, when I performed in Tiananmen Square, it was during the daytime, but that didn't produce the ideal conditions of ice that I anticipated. Moreover, there were so many spectators that I had no means of continuing. Tiananmen Square is universally recognized as a highly sensitive location. Even now, it is impossible to do as one pleases there. So I then decided to conduct the performance at night, around 7:00 or 8:00, when the air was colder and there were few people in the vicinity. It took approximately forty minutes to breathe a piece of ice onto the pavement. The next morning, I went to Houhai. The entire lake was frozen. There, I also spent approximately forty minutes breathing onto the surface. The temperature was very low. My breath was cool. The ice remained as ice.

I lay down in Tiananmen Square. At my side, I had a camera set up. Yin Xiuzhen helped me photograph. Four People's Liberation Army soldiers came over and asked what I was doing. I said that I was an art teacher, and showed them my work ID. I said that I was showing my students how to draw breath at night in Tiananmen. So, I had to take photographs. Moreover, I needed to take many photographs in order to select the best one. Because I didn't have an official permit, and it isn't permitted to take video footage in Tiananmen Square, I only have photographs and a partial audio recording of my breathing from this performance. Performance itself is my art. But because of the specific nature of the performance site, there were only five people in attendance: Yin Xiuzhen and the four PLA soldiers. After a while, there were only Yin Xiuzhen and two soldiers because the other two realized that I wasn't presenting any type of threat and left to patrol the other areas. People who have come to understand this performance have only done so through the photographs. Because I was originally a painter, I have an intuitive grasp of composition and other formal elements. Choosing that particular brick was accidental. It was far from both of the main roads, so that it wouldn't draw unwanted attention from tourists. It wasn't that I was afraid of being seen, but that too many spectators would draw the attention of the police and the performance would subsequently be terminated.

SUI Jianghuo, YU Fan, ZHAN Wang (Three Man United Studio)

On *Woman/Here* (CAT. 25) [Text by Sui Jianghuo.]: This piece, about my mother, adopts the form of a bulletin board, a format that is very familiar to all Chinese people. In the 1960s and 1970s, everyone dreamed of appearing on the propaganda boards, and my mother was no exception. My mother is already retired and, like the bulletin board, has long been forgotten by time. Now the items displayed on the bulletin board no longer speak only to her credited achievements, but her entire life story. She flew to Beijing from Qingdao to appear on site in order to provide an explanation of this piece. This was necessary because it was her show—I am only an editor striving to show the realities that she hopes to have represented. At the exhibition, the televisions were broadcasting live events from the closing ceremony of the World Women's Forum. The broadcasted rowdiness of the crowds stood in stark contrast to the silence of the individual. The exhibition lasted only one day. For my mother, it exhibited her entire life. For the audience, it exhibited a period of the bygone past and reflected their existence.

SUN Yuan

"So if anyone tells you, 'There he is, out in the desert,' do not go out; or, 'Here he is, in the inner rooms,' do not believe it…"—Matthew 24:26

This biblical passage tells of the catastrophic signs signaling the oncoming of the apocalypse and of false prophets who will speak of extraordinary visions in order to lead the gullible astray.

This work, *Shepherd* (CAT. 95), is a vision of the herdsman and his flock in this catastrophic era. The sheep, reduced to only their spines, resemble worms spread onto the snow-covered ground, while the shepherd bears only a vague resemblance to a human figure. I produced these works both indoors and outdoors to symbolize the omens portending the coming of the apocalypse. In doing this, I assumed the role of a liar or a false prophet. After all, art is the work of liars: artists create visions that tell both truth and lies for the purpose of luring the gullible astray.

WANG Gongxin

I really enjoy seeing my work described and given meaning by others, since I am always reminded that a piece of artistic work has its own existence once finished, independent of the artist's original ideas and its geographical context of production. Its meaning and value can only be established through the response from viewers, in a specific moment and place. For these reasons I believe that my work should be understood through other's words more then through my own explanation.

WANG Jin

I believe that photography cultivates quality. My work does not have obvious themes; it simply reflects a kind of psychological need. I did not purposefully choose photography but simply used it to record.

WANG Jinsong

In Beijing, high-rise buildings without any distinguishing features are the most striking manifestation of modern urbanization. Compared to my other work, *City Wall* (CAT. 62) Was relatively simple to produce, since I photographed buildings while driving through Beijing. The process was like blinking: I simply pushed the shutter frequently. Later when I assembled the one thousand black-and-white photographs, I felt suffocated; I felt surrounded by thick, gray-colored walls, with cultural relics and people cramped and squashed in the middle. I added a few color photographs amidst this sea of gray walls. These color images seem like small lights obscured among the repeated patterns of the high-rise buildings. But the effect is surprising. It results in the recognition of symbolic content that represents the sensation of oppression and constriction. I draw inspiration from my surroundings. A camera is certainly the quickest and most accurate way to represent things—click, click, click! Photographs can be snapped as quickly as one can blink—but underlying ideas must direct the camera.

All my work is open-ended, and can be continued, not only by varying the size and exhibition formats of individual works, but also by continuing to explore the ideas that lie under the images.

WANG Jianwei

On performance: To perform is to temporarily suspend certain relationships through an artificial, subjective method, assisted by the aid of certain instruments. It requires a nostalgia for some utopian idea, as well as skepticism towards the act of performance itself.

On *Spider* (CAT. 61): The juxtaposition and overlap of various spaces is forced by means of the shifts and displacements of performance. Different usages impart new meanings to these spaces and shake our fixed, explicit notions. "Spider" makes meanings appear gray.

WANG Qingsong

My mind has been haunted by the position and destiny of the Chinese people over our long history. Today, in a time that lacks ideals, people cast doubts on the heroes and ideals of past eras. I wanted to create scenes in which old hopes are replaced with contemporary desires for money and power. To compare the past and present, I have reimagined old and new masterpieces in ways that reflect current social realities.

Night Revels of Han Xizai is one of the best traditional Chinese figure paintings. It reflected social life amidst torrents of transformation, and depicted the life of Han Xizai, a worried intellectual and high official in the late Tang Dynasty. He was powerless to fulfill his ideals of reconstructing the country and chose escapism and indulgence. After several centuries, even though the Chinese dynasties have changed frequently, the status of intellectuals in society has remained the same, and I created *Night Revels of Lao Li* (2000 CAT. 97) as a portrait of the current position of intellectuals in Chinese society.

I find that public urban sculpture reveals much about our history and ideals. However, I have some doubts about what we have achieved and what we expect. With that in mind, I shot *Past, Present, Future* (CAT. 27) in late 2001. This triptych emulates the group sculptures—which commemorate revolutionary times and the construction of the modern era—that stand in front of Chairman Mao's memorial in Tiananmen Square. In the past, people showed deep respect for such statues. Now, these figures have become props in tourist photos. Such sad scenes make me think that history is gone and we are living in times that lack ideals. In *Past, Present, Future,* I included myself in the image as a bystander, a tourist, and a participant, and covered the other models with mud and with silver and golden powder to hint at changes from revolutionary times to the modern age and on to the future. I hope this work inspires reflections upon history and the past, the reconstruction of the present, and the beauty of the future.

WANG Youshen

On *Washing* (CAT. 28): In the exhibition site, clear water is circulated to wash over the news film on the bathtub. This process produces a recycling of water that extends beyond its physical nature as well as a gradual disappearance of the image. Through the audience's interaction, the piece intensifies the public's psychological reading process.

WENG Fen

Our Future is Not a Dream (CAT. 29): is about my attitude toward humanity's constant pursuit of a more ideal future. First, I selected clips of Chinese films from the 1950s to 2000 that hypothesized about the future, and edited them into a new movie. Next, I videotaped ten people—a variety of people and friends living in Haikou—talking about their own bright hopes for their future. I edited their discussions as a video work. When exhibited, the two pieces play simultaneously. Film itself is a medium of fantasy and speculation, which makes it easier for people to see the conditions of thought and the orientation of values that exist in society at different times.

WANG Wei

On *1/30th of a Second Underwater* (CAT. 126): The compressed faces in the water convey a feeling of suffocation. The sounds of flowing water and murmuring human voices from above intensify a sense of dislocation. Through a combination of image and sound, this piece creates an ambiguous sense of simultaneously being and not-being. At the time and place of the exhibition, the audience's response becomes part of the work. The work itself is highly transmutable in its ability to adapt to its changing environment, denying a sense of completeness.

XING Danwen

I made my *Scroll Series* (CAT. 63–65) in the summer of 1999–2000 in Beijing. There are two series of horizontal works: *Scroll A* and *Scroll B*. *Scroll A* concentrates on outdoor leisure life and focuses on human activities; *Scroll B* is comprised largely of images of Beijing streets and focuses on vernacular architecture.

The format is exceptionally long, narrow, and horizontal. However, the works' dimensions should not be misconstrued as an attempt to re-create traditional Chinese hand scroll painting. My aim is to create an image from similar panorama-like subject material; I shoot them manually without any computer manipulation. I work with several medium-format cameras and shoot successively and directly with 120 mm film. In this way, I rely on the film's original data without editing either the image or the negative. This raw data becomes part of the final work, which is composed of a long series of images, which together comprise a panoramic vision typical of—and perhaps unique to—Beijing. In shooting and composing the work, my goal is to create one continuous frame from each roll of individual shots. My vision is always to use one roll of film to create one complete composition.

I have always been attracted by the world of movies and aim to integrate a filmic sensibility into my photography so that a single still image continues like multiple motion picture images. This places each recorded moment within a continuous timeline. I establish a parallel between the time and dimension of a subject to invent my own panoramic photograph from a multi-vantage-point perspective, which, finally, is much like a study from traditional Chinese painting. I've deliberately broken with the usual way of viewing photography by asking the audience to *read* my work rather than to *look* at my images.

XIONG Wenyun

In 1987, I lived in Japan, studying traditional Japanese art and then modern abstract paintings. During this time, I remained preoccupied by my enchantment with the western plateau, where I had worked on a farm in Wenchuan county of the autonomous prefecture of Tibet. When I was a student in Tokyo, I often went back to the Tibetan plateau. The crossing of these two places—Japan and Tibet—pushed my work from complex to simple. The only thing left was to record the colors of life's up-and-down cycles.

In May 1998, I left Tokyo for Beijing. After seeing a painting exhibition in a museum, I fell into a time of emptiness and dark soul-searching, and then I put my bags together and went to Tibet. The mountains and rivers in the plateau filled me with life again. After the rain, a rainbow appeared, embracing everything between the snowy mountains and the blue sky.

The end of July 1998 was scorching hot as I hit the Chuan Zang highway with a transport team, and the heat foreshadowed a distrastrous time. While we were crossing a mountain, all our luggage was stolen and I was left with just my camera and some money that I had hidden. I followed the local police as they searched for the stolen goods, entering many impoverished roadside tire repair stores. When I entered the stores I discovered a bond with the stores and their owners. Ever since, hundreds of roadside stores along some 1,400 kilometers of the Chuan Zang highway became a central subject of my work.

Once, as an experiment in making a "moving rainbow," I made seven color awnings and asked road maintenance workers if they would let me hang these awnings on their trucks and photograph them. To my delight, several drivers agreed. My fellow photographer, Luo Yongjin, and I waited several hundred miles ahead. Everything was quiet in the mountain valley. Then the engines of the trucks began to roar, and the overloaded trucks with their rainbow awnings began to appear. It was orderly, simple, peaceful, and beautiful. God gave me my happiest moment at that instant; everything before and after that was overshadowed. All life's pains and bruises were healed. At the moment that rainbow appeared, I felt that the paintings in my studio had become a burden.

Later, other such moving rainbows were supported by drivers, transport and communications departments, and the media. I hoped very much that the moving rainbows would awaken people's concern for the natural ecology and the human environment along these roads that run across the roof of the world. I hoped that the moving rainbows would bring some practical benefit to drivers, road maintenance workers, and local people.

During my journeys, whenever I climbed a mountain I saw colored scriptures that had been left by Tibetan drivers and passengers. The Tibetans like these arrangements of red, orange, yellow, green, blue, and purple. It is said that this arrangement comes from rainbows, and rainbows are stairways to God. I believe that this orderly form is the most pure form of beauty in the universe. An eternal mystery hides in this pure form of beauty.

XU Zhen

When images of bodies enter our field of vision as a kind of suggestion, how do we view our world and ourselves? We've always tried to thoroughly understand ourselves from various perspectives; our bodies are the key element that mediates between ourselves and our surroundings. For a long time, I have created art in which the body interacts with its surroundings, and I depict the results of these interaction visually. In a way, I use this process to deal with my own confusion about the problems of the world. It feels as if the body can be separated from these problems; I can tend it.

Temptation is my favorite thing. It comes from the mind, travels through the body, and rests within the heart. It is the inspiration for my work.

YANG Fudong

Art is definitely not my profession, but it has become an integral part of my life. It's like going to sleep every night and dreaming. It's something that is always going to happen, something that ends and then begins again. It's like when you wake up in the morning knowing that you had a dream last night, but you cannot recall what it was that you dreamed. Still, a feeling lingers in the back of your mind that you had a strange or even frightening dream last night. You know if you try to tell the dream to someone else, they just won't be able to relate. So you can only keep it inside you.

You live in a big city, hiding in your little corner, and it's doubtful that even a few people know of your existence. Yet you are a part of the city. It's you and a lot of other people who make up this city. The feeling of the city depends on all these people living in their own dreams. My relationship with society to a large degree is a kind of metabolic relationship. Society needs ever-changing relationships, just like those that are occurring today. I too am ever-changing. I was unable to choose which generation I was born into, yet I have to learn to adapt to the times.

YANG Yong

She performs the most white-collar of work (of course, with a haughty gaze and brand-name clothing), occasionally conveying a vapid expression, haunted by paranoia, engaged in part-time prostitution and masturbation, affected by the transcendental charm of cheap and expensive drugs, having an affection for guns (of course, fake guns) and an exaggerated imagination that reveals her hidden lust for killing. Standing on the balcony, randomly locking her target, she imagines him as the man who violated her one night, and then bang, bang, bang.

She imagines a life on the run. The source of her persecution might be her boss, a phone call, or even just the air. With a trembling nervousness, she appears in the office, and hastily disappears into the dim ominous tunnel. At 3:00 a.m., the roadside and the burning cigarette invoke desire. The taxi flees. Fantasies and urges in the bathroom are enough to drown any audience; in the noisy lit streets, the fuzzy lights, the blurry people, and the slanting street are enough to make her pleasure soar exceedingly "high." The fleeing shadow glides past the park imbued with stories, the large bed with the sunken mattress, the drunken alleyways, the high balcony ideal for jumping off of. She licks the large bathroom mirror, intoxicated in the kind of bar where you can intensely clutch and kiss someone—man or woman—after five seconds of acquaintance.

Rather than directing the main characters, I play a game with them; we improvise scenes. The rule of this game is that there are no rules. The main character is cast as a complex simulation of the new millennium, capable of assuming many roles. When she makes her appearance—in the most natural manner—in the scenes of daily life, we can almost hear her whisper, "Am I myself?" These photographs (or even just one photograph) are like film stills. Aren't they just like a screening of "Cruel Diary of the Youth"?

It is precisely this virtuality completed through simulation that excites me.

YANG Zhenzhong

On *922 Rice Corns* (CAT. 31): A cock and a hen pick at a heap of rice on the ground. With a nicking movement of their beaks, they count the exact number of rice corns. Sound: Male and female voiceover counting. Subtitles: numbers indicating the rice corns counted by the cock (left), the hen (right), and the total (middle).

I held a handful of rice in my palm. I wanted to know how many grains there were. If I counted them one by one, it would take too much time. So I put the rice on the ground and let two chickens help me count them. I thought this was a clever way to do it. But the chickens were not teachable. Sometimes they didn't finish eating the rice; sometimes they fought each other. I tried again and again to film them, and it took more than a week to edit the video on my computer.

In the end, I got the number: 922. Now I know I am foolish. Chickens never want to know how much they eat. This is a human problem. Humans are stupid.

On *I Will Die* (CAT. 99): This video work arose from a single idea. It is an awkward thing to ask people to say, "I will die" *(hui si de)*. Different people have different ways of expressing it. When they say "I will die" to the camera, they are performing without thinking about it. Viewers will find this heavy as well as amusing. This might be the power of the video camera. The sentence "I will die" serves as a starting point. I will continue the experiment in other countries and cultures worldwide.

YIN Xiuzhen

[The artist requested that this statement by her husband, the artist Song Dong, represent her in this publication.]

To understand another person there is no better way than to spend day and night with them.

It is difficult for me to write an essay to introduce Yin Xiuzhen's work. Because we are so close, there is an inherent conflict of interest. If I use too many words of praise, everyone will feel that it's too sweet. But, if I don't do so, it won't be objective. I thought about writing under a pen name, but the text would assume a colder tone. If that's the case, it'd be better to not write it at all. Huang Zhuan has made up a skit about the two of us, saying that we idolize each other, and this text is like a footnote to that skit. It stands as evidence that we do, in fact, idolize each other. For two people to stay together for sixteen years, it is not possible to not idolize each other. Having said this much, I am already sick from the sweetness. Apart from my own name, "Yin Xiuzhen" is the most oft-heard name in my work and life. In the modern Chinese dictionary, there are two definitions of "name": 1. One or two characters, together with the surname, that represent a person in order to distinguish him/her from others. 2. One or more characters used to represent a thing, in order to distinguish it from other things. To discuss Yin Xiuzhen, I cannot depart from these two meanings. The name "Yin Xiuzhen" refers both to "person" and "thing": Zhenzi and shoes. (Zhenzi is what I call her. Using this name conjures a feeling of closeness.)

Zhenzi often uses discarded shoes and clothes in her work. She says that these remnants carry "experiences, memories, and traces of time." She thinks that shoes are like boats or some other vehicle of transportation, for they carry a person thousands of miles.

In the photographic work *Yin Xiuzhen* (CAT. 100), she put ten portrait photographs of herself—ranging from childhood to the present—inside cloth shoes. Women born in the 1960s can recall this particular style of shoe. Zhenzi rarely had the opportunity to purchase new shoes. She, like other girls, wished for store-bought shoes, particularly leather shoes, but, during that era, it was very hard. In my memory, most girls from that time wore that style of cloth shoes: simple and pristine. Zhenzi uses such shoes in order to re-represent that part of her life.

These shoes are now back in fashion. As symbols, they bear the double mark of history and the present. The style of the shoe has not changed, but the person in the photograph has, according to the passage of time. It is difficult to notice changes when you spend day and night with a person; only by looking through old photographs do you realize how big the change is.

From her albums, Zhenzi selected photographs, reprinted them, cut each into the shape of a sole, and placed each in a shoe. She has adhered her own face so close to the bearer of memories. The separation of her face into the two shoes evokes a feeling of violence. Here, the photograph attached to the shoe has surpassed its function as a representational image to become material that captures memory and the reflection of memory. She used ten pairs of shoes to allude to the mother's ten months of pregnancy. These pairs represent the ten phases of her life: 1. Infant, 2. Toddler, 3. Pre-school, 4. Primary school, 5. Middle school, 6. High school, 7. College, 8. Work, 9. Living abroad, 10. Present

I have a special appreciation for these shoes. Through them, I can see Yin Xiuzhen as she was before I knew her.

ZHANG Dali

In the summer of 1992, I began to implement the plan for my work, which was intended to take art out of the studio and let it communicate directly with the outside world. At that time I chose graffiti, which has two advantages: it's fast and it blends seamlessly with the environment. My photography recorded and exhibited the concept behind this work: I believe that human beings are the products of their environment. I am concerned about the changes in our living environment that have been imposed by money and power, and about human rights in the midst of such a process of imposition. Under normal circumstances, the relationship between humans and the environment would be naturally balanced. However, the current reality is one of force and passive acceptance.

I don't think that I can solve the problems. But through art, I can demonstrate—to those subjected to control and numbed by habit—the truth of the afflictions that we suffer. Bulldozers alter the appearance of streets overnight, which makes people accept modernization, while depriving many people of their possessions and their spiritual resources. I document the demolished homes and the new life established among the ruins.

My camera (a Yashica FX-3) is not only my eye, but also a tool for my thinking. The fortress of reinforced concrete that has been erected amidst the stink of money and red slogans has impaired the vision of good people and sedated the nerves of those who were once awake. Some people are used to being slaves; some people chose to be accomplices. The judgment and distinction between good and evil is a difficult problem confronting Chinese artists and the entire nation. Is the emperor wearing new clothes?

ZHAO Bandi

The image of me and the panda represents the spirit of Chinese culture. When this spirit contacts society in some way, a space that never previously existed appears. The images, photos, and videos are just documents; I would like to thank those who took the photos.

ZHAO Liang

On *Social Survey* (CAT. 103) I wandered around all kinds of public places in Beijing with a simulated pistol in my hand in order to understand people's reaction to violence. Thousands of people passed by me under my muzzle, and only one person protested. The majority were numb.

ZHAO Shaoruo

In my opinion, photographs that concretely reflect a particular place and time are like Marcel Duchamp's urinal: manufactured goods and nothing more. A photograph's verisimilitude, or lack thereof, is secondary; the important thing is my own appearance or my feeling that I am already there—this is enough. When I create photographs that preserve concrete times and places and simply delete the people and things present, my goal is not to stress or voice respect for reality but is in fact precisely the opposite: to criticize and thoroughly deny historical truth. I believe that, in this objective world, we should doubt what we are told. (I hear that the famous British astronomer and physicist Stephen Hawking has proven that the concrete world does not exist in theory, that the universe is empty, silent, and black, and that our existence is, at most, the dust left over from the Big Bang.) Nonetheless, I still happily tolerate myself, even in light of this incredible history, and I resort to my senses to make judgments: in a true and concrete fantasia I can feel the biological happiness that has been given me. Extra stimuli are provided, but this is still not enough. Actually, I have an impetus for this kind of thinking—perhaps it was the philosopher Husserl, or Heidegger, who said "Ignorance is power." This has been interpreted in an even more interesting way by Old Man Shu in the *Tao Te Ching* who said "When knowledge is expelled, great deeds are done." I rejoice that I have read very few books. I have been to a few places, but all I have seen are the same, with only small differences. A person might have experienced birth, aging, sickness, and death and yet remain unaware of things that have happened in other places. Perhaps they have experienced too much failure, hopelessness, and pain; this doesn't mean their hearts will grow cold, but they have no hope in themselves, so their minds are unstable or they wish to rebel and dismiss notions like greatness, truth, glory, and honor. They are also dismissive of leaders, heroes, giants, gods, goddesses, and even God, the soul, and other notions. For this reason, I have summarized my thoughts and route over the last ten years (perhaps this is art), as this is all that is in my power: to use photographs in my work that already exist, all according to my own image. As I encounter something in a photograph, I draw it. If I encounter a man, I am a man. If I encounter a woman I change myself into a woman. If I encounter old people, I become old, and if I encounter young people, I become young like them. If my partner is fat, I naturally grow fat too; if my partner is homosexual, I become like him (her). Who are you? Who am I? Who are we? You are me, I am you; there are millions of people, and there are millions of me. All in all, I am everywhere and nowhere; I am everything and nothing; I am everyone and everyone is me; the Buddha is me and I am the Buddha; God is in heaven and I am below ground but the earth is in a remote place in the universe, and heaven is very big! If people ask, "Where is God?" I reply that perhaps he is far away in the sky, or right in front of our eyes, or perhaps he is even me.

ZHENG Guogu

On *Life and Dreams of Youth of Yanjiang* (CAT. 79): In this southern Chinese border city, as in any other place, there are parties, grand weddings, and brawls. One can see puppet performers everywhere; the craziest ones are the most interesting.

I've realized now that I've found a reason for making art: everything can be imagined.

The life of young people of Yangjiang can be imagined.

My bride can be imagined.

The honeymoon can be imagined.

Moreover, my way of making art derives from an ability to imagine scenes based on experiences in real life.

That which is still unknown holds a special fascination.

ZHOU Xiaohu

On *Utopian Machine* (CAT. 130): Animated claymation work, the content of which is a selection of news episodes broadcast over a TV network. I capitalize on clay's flexibility in order to produce a myth about the commercialization of an era's ideology and its material and mental life.

Summary of the news:
Title of CCTY News; meeting; meeting the foreign head of state at the airport; municipal building in Shanghai; first meeting site of the Chinese communist party court; Che Guevara at Beijing University; activity of The Long March held a meeting in Zhun Yi; news of a performance during the The Long March; international academic meeting was broken off by the shock-wave; news of 9/11; the Long March is going on; the child fell into the marshland; the helicopters rescue promptly; the end.

ZHU Ming

An artist should be a real person; reality is not a right moral conception. My artistic creation is established on the basis of reality; its content and form reflect real people and actual living environments. Reality, of course, is generated by the mind and contains illusion to some extent. The extrovert and introvert have different relationships to reality, since that relationship is based on perception.

After studying the bubble for a long time, I have come to feel that the strength of illusion is becoming more and more powerful. My life and social activities contain potential illusions: information from society, from dreams, and from communication among people. I understand the strength of illusion by observing nature. The conversion of energy among living things, the shift from life to death, the existence of the earth, the interrelationships between internal and external worlds, and so forth all have a kind of invisible, latent energy. Things have a material existence in the world, but in my consciousness the world is actually a combination of illusion and reality. The two worlds interact: illusion is reflected by reality, and reality exists through illusion.

ZHUANG Hui

I really don't have any particular sensitivity toward cameras. Because of my poor eyesight, everything appears to me as a haze through the viewfinder. Once at an exhibition, I ran into several photographer friends. F took out his new Leica camera and spoke excitedly about the shutter speed and aperture. This made me feel like I was meeting a group of technicians from a state-run factory. However, when I received a heavy, palm-sized Olympus camera that Ai had purchased from a second-hand store, I began to develop an affection for cameras. I was particularly fond of that camera and its physicality, a sensitivity toward touch that can only be compared with the feel of a woman's body.

Even now, I don't have my own camera. Initially, the camera used to shoot the series *Group Photo* was rented from the old state-run People's Photography Studio. Mr. Mai explained to me that this particular camera, a genuine American product, was purchased from an American in the 1930s by a Shanghainese photographer, Mr. Wang, for the price of ten gold bars. After passing through several owners, it finally ended up with Mr. Mai. Although it is now extremely shabby and worn, Mr. Mai still treats it in the same manner as his own eyes. The camera comes with an adjustable wooden tripod, on top of which is a round disc with numbers that aids in rotating the camera. In the center of the disc, there is a small level. When the level and the supporting tripod have been adjusted, the camera is mounted and prepared for shooting. Before taking the picture, it is necessary to use a crank to fully wind up the camera. The subjects photographed are positioned along a curved line. The line is a 360 degree curve, at the center of which is the camera. When the shutter is pressed, the camera rotates from left to right. For the exposure, the film within the camera collects along a reel at the same pace as the movement of the camera body. Depending on the number of people being photographed, the length can be extended to as much as three meters. According to the traditional techniques for developing, the negative cannot be enlarged or made smaller. Only photos of the size of the negative (eight inches wide) can be printed.

My father was a happy and hard-working photographer. Right after China's liberation, he carried his camera about and took pictures for the local people. In the mid-1950s, our family moved from Henan to Yumen, which is located in the remote area of northwest China. We moved in order to escape the criminal activities inflicted by groups of thugs and hoodlums. Later, my father opened the only photography studio in Yumen, but before long, it was repossessed by the government during the Great Leap Forward. When I was younger, my father was often asked to travel to far-away places to photograph the farming army groups who were stationed near the Northwest border. He often took me with him. This experience formed an indelible memory of my father, who died of leukemia in the winter when I was seven years old.

I often flip through my father's photographs of my mother, sister, and brother, as well as group photos of my father and his friends. I am moved by the solemnity and serenity conveyed by the people in portrait photographs. Why is it that when people face a camera, they instinctually respond with calmness? The first time my American friend, W, visited my studio, we addressed these topics when we discussed the piece *One and Thirty*. The very instant when a person faces the camera, the individual undergoes a transition from a psychological process to a spiritual process. Once the image has been developed and printed, the symbol of one's identity and representation is determined and documented. This process is one that spiritualizes the material world. It is a ritual in which people confront the material world.

Then what about group photos? These represent a communal relationship. For example, when I choose different people for group photos, I first have to consider the feasibility of the group's dynamic. A group of peasants can, by no means, be photographed with a group of scholars or factory workers (although this was possible during the Cultural Revolution). This is due to their differences resulting from their social division of labor, lifestyles, and social status. This same idea applies to taking group photos. The group photo of a hundred people represents close relationships in modern times. I think this type of group photo would be impossible in America. W says that this can be ascribed to the differences in social systems. In America, the notion of individualism means people are independent of each other. However, the foundation of contemporary Chinese society is still dominated by a primitive group ideology. Nevertheless, China has experienced immense changes since its opening to the world. I believe this style of group photo will remain unique to this existent social structure and will not last long.

My friend Gao brought myself and two photographers to the old town of Daming. As it was his hometown, everyone there knew him well. Even with the help of a bullhorn, it took the village head quite a while to gather all the villagers (more than four hundred people) into an empty schoolyard. Because of all the various connections and conflicts between families, neighbors, and men and women, it was very difficult to arrange the group. If someone was dissatisfied with the arrangement, she or he would threaten to abandon the project. After several hours, under the command of Mr. Li, the camera started to rotate. From a distance, I saw the camera bounce several times. I was so nervous that my heart stuck in my throat the whole time.

TRANSLATION CREDITS

AN HONG, GAO BROTHERS,
HU JIEMING, LI WEI, LIU JIAN AND
ZHAO QIN, SHENG QI,
WANG WEI, YU FAN, ZHANG DALI, ZHANG HUI:
initial translation by
International Language and
Communication Centers, Inc.;
revised translation by
Mia Liu and Peggy Wang.

BAI YILUO, FENG FENG, HUANG YAN,
LI WEI, MIAO XIAOCHUN,
MO YI, QIU ZHIJIE, SUI JIANGUO, SUN YUAN,
WANG JIN, WANG JINSONG, XIONG WENYUN:
translation by
International Language and
Communication Centers, Inc.

CUI XIUWEN:
translation by
Kris Ercums and Joy Le.

HONG LEI, SONG DONG, WANG JIANWEI,
WANG YOUSHEN, YANG YONG, YIN XIUZHEN:
translation by
Mia Liu and Peggy Wang.

LIU WEI, LUO YONGJIN,
RONG RONG, WENG FEN, XU ZHEN, ZHAO LIANG:
translation by
Joy Le.

LIU ZHENG:
translation by
Meg Maggio.

ZHENG GUOGUO:
translation by
Kris Ercums.

MELISSA CHIU is Curator of Contemporary Art at the Asia Society and Museum in New York. She is a faculty member of the Rhode Island School of Design and was recently awarded a Getty Curatorial Research Grant. Previously, she was the founding Director of the Asia-Australia Arts Centre (Gallery 4A) in Sydney for six years. Ms. Chiu has curated exhibitions over the last ten years that included artists from China, Hawaii, Malaysia, Singapore, Thailand, and Vietnam. She has published widely on contemporary art and is a regular contributor for *Art AsiaPacific* magazine, for which she was a guest editor in 2001 and 2003. She is also one of the founding members of the Asian Contemporary Art Consortium, the organizing body for the annual Asian Contemporary Art Week in New York.

LISA GRAZIOSE CORRIN is the Deputy Director for Art/Jon and Mary Shirley Curator of Modern and Contemporary Art at the Seattle Art Museum. From 1997 to 2001, she served as Chief Curator for the Serpentine Gallery in London, one of Europe's premier venues for international modern and contemporary art, where she curated over twenty exhibitions. From 1990 to 1997, Corrin was Curator at The Contemporary Museum, Baltimore, a nomadic museum presenting art in temporary sites. Her work there included the landmark exhibition *Mining the Museum: An Installation by Fred Wilson* at the Maryland Historical Society. In Seattle, Ms. Corrin is responsible for shaping the Seattle Art Museum exhibitions and collections programs, planning the reinstallation of the museum's collections in conjunction with a major expansion (opening 2007), and developing the artistic program for the museum's Olympic Sculpture Park (opening 2006). In addition, Ms. Corrin has written numerous publications in the fields of museum studies and contemporary art history.

CHRISTOPHER PHILLIPS, Curator at the International Center of Photography, is a widely published critic and photography historian who served as Senior Editor at *Art in America* for ten years before moving to ICP. He has curated and co-organized numerous key exhibitions including *The Rise of the Picture Press* (2002), *Cosmos* (1999), *Voices* (1998), *Montage and Modern Life* (1992), and *The Metropolis and the Art of the Twenties* (1991). His books include *Photography in Europe in the Modern Era* (Aperture, 1989), *The New Vision* (with Maria Morris Hambourg, Metropolitan Museum of Art, 1989), and *Steichen at War* (Harry N. Abrams, 1981).

STEPHANIE SMITH is Curator at the Smart Museum of Art at the University of Chicago, where her key exhibitions have included *Illuminations: Sculpting with Light* (2004), *Dawoud Bey: The Chicago Project* (2003), *Critical Mass* (2002), and *Ecologies: Mark Dion, Peter Fend, Dan Peterman* (2000). Ms. Smith served as Assistant Curator at the Rice University Art Gallery from 1996 to 1998 and Curatorial Assistant at the Contemporary Arts Museum, Houston from 1992 to 1995; she developed contemporary exhibitions, publications, and programs for these two institutions. Ms. Smith leads the Smart Museum's programs in contemporary art and photography, and co-teaches in the university's Committee on the Visual Arts.

WU HUNG, Harrie A. Vanderstappen Distinguished Service Professor in Chinese Art History at the University of Chicago and Consulting Curator at the Smart Museum of Art, grew up in Beijing and received his BA and MA in art history from the Central Academy of Fine Arts in Beijing. From 1973 to 1978, he served on the research staff at the Palace Museum, located inside Beijing's Forbidden City. He served as Professor of Art History at Harvard University from 1987 to 1994, and has taught at the University of Chicago ever since. A prolific writer on traditional Chinese art, he has also played a major role in introducing contemporary Chinese art to the West. In the late 1990s, his pioneering research on Chinese experimental art resulted in major exhibitions and publications including *Transience: Chinese Experimental Art at the End of the Twentieth Century* (1999) and *"Canceled": Exhibiting Experimental Art in China* (2000), both at the Smart Museum of Art. He was the chief curator of the first Guangzhou Triennial exhibition, *Reinterpretation: A Decade of Experimental Chinese Art (1990–2000)* (2002), and compiled a catalogue that reviewed the development of contemporary Chinese art since the late 1980s. Other recent publications on contemporary art include *Chinese Art at the Crossroads: Between Past and Future, Between East and West* (New Art Medium, 2001) and *Rong Rong's East Village* (Chambers Fine Arts, 2003).